FASHIONING THE BEATLES

FASHIONING *THE* BEATLES

THE *Looks* THAT SHOOK THE WORLD

DEIRDRE KELLY

sh.
SUTHERLAND
HOUSE
TORONTO, 2023

Sutherland House
416 Moore Ave., Suite 205
Toronto, ON M4G 1C9

First edition, September 2023

If you are interested in inviting one of our authors to a live event or
media appearance, please contact sranasinghe@sutherlandhousebooks.com
and visit our website at sutherlandhousebooks.com for more
information about our authors and their schedules.

We acknowledge the support of the Government of Canada.

Manufactured in India
Cover by Lena Yang
Book composed by Karl Hunt

Library and Archives Canada Cataloguing in Publication
Title: Fashioning the Beatles : the looks that shook the world / Deirdre Kelly
Names: Kelly, Deirdre, 1960- author.
Description: Includes bibliographical references and index.
Identifiers: Canadiana (print) 20230204627 | Canadiana (ebook) 20230204783 |
ISBN 9781990823329 (hardcover) | ISBN 9781990823381 (EPUB)
Subjects: LCSH: Beatles. | LCSH: Rock musicians—Clothing—History. |
LCSH: Fashion—History—20th century.
Classification: LCC ML421 .B4 K29 2023 |
DDC 782.42166092/2—dc23

ISBN 978-1-990823-32-9
eBook 978-1-990823-38-1

Contents

*In memory of Kevin Courrier, a fellow Beatles freak,
who said, "You know? That's a good idea."*

"I can't overpitch this, the Beatles changed everything. Before them, all teenage life and, therefore, fashion, existed in spasms; after them, it was an entity, a separate society."

—Nik Cohn, *Today There Are No Gentlemen*

Preface

The Beatles remain resonant in our imagination precisely because they were never "in fashion." That might sound odd, because just as we all believe the music of our youth was second to none, so we all believe that those four young lads set the agenda—or should that be set the style—for much of what occurred in those crazy days of our golden summers in the sixties. Yes, the haircuts; yes, the suits; yes, the paisleys, the Nehru collars, and the tight trousers. All of this was endlessly imitated by a whole host of acolytes. But the Beatles didn't set out to be the trend.

They were innately stylish young men who, by constantly changing their appearance (mostly to please themselves), altered the look of a generation, not once but time and time again. Why? Because they were original. They did not follow fashion. They took it in new directions, becoming the leading style makers of their day.

Not much has been written about that, how their look permeated contemporary culture much like their music. It's a subject worthy of an attentive, detailed and intelligent study and Deirdre Kelly has risen to the challenge. Her magnificent book is both broad and deep, offering an unparalleled survey and analysis of the Beatles as the enduring epitome of pop style.

London in the mid-sixties, from the mini skirt to the coats of many colors, was the center of the Universe, or so it believed. For a while there, Carnaby Street eclipsed Paris as the international capital of style. Did the Beatles themselves create that? No. But by embodying a desire for freedom and self-expression, an ideal reflected in their individualistic clothing choices and hair styles, the Beatles energized the world with creativity, hope and endless possibilities. We might have lost sight of that now. But this book powerfully reminds us just how bright and important they were and continue to be.

Tony Palmer, director, *All You Need Is Love*

DRESSING FOR PEPPERLAND

"We were slightly—you could call it arrogant or confident—in our own sense of fashion."
—PAUL MCCARTNEY

With their boldly original outfits, high-stylized hair and mustaches, the Beatles projected a radical personal appearance that made them not simply different but extraordinary. (Piers Hemmingsen)

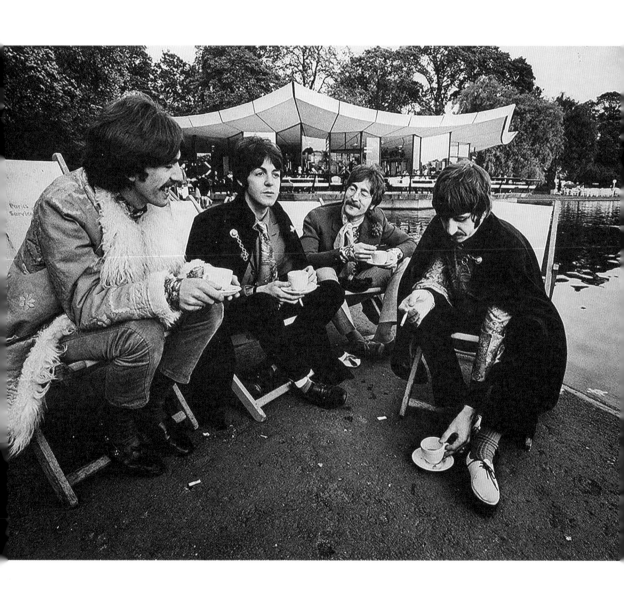

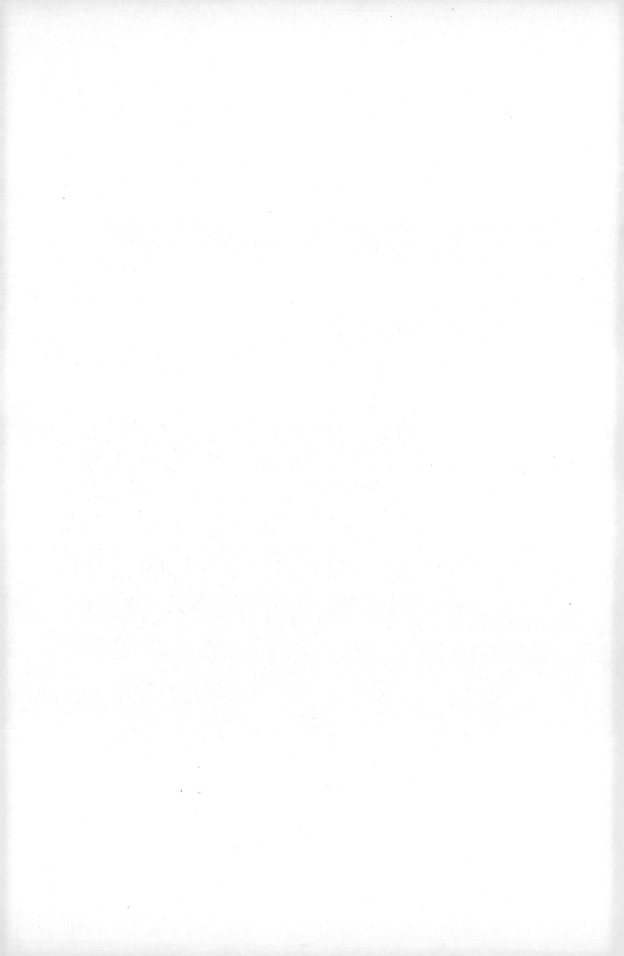

On May 18, 1967, the day before the Beatles unleashed *Sgt. Pepper's Lonely Hearts Club Band* on an unsuspecting world, the famous foursome arrived at an outdoor photo session colorfully and eclectically dressed. Each Beatle was attired for the occasion with mismatched articles of clothing, combinations of made-to-measure and mass-produced. Together they reflected every hue of the rainbow. No one else in London's Hyde Park that afternoon came close to approximating the group's vivacity. The Beatles burst on the eye like gilded butterflies in a gray landscape, heralding the arrival of the Summer of Love and their ascendance to a new pinnacle of international pop culture stardom. A crowd of people stood and stared.

There was much to take in. These were the Fabs after all, the British hitmakers who in the 1960s restored English influence on the world's cultural stage. The nation had been enthralled with how these young men dressed, played, and generally comported themselves since the outbreak of Beatlemania just four years earlier. Shooting for *Time* magazine, photographer Marvin Lichtner highlighted the band's distinctiveness by posing the Beatles in the park alongside tropes of traditional Britishness: schoolboys in shorts and caps uniforms, matrons in buttoned-up cloth coats, and a City gent in a dark bowler hat and tailored suit reading a Fleet Street newspaper on a bench.

The novelty of the scene was enhanced by the fact that the Beatles had not been seen much lately, having gone underground since they quit touring almost a year before. Ever since, they had been sequestered in the recording studio, conjuring a new psychedelic sound. Fans had not yet heard it. The group's radically altered image signaled a mighty transformation.

Draped over Ringo's paisley-patterned shoulders was a cape of shiny ecclesiastical purple, a vintage find fastened with gold chain. Paul's own cape, in policeman black, dramatically offset the brilliant threads worn underneath—a paradise pink suit jacket, orange, mauve, and raspberry silk print tie, and tailored periwinkle blue shirt. George tapped into the back-to-the-earth movement then transporting him to new heights of serenity, donning an imported Afghan sheepskin jacket, love beads, and sage-colored cords. John mashed it up in a floral high-collar shirt, green silk neck scarf, red Regency-style jacket, and Scottish sporran hanging pendulously over the crotch of his lilac trousers.

It was a new look, a bricolage of ethnic garments, flamboyant accessories, and moth-nibbled relics of Empire which the Beatles had merged,

modified, and transfigured into a potent personal style statement. Like everything they wore, it would have an enormous influence, shaping the course of fashion on a grand scale, at that moment and in years to come. From then on, the uniformity that had typified public dress since the Second World War was shattered and one of the most colorful and exciting eras in the history of fashion was unleashed, allowing young people to dress with freedom and exuberance unimaginable to their parents.

The formerly black-and-white Mop Tops had not set out to be trendsetters. They dressed to please themselves and, yes, to attract attention. Tailoring a series of disparate looks from a variety of fashion sources, they succeeded in making themselves stand apart from the crowd to become the biggest and most culturally significant rock-and-roll band of all time. What they wore deeply mattered. Clothing to the Beatles was neither simply utilitarian nor a frill. It was a visible manifestation of their uninhibited creativity and never-ending quest for originality—a key component of their unprecedented success and enormous fame. And it was constantly changing, mirroring their artistic progression, their rise to the top. To those taking in their kaleidoscopic appearance that day, the Beatles were not just dandy dressers. They were everything the pop experience personified, the quintessence of genuine style. And that's why people, including many of the best designers of our own time, have never ceased looking to them for inspiration.

1960
TOUGH LEATHER
"That outfit of mine was very risky."
— GEORGE HARRISON

Crafting a look that spoke volumes about who you were, where you came from, the music you liked, how you viewed the world and your place in it, was what the young Beatles had in common. (Alamy Stock Photo)

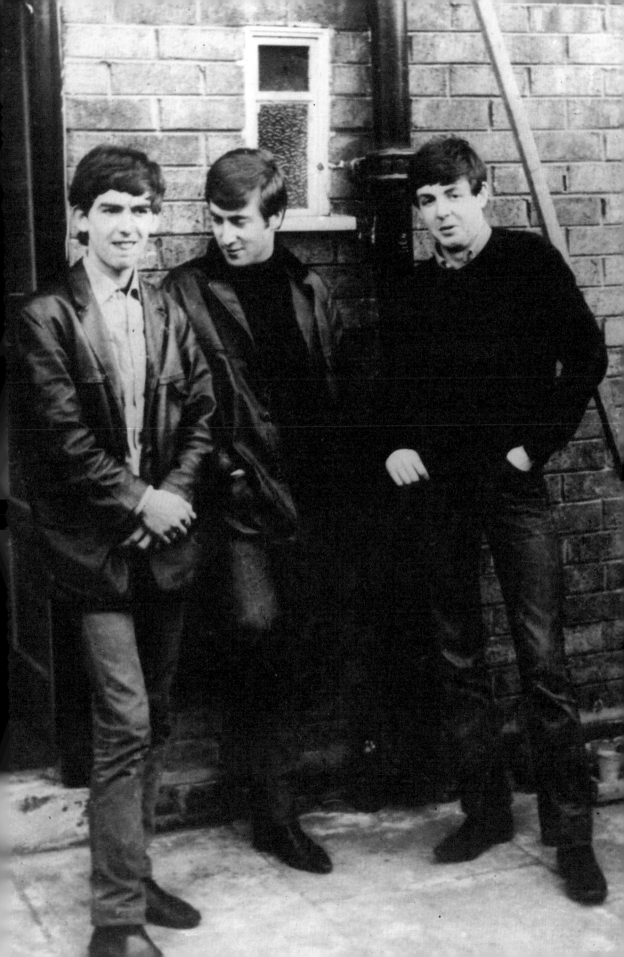

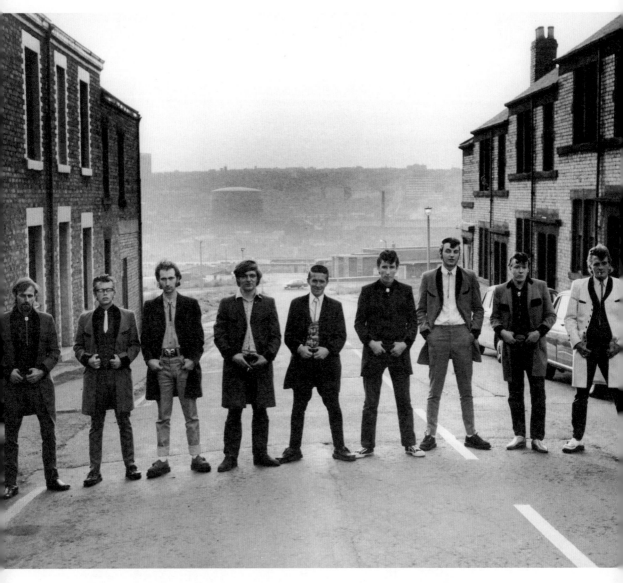

The early Beatles adopted Teddy Boy style, characterized by tight drainpipe trousers, pointy shoes, and long Edwardian drape jackets. (Alamy Stock Photo)

George Harrison was the baby of the Beatles, nearly three years younger than John Lennon and Ringo Starr, who were both born in 1940, and nine months younger than Paul McCartney who would forever remind him of their age difference. But when it came to sartorial cool, George often led the way. From a young age, the last-born son of a Liverpool bus driver and his indulgent Irish-Catholic wife was always up-to-the-minute, if not before his time in terms of clothing.

While a student at the Liverpool Institute, the grammar school he and Paul both attended, George began tailoring his school uniform to reflect his rebellious but innately stylish nature. Taught by his mother to use the family's sewing machine, he stitched the legs of his trousers to make them tight. He was going for the drainpipe look favored by Teddy Boys, a subculture of street-smart, clothes-conscious, rock-and-roll-loving toughs in mid-1950s Britain. At age fifteen, George went around to a local haberdasher with a sketch of a luminous pink shirt he wanted custom-made. He was clothes obsessed:

> I'd started to develop my own version of the school uniform. I had some cast-offs from my brother. One was a dog-toothed check-patterned sports coat, which I'd had dyed black to use as my school blazer. The colour hadn't quite taken, so it still had a slight check to it. I had a shirt I'd bought in Lime Street that I thought was so cool. It was white with pleats down the front, and it had black embroidery along the corners of the pleats. I had a waistcoat that John had given me, which he'd got from his 'uncle' Dykins [his mother's boyfriend], Mr. Twitchy Dykins. It was like an evening-suit waistcoat—black, double-breasted, with lapels. The trousers John also gave me, soon after we first met— powder-blue drainpipes with turn-ups. I dyed them black as well. And I had black suede shoes from my brother.[1]

Courting expulsion, George further embellished his school uniform with a canary yellow vest worn under his blazer and used fistfuls of grease to pile his luxurious brown hair on top of his head until, as one friend said, it "looked like a fucking turban."[2]

Paul was a grade above George at school, but he admired the younger boy's outlandish sense of style as well as his skill in playing the tricky chord

progressions of the latest rock and roll. Paul lobbied John hard to bring George in as lead guitarist for the group that would eventually become the Beatles. He could play and he was an original, deploying fashion to present himself as extraordinary. "Going in for flash clothes or at least trying to be a bit different, as I hadn't any money," he later explained, "was part of the rebelling."[3]

Paul also liked to stand out but took a subtler approach than young George. In an early class photograph, he wears a school uniform with a cap like the other boys in his grade yet he's reading a comic book and scrunching his face in mock earnestness, a born showman. Paul grew up in a musical home, a gifted musician with an innate genius for song writing and self-presentation. His father had been a trumpeter with his own Liverpool jazz band before marrying Mary, a midwife who died of cancer when Paul was fourteen and his younger brother Mike twelve.

As a single parent, Jim McCartney, now working as a cotton salesman, imposed discipline over his boys that extended to their mode of dress. Like most people of his generation, his views about clothes were deeply conservative, a holdover from the Second World War when everyone was in uniform. That mindset was reinforced by National Service, a post-war form of conscription imposed on all healthy British males between the ages of eighteen and forty-one. It encouraged young men to "man up" and dress like their starchy fathers. National Service was dismantled toward the end of the fifties, giving boys like Paul and George the freedom to rebel against convention and authority, particularly in their personal style. Paul, too, liked drainpipe trousers, or drainies, but he hid them under the baggy trousers of his school uniform, stripping down on the bus once out of his father's sight. The jeans, T-shirts, and crepe-sole shoes worn by some of Paul's rock-and-roll heroes in America were better tolerated on the home front.

After taking in the 1956 Hollywood movie, *Rock Around the Clock*, Paul developed a taste for hip-length sports coats in eye-catching patterns and cotton shirts slung round with western ties, in the manner of Bill Haley and his Comets, whose chart-topping song led the soundtrack. "They had tartan jackets, which sounds terrible now," Paul said, "but it was great then. It was something special, and that's what I was after: *chills*."[4] Elvis Presley was another style influence, not least because his 1957 version of "Blue Suede Shoes" made it cool for guys to obsess over things they wanted to wear.

George Harrison exhibited a non-conformist fashion sensibility from an early age. (Media Drum International)

No one recalls Paul in blue suede shoes but he mimicked the King in other ways, piling his dark brown hair on top of his head and sweeping it back at the sides to form a ridge at the rear. The style was known as a duck's arse, DA for short, for obvious reasons. Elvis sported this same haircut. Wanting to be just like his idol in every way, Paul taught himself the chords to "Be-Bop-A-Lula" on a guitar, playing it upside down to accommodate his left-handedness. His playing and rockabilly look instantly captivated John Lennon when they met for the first time at the Woolton Village Garden Fete on July 6, 1957.

John was performing outdoors on a makeshift stage with his first band, The Quarry Men skiffle group. Paul was in the audience, having been brought to the community party by a mutual pal, Ivan Vaughan, who later brokered the introduction. John was taken with the cocky teenager before him. He knew all the words to "Be-Bop-A-Lula" and "Twenty Flight Rock" and cut quite the figure. "He also looked like Elvis," said John. "I dug him."[5]

John, too, favored a rockabilly mode of dress during his early teenage years: string ties, gingham shirts, and jeans. But he made a radical wardrobe change after a drunken off-duty police officer ran down and killed his estranged mother, Julia, on the night of July 15, 1958. At age seventeen, he began dressing head-to-toe in nihilistic black, cutting a menacing but intriguing figure at the Liverpool College of Art, one of England's oldest art schools, whose hallowed doors he had entered the year before. Bill Harry was at the college with John at the time: "I said to myself, the art students are supposed to be the bohemians, yet he is the rebel. I've got to know him. His whole presence was like, WOW."[6]

John also took to wearing a dark oversized coat that had belonged to another dearly departed, George Smith, husband of his Aunt Mimi, Julia's older sister. George had been his guardian since John was five years old, the only father figure he had ever known. His biological father, Alf Lennon, a merchant ship's cook who did some jail time, barely figured in his son's life. Uncle George had died suddenly in 1955 when his heart gave out. John wore his coat as a memento mori and a means of camouflaging his inner anguish. Helen Anderson, another fellow art student who would later become a fashion designer and retailer with her own Liverpool shop, has remembered that the three-quarter-length Crombie coat sometimes smelled greasy from the battered and deep-fried potato slices John used to buy for lunch from a chip shop on Falkner Street.[7] Not that this put her off. She found

John's pranks and the funny faces he pulled in class uproariously funny and soon after meeting him became a lifelong pal. Their friendship revolved around a shared love of clothing. "John was always passionate about clothes and how cool he wanted to look," Anderson said. He once bartered a sketchbook of his drawings for one of her baggy yellow sweaters, which he wore at the college, again making himself conspicuous. He sweet-talked her into narrowing his trousers for him on her home sewing machine, which she regularly did, according to his specifications. Anderson also made clothes for John, including a black leather waistcoat with buttons and a matching black leather tie. "He wouldn't normally wear a tie at college," she observed, "but he loved that one because it was narrow—1.5-inches wide."[8]

A dominant personality who as a child had been expelled from his Mosspits Infants School for bullying, John did his best to live up to his black leather look. "I was pretty self-destructive at college," he has said. "I was a drunk and smashed phone boxes."[9] A lackluster student, he distracted and disrupted fellow students and teachers alike, developing a reputation as a Teddy Boy, a young street tough attired in mock Edwardian clothing that masked a rebellious and often violent lifestyle. Emulating the Teds, John wore a long drape jacket with tight drainpipe trousers and crepe-soled shoes, a costume that frightened Paul when he first spied him on a Liverpool bus.[10] "I mean, I know how I saw John," Paul said. "He was just a Ted, on the bus—greasy hair, long sideburns, shuffling around like he was Mr. Hard. And I saw him on the top deck of the bus often, before I met him. Saw him in the queue at a chip shop once. And I thought, 'He looks cool.'"[11] Exactly what John thought of Paul.

Without this shared visual attraction, it is unlikely that Paul and John's musical collaboration would have happened. These two central figures in the Beatles had to vibe first on the level of clothes. They were, in essence, opposites: Paul smiling and outgoing, John unsmiling and quick to offend. But those differences complimented each other. Paul smoothed John's rough edges and John put fire to Paul's cautious nature, encouraging him to take greater risks and defy his father over what he, as a fledgling rock-and-roller, should wear and do with his life. Their joint chemistry was a perfect blend of sweet and sour, hot and cold, and it produced among the best harmonies ever heard in pop. Paul's higher register meshed seamlessly with John's nasal delivery, helping to create a signature sound. George, too, could sing, and depending on who was on lead vocals, he would pair up with

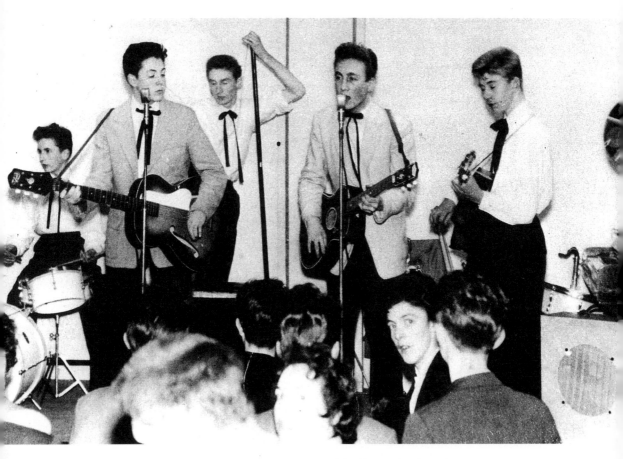

Once Paul McCartney and John Lennon joined forces, they dressed alike, signaling to the world their creative bond. (Canadian Press)

either John or Paul at a stand-up microphone to strengthen their intertwining voices. The Everly Brothers were an early influence, but the Beatles went further, combining elegance and grit in one potent package. Their roles weren't fixed, either: Paul had a nasty streak and John had a core tenderness that belied his harsh exterior.

Extremely short-sighted, John wore glasses and ran scared whenever a real Ted was in his midst; he once sought a police escort to walk him to a bus stop in fear of two older boys who had chased him after he had heckled them. In some ways, John was a sheep in wolf's clothing. "I came from the macho school of pretense," he would later explain. "I was never really a street kid or a tough guy. I used to dress like a Teddy Boy and identify with Marlon Brando and Elvis Presley, but I was never really in any street fights or really down-home gangs. I was just a suburban kid, imitating the rockers."[12]

Still, the look brought him attention. "When I'd first looked at John I'd thought, yuck, not my type," said his first wife, Cynthia (née Powell) Lennon, a fellow student at the Art College. "With his Teddy-Boy look—DA haircut, narrow drainpipe trousers and a battered old coat that was too big for him—he was very different from the clean-cut boys I was used to. His outspoken comments and caustic wit were alarming. I was terrified he might turn on me, and he soon did, calling me 'Miss Prim' or 'Miss Powell' and taking the mickey out of my smart clothes and posh accent."[13]

Of the Beatles, only Ringo, the poorest and least educated of the group, had been a real Teddy Boy. Raised by a single mother in the Dingle, one of Liverpool's toughest neighborhoods, he was sickly as a child and missed so much school his teachers forgot about him. He became a Ted by default, joining the ranks of poor, mostly futureless British teenagers with little more than time and Brylcreem on their hands. It was either become a member of the brass-knuckled tribe or get the shit kicked out of you.

"I had a Teddy-boy suit," Ringo said. "My cousin who went to sea—it all revolves around sailors—would give me his old clothes, and he was a Teddy Boy. So I had a big long jacket with very tight trousers and crepe-soled shoes. But he was much bigger than me, so I had to strap the pants up with a big heavy belt, which I'd put washers on. I started to dress like that when I was sixteen."[14]

Born Richard Starkey, Ringo got his stage name from the proliferation of rings he wore on both hands. They doubled as weapons on a closed

fist, another Teddy Boy style point. His nickname was also inspired by Johnny Ringo, the real-life gunslinger played by Gregory Peck in the 1950 Hollywood movie, *The Gunfighter*. Ringo loved the Old West and had thought to immigrate to Texas but was put off by the paperwork required. One of his first groups was the Raving Texans, a Liverpool rock-and-roll outfit that later morphed into the country-and-western band, Rory Storm and the Hurricanes. Ringo drummed for the Hurricanes before joining the Beatles in 1962, the last member aboard. He had met John, Paul, and George two years earlier in Hamburg when all of them, in their respective bands, had been participants in the German port city's notorious club scene. Ringo might have been a latecomer, but he fit right in, mainly because of his appearance.

When the Beatles were first in Hamburg, they went regularly to see the Hurricanes whose matching fluorescent suits, professional instruments, and tight sequencing of songs made them seem impressively professional. Front man Rory Storm[15] was a striking performer, jumping about on stage, swinging his mic, dressed in gold lamé and drawing a large comb through his waves of blonde hair. But it was the bloke at the back, perched above his drum kit in a flaming pink suit with matching handkerchief and tie, who was the one to watch, agreed the early Beatles. Off stage, Ringo dressed like a Ted, even in Germany. He had a gray streak in his hair, one gray eyebrow, and a big nose that made him look cocky and mean. "I know we all had the same impression about him," said George, "You'd better be careful of him, he looks like trouble."[16]

But as George and the others would discover after they all drank beers together following their respective late-night sets, Ringo wasn't as tough as he looked. He liked to hang out and have a laugh. He shared the Beatles' mischievous sense of humor, deep love of rock-and-roll, and fondness for clothes. When not working with the Hurricanes, he'd go to where the Beatles were playing and sit quietly at the back of the room, watching them thrash about on stage. He liked them as much as they liked him. Crucially, he spied on the group's potential early on, convinced it was just a matter of time before they made it big.

* * *

Besides John, Paul, and George on guitars, the Beatles, as Ringo first saw them in the summer of 1960, consisted of bassist Stuart Sutcliffe, John's talented art school friend, a James Dean lookalike who couldn't play a note, and drummer Pete Best, whom they had met at a new Liverpool coffee bar with a jukebox and a makeshift stage set up for live bands. Pete's Anglo-Indian mother, Mona, had created the Casbah Club in the basement of her large Victorian-style home, partly as a way for her good-looking but introverted son to play and listen to music with like-minded teens. The Beatles had some of their first performances there, drawing in Pete mainly because they had to. There was no other drummer at the time. It was a longstanding void in their lineup.

They had been together less than a year. As scrappers who had bought their instruments on credit, they had performed as Johnny and the Moondogs and the Silver Beatles—the latter sometimes spelled with double 'e's—before settling on the Beatles. Prior to Pete Best, they had persuaded a bloke named Tommy Moore to drum for them. Now merely a footnote in the story of the Beatles, Moore, a fork-lift operator who played on the side, served a brief but important role, accompanying the Silver Beatles on their first tour of Scotland as a back-up band to the British heartthrob Johnny Gentle.[17]

To make themselves seem professional, the Beatles outfitted themselves in matching clothes for the Scottish trip: dark long-sleeve button-down shirts edged with silver thread at the collar, denim-like trousers, and two-tone string shoes with rubber soles. The look was early Elvis. John would later describe it as art-school-inspired: "We looked arty compared with other groups, who looked like clerks or dockers. We looked like students . . . so we had a bit of a classy touch right away, which was different."[18]

They also adopted stage names. John was Long John (as in Long John Silver, the fictional pirate from Robert Louis Stevenson's book, *Treasure Island*); Paul was Paul Ramon, the name later adopted by the Ramones; George was Carl Harrison, a tribute to his guitar idol Carl Perkins, creator of "Blue Suede Shoes;" Stu Sutcliffe, showing off his intellectual bent, was Stuart de Staël, from the French painter Nicolas de Staël whose abstract landscapes he admired;[19] Moore, lacking the others' wit and imagination, went by his formal name, Thomas. Moore also refused to dress like the others, appearing at gigs in a windbreaker and work shirt, looking like a docker indeed.

The self-taught musicians were woefully under-rehearsed and largely ignored. Billed as Johnny Gentle's Band, they didn't even get to play under their own name. Nor did they play their own songs—Paul was then boasting in letters to would-be promoters that he and John had written more than fifty original compositions. In Inverness and other parts of northern Scotland, the group played Gentle's playlist, mostly slow dance tunes: "Only Sixteen," "A Teenager in Love," "Living Doll," and the saccharine-like.[20] It didn't take long for the excitement of being on their first concert tour to drain away, especially when forced to sleep in their stage clothes in the cramped quarters of the tour's van. "Our shoes were full of holes and our trousers were a mess," George would later recall. "The band was horrible, an embarrassment. We didn't even have amplifiers."[21]

The Beatles came home poorer than before they went out on the road. But the experience had paid off in other ways. It taught the Beatles the value of thinking through their performance and presentation. They learned this directly from Gentle, a seasoned entertainer who performed in what George called "a posh suit." He schooled them on the virtues of "looking sharp" on stage.[22]

Paul had needed little persuading on that point. He knew clothes could make a band. When he was thirteen, on vacation with his family at the Butlins summer camp in Pwllheli in North Wales, he had seen five young men exit the ballroom, dressed in identical tartan shorts, pumps, flat caps, gray crew-neck sweaters, and carrying white towels under their arms. Everyone turned to look at them. For Paul, it was an epiphany.[23] "In that second, a penny dropped for me," Paul recalls, "and I realised the power of looking something. They won the talent contest at Butlins that week for whatever they did—and you just knew they would win."[24]

It must have been Paul who convinced John on this point. Before he joined the Quarry Men, they were a motley crew: checked shirt on John; a sweater and open shirt collar on Eric Griffiths; plaid on Colin Hanton; more checks on Rod Davis; a sports jacket on Pete Shotton; a plain shirt on Len Garry. When Paul made his Quarry Men debut at a Conservative Club social at the New Clubmoor Hall in Liverpool on October 18, 1957, the group was dressed more uniformly and with rockabilly flair. Paul and John both wore matching "creamy-coloured, tweedy sport coats," which the other band members were persuaded to help pay for at a rate of "half a crown a week, collected by Nigel [Walley] until the bill was paid," Hanton recalls.

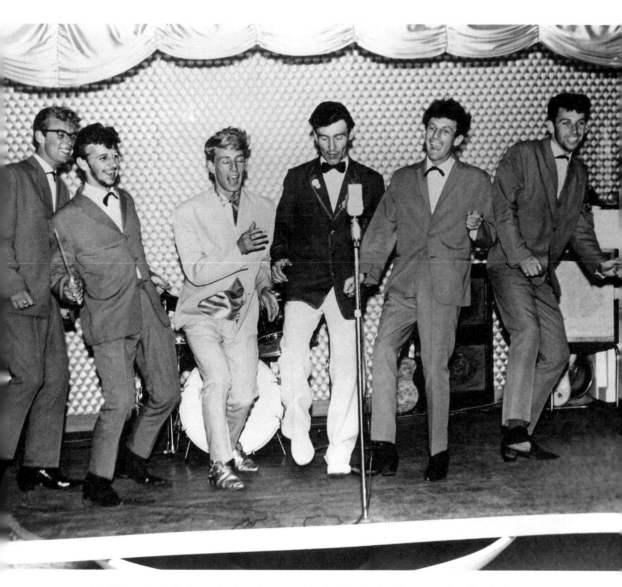

Rory Storm and the Hurricanes is where drummer Richard Starkey became known as Ringo Starr for the many rings he wore with his flashy stage clothes. (Alamy Stock Photo)

The others were urged to adopt "white shirts with tassels and black piping and black bootlace ties," as a way of imparting a visual sense of cohesiveness.[25] It is noteworthy that at this point in their shared history, Paul and John dressed alike and differently from other people, their matching outfits appearing as an outward sign of their growing creative partnership.

The Hamburg opportunity came about because Rory Storm and the Hurricanes were double-booked. The Beatles were hired as a last-minute replacement by a desperate Allan Williams, a Liverpool club owner and promoter who supplied groups for the German circuit. Williams paid for the Beatles to go to Hamburg, arranging everything for them and expecting them to show their gratitude by keeping him as their manager. But the Beatles dropped him as soon as they found success, cheerfully burning bridges. They were their own men, even if they didn't half know what they were doing.

Paul believed he knew what he was doing by creating a visual identity for the band and when it came time to dress the Beatles for Hamburg, he again took charge. He chose custom-made jackets, a more ambitious look than anything the Quarry Men had tried. Paul perceived the overseas gig as a definite improvement in their collective fortunes and wanted clothes that looked as if they were on their way up. The resulting lilac-colored velvet sport coats were made by David Richards, a tailor from Paul's old neighborhood.[26]

The Beatles wore these matching jackets over black or white shirts, tight black drainies, and pointed toe winklepickers made of imitation crocodile.[27] Nice as they were, those early suits took a beating. Within a week of wearing their custom-made clothes on stage at the Indra, a strip club near the Repeerbahn converted to a live music venue, the suits succumbed to the nightly onslaught of sweat, smoke, and beer. Later, the Beatles added "funny little grey and white dog-tooth jackets, set off by black shirts and pants and grey winkle-pickers" to their stage outfits,[28] in addition to red-and-black striped jackets worn with plain jeans. These store-bought items were also intended to make the band seem professional but they, too, died an ignoble death.[29]

Club manager Bruno Koschmider, a war survivor who walked with a limp and carried a truncheon, insisted that the Beatles *mach schau*," or make show. In other words, give the audience of gangsters, hustlers, and perverts their money's worth. To fortify themselves, the band gulped

Preludin, described by Beatles biographer Philip Norman as "a brand of German slimming tablet which, while removing appetite, also roused the metabolism to goggle-eyed hyperactivity."[30] Their performance style, developed over fourteen weeks and about 415 hours of intense rock and roll, became anarchic. The Beatles literally rolled on the stage and foamed at the mouth. The suits melted away.

Photographs of the Beatles from this first Hamburg trip show them as a rag-tag tribe of fang-baring degenerates. In one image, John wears a toilet seat as a necklace, dressed only in his underwear. In another, Paul is in a ripped shirt, his face contorted in a scream, dripping with sweat. Hardly sharp at all. John, at this point in the band's demented apprenticeship, organized the other Beatles to mug and rob a seaman of his wallet. Only Pete Best went along with it. But the sailor proved to be less drunk than he looked and managed to fend off Pete and John who ran, frightened, for cover. The nastiness did not end there. John allegedly pissed on the heads of nuns from an upper balcony. Paul got the clap from the Herbertstrasse red light district prostitutes and the strippers who had become their frequent bed mates. The Beatles were squeaky clean. In Hamburg, in fact, they barely washed at all. George remembered that the whole of their personal grooming was accomplished in small public lavatory sinks where they could rinse their teeth but not much else: "I don't think we bathed or showered at all when we were first there, probably not even the second time."[31]

In October of 1960, Koschmider agreed to transfer the Beatles from the Indra to the Kaiserkeller. While one of the seedier night clubs in Hamburg's notorious St. Pauli district, the Kaiserkeller, a literal cellar, was, in its way, a step up. It was a larger venue, closer to the centre of things. It was also where the Hurricanes played. More familiar with Hamburg by then, the Beatles knew about the small flea market by the cafes on the banks of the Elbe River. They found cheap clothing, hats, and trinkets to replace their battered outfits. They no longer matched. It would take an outsider to bring the group back to a consistently uniform look.

An only child born to a well-to-do German family, Astrid Kirchherr was a twenty-two-year-old photographer's assistant in head-to-toe black clothing—a homage, she said, to Jean Cocteau and Juliette Gréco. She understood the power of image and fell in love with the Beatles the minute she first laid eyes on them, attracted by the rawness of their look. Her

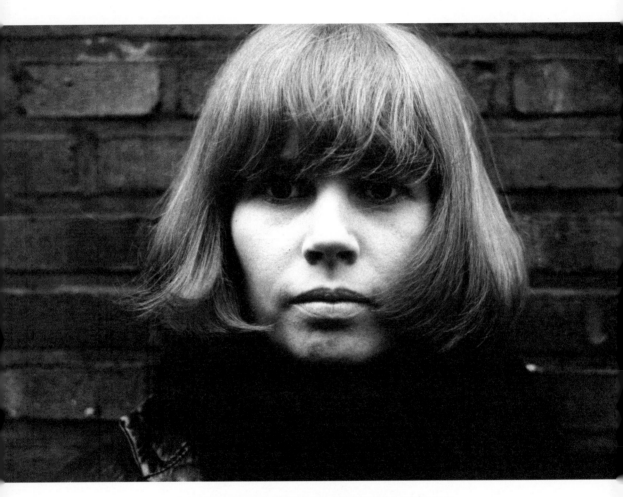

An outsider named Astrid Kirchherr instigated a makeover that gave
the Beatles a distinctive style. (Alamy Stock Photo)

boyfriend at the time, Klaus Voormann, a life-long friend of the foursome, made the introduction.

The now-familiar story goes that one evening, following an argument with Astrid and needing to let off steam, Voormann was drawn into the Kaiserkeller by the pounding sound of the Beatles' music. They made an immediate impression on him. "It was early when they started playing an . . . it just blew me away," Voormann remembered, "and the thing was each member was so special because this was not just a bunch of people, they talked to one another. They had a great communication between them. It was really very exciting."[32]

Returning the next night, Voormann brought along Astrid and Jürgen Vollmer, who worked with Astrid at the studio of German photographer Reinhart Wolf. Influenced by French philosophy and fashion, these young German intellectuals called themselves "exis" in homage to the French existentialists, in particular Jean-Paul Sartre and Albert Camus whose writings they adored. Their style was anti-bourgeois and non-conformist. They wore black leather jackets to mark themselves as part of a post-war sartorial tribe whose heroes were the French singers and poets of the Left Bank. "Our philosophy then, and remember we were only little kids, was more in following their looks than their thoughts," Astrid said. "We were going around looking moody. We wanted to be different and we wanted to be cool although we didn't use that word."[33]

They settled in at the Kaiserkeller to see "a little scruffy band" that Voormann nevertheless deemed "fantastic."[34] The Beatles could not help but notice the three friends. Each dressed in black, they stood out in the crowd. The "exis" embraced the Beatles as kindred spirits. In turn, the Beatles would call them their "angel friends," the people who helped them most in creating a signature style. Their new look would be all black.

George, then just seventeen, led the way, buying a second-hand black leather jacket off the back of a Hamburg waiter, then acquiring new dark drainpipe jeans, creating a whole outfit.[35] He added flame-patterned cowboy boots to the mix, a gift from his mother, Louise, back in Liverpool. Louise Harrison had purchased the multi-colored boots during a 1960 trip to Kirkland Lake in the Canadian province of Ontario.[36] She brought them back to George, who proudly wore them on stage in Hamburg.[37] The other Beatles wanted something similar. At the recommendation of singer Tony Sheridan, they went to Erdmann, a German department store with a

leather goods division that catered to bikers. There, John, Pete, Stu, and, lastly, Paul (always careful with his money) bought leather cowboy boots and black leather jackets. The look was coffee bar cowboy. It drew inspiration from the Rockers, also known as greasers for their love of motorcycles and slicked-back pompadours, another British youth subculture linked to the Teds and admired by the Beatles.

Dressed alike in leathers, the Beatles stood united. They topped off their new stage uniform with pink fabric flat caps whose form, they thought, evoked a distinctive aspect of the female anatomy. The Beatles cheekily called these twat hats and perched them jauntily on top of their greased back quiffs. John said the look was a homage: "We looked like four Gene Vincents," referring to the American rocker who dressed in black leather and whose backup band was called the Blue Caps for the headgear Vincent had adopted when a marine. Vincent's tough-guy look, along with his yelping rock-and-roll sound, exerted a strong influence on the Beatles.[38] But there was another attraction to the leathers. They marked the group as outsiders, and the Beatles liked that. It's how they saw themselves. "Even nowadays kids with leather jackets and long hair are seen as apprentice hooligans, but they are just kids; that's the fashion they like—leathers. And it was like that with us," George said. "With black T-shirts, black leather gear, and sweaty, we did look like hooligans."[39]

Voormann summed up their allure: "Rock hair, rock clothes, and rock jargon."[40] Astrid, too, succumbed to the Beatles' charms, particularly the moody presence of Stu Sutcliffe. On stage, he wore Ray Bans and turned his back to the audience as if he did not give a damn (in fact, he was trying to hide his lousy bass playing). A gifted painter, he was in the Beatles because John liked his look. With his blond hair, square jaw, chiseled cheek bones, and lanky body, Stu looked like James Dean. His androgynous handsomeness reflected something of the haunting beauty of Astrid, a resemblance that became more pronounced as the two became romantically entwined.

As soon as Astrid had replaced Klaus with Stu in her bed, she began experimenting with his appearance. The other Beatles watched, amused, and awed, from the sidelines. After inviting him to move into her family home where her bedroom was as black as her clothes, Astrid convinced Stu to dress in her clothes. A coveted piece was a woman's collarless jacket, cut from a bolt of corduroy, that Astrid had made herself at home after an original design by Pierre Cardin. Stu wore the garment when he returned

to Liverpool. Paul's brother Mike McCartney thought Stu "a bit daft for doing that."[41] But this feminizing influence would soon spill over into the Beatles' overall style. "Astrid took them to shops," Voormann said, "and showed them clothes they could wear."[42] George recognized the central role she played in fashioning their stage appearance. "We looked so cool," he said. "Astrid was totally responsible for our whole image."[43]

That image looms large in a series of now iconic black-and-white photographs Astrid took of the band just before they left Hamburg in the fall of 1960. She shot them at the thrice-yearly Dom Fun Fair on Hamburg's *Heiligengeistfeld*, a carnival-like setting suggestive of a masquerade. And she constructed a sort of mask for them, a look intended to both project and protect the band's identity as musicians/artists. Astrid dictated their wardrobes: the black leather jackets, rolled cuff black denim, black rollnecks, and T-shirts. She positioned the Beatles in slouched defiance on a flatbed truck laden with fairground equipment. She instructed them to clutch their instruments so as not to be mistaken for the itinerant scruffs working the fair.

Another crucial component of the Beatles' look was their hair. Astrid had styled Stu's hair like her own, short at the back, long in front, with the hair pushed forward to cover the forehead and the brows. It was a French style, what the Germans called *pilzen kopf*, or mushroom head, the latest version of the ancient bowl cut, which came to be associated, post-First World War, with manual laborers and children. From the 1920s on, respectable adult men were expected to keep their foreheads clear of hair; even a natural quiff, curl, or wave was supposed to be combed back from the brow—in the 1950s, combed up vertically, but still back. Hair over the forehead was seen as juvenile, teen defiant, or working class—hence its appeal to rebels and fashion nonconformists. "All my friends in art school used to run around with this sort of what you call Beatles' haircut," Astrid later said. "My boyfriend then, Klaus Voormann, had this hairstyle, and Stuart greatly liked it. He was the first one who got the nerve to get the Brylcreem out of his hair and asked me to cut his hair for him."[44]

The other Beatles sniggered, initially. Once they got used to the look, they, too, were styling their hair in the continental fashion. John and Paul were first. An aunt had given John money as a twenty-first-birthday present, which funded a side trip to Paris in October 1961. While there, the Beatles looked up to Vollmer, who had moved from Hamburg to Paris to

take up a position as assistant to the American photographer William Klein. Vollmer took them shopping at the Clignancourt flea market, in the north of the city, where John bought a green corduroy jacket like Vollmer's and Paul a patterned polo-neck sweater. John and Paul implored Vollmer to cut their hair like his, in the combed-down *pilzen kopf* style. "It sounds conceited but it's the truth," Vollmer said, "they really wanted to look like me."[45]

The long-haired look for men was then *à la mode* in Paris and the two Beatles found that their greased-back DAs repelled French girls. Vollmer liked them looking like rockers but ultimately agreed to help. In his Left Bank hotel room, he took a pair of scissors and cut their quiffs.[46] It was the snip that established the Beatles as being at the forefront of fashion. According to Paul, "When we got back to Liverpool it was all, 'Eh, your hair's gone funny'—'No, this is the new style.' We nearly tried to change it back but it wouldn't go, it kept flapping forward. And that just caught on."[47]

It caught on because Paul and John committed to the French style, soon to be known around the world as the Beatles' style, as the band's signature look. It marked them as originals. George soon changed his hair to match John and Paul's. Pete Best, to his detriment, refused to modify his Tony Curtis hair style, later saying that his decision "wasn't a case of not conforming . . . it was just the fact that it didn't seem important at the time."[48] But important it was. Pete's refusal to let his hair down gave the other Beatles one more excuse to sack him—that and the fact they preferred Ringo's drumming.

Before Ringo could join the Beatles, John demanded that he "comb his hair forward and shave his beard . . . his 'sidies' however could remain."[49] Ringo understood the importance of hair and paid close attention. He had ambitions to one day open a string of ladies' hair salons or so he told reporters in the early days.[50] He gave John little resistance, if any. If he were to become a Beatle, he'd have to look like one. "I used to have my hair right back, like a Teddy boy," Ringo has said, "with a Tony Curtis cut and sideboards and suddenly it was, 'Shave them off and put your hair down,' which I did."[51]

Back in England on December 27, 1960, the Beatles performed at a dance at the huge Litherland Town Hall ballroom, five miles north of Liverpool's city center. They made a sensational appearance, dressed head-to-toe in their Hamburg clothes: black leather jackets, black T-shirts, and

black lean-cut jeans tucked into top-stitched leather cowboy boots. The street-inflected ensemble went beyond what was considered acceptable for young men to wear in public at the time. "You could get the shit kicked out of you for it," said Beatle friend Arthur Kelly, after seeing his mates in their body-hugging gear, "but I was still envious as buggery."[52]

Billed as "DIRECT FROM HAMBURG" and augmented that night by bassist Chas Newby, a temporary substitute for Stu who had remained in Germany, the Beatles drew stares even as they were setting up. Don Andrew, a member of the Remo Four, a rival Liverpool group that wore starched shirts and bow ties on stage, was in the audience that night and from his prim perspective the Beatles "looked dirty."[53] But if their roughness repelled him, it thrilled the two to three hundred young revelers in the hall, gals in circle skirts and sweaters, guys in suit jackets and vests. They had come to twist and jive and flirt, but as soon as the Beatles tore into their opening number, Little Richard's "Long Tall Sally" with Paul hitting the high notes, the dancing stopped and the crowd stood transfixed, staring in amazement at these menacing looking musicians who played American rock-and-roll as if they had invented it.[54] The Beatles upped the volume to a near-deafening degree, stomping out the big booming beat with their wooden heels. Closing out with a ripping version of Ray Charles' "What I'd Say," they pounded the town-hall floor with such maniac energy that, after the riotous set was over, Newby complained that he could no longer feel his feet.[55] All those hours honing their craft in the bars of Hamburg had paid off.

Nearly everyone who saw the Beatles that night, male and female alike, went berserk in response to their raw charisma, raucous new sound, tough-looking threads, and dynamism. Fans rushed the stage as they played and afterward mobbed them for autographs. Some were surprised that the Beatles spoke English, believing that "direct from Hamburg" meant they were foreigners. "And we probably looked German, too; very different from all the other groups with our leather jackets," George said. "We looked funny and we played differently. We went down a bomb."[56]

From that night onward, the Beatles' popularity grew. "Suddenly we were a wow," John recalled. "It was only back in Liverpool that we realized the difference and saw what had happened to us while everyone else was playing Cliff Richard shit."[57]

Wow was the word.

After Litherland, the Beatles secured the first of their many now-famous gigs at Liverpool's Cavern Club in the first months of 1961. Bob Wooler, the Cavern's compère or deejay, had worked that Litherland show. A huge early supporter, Wooler had an encyclopedic knowledge of the local scene and could put the Beatles in context when writing about them in the column he penned for *Mersey Beat*, a new Liverpool music paper dedicated to covering the city's flourishing beat scene. While an early fan of their music, Wooler knew that it was their bold rule-breaking look that set the Beatles apart. They "were not pretty boys." They were "on the raw side, on the raucous side," and this gave them their edge.[58]

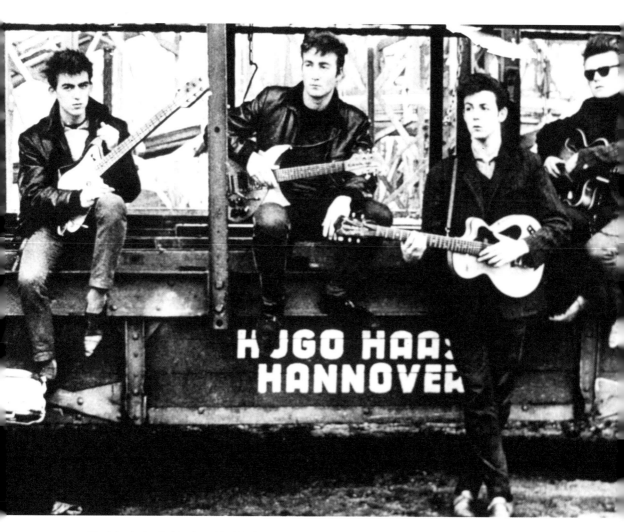

After introducing the Beatles to black leather, Astrid photographed the group at a Hamburg fun fair, capturing them as they looked before they made it big. (Alamy Stock Photo)

1961
COSMETIC CONVERSION

"We had to wear suits to get on TV.
We had to compromise."
— JOHN LENNON

The Beatles all gladly put on suits, making the trip across the Mersey to be properly fitted once they realized the value to their career of dressing smart. (Alamy Stock Photo)

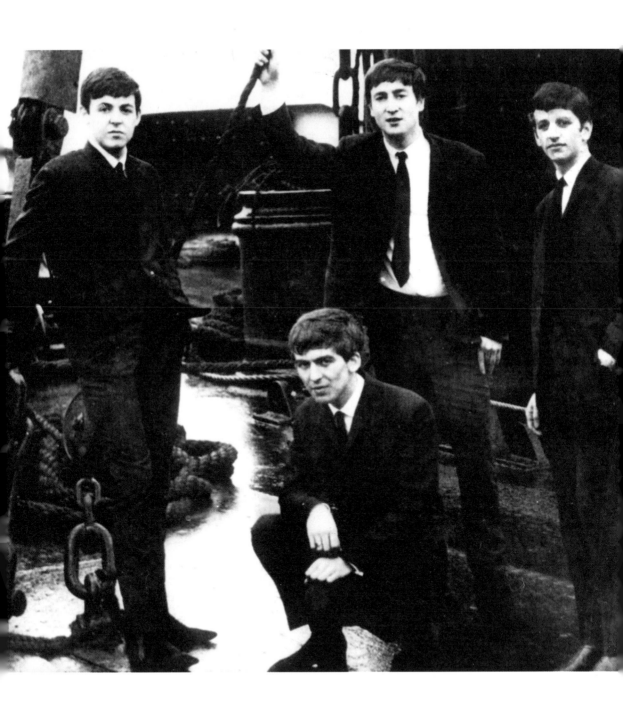

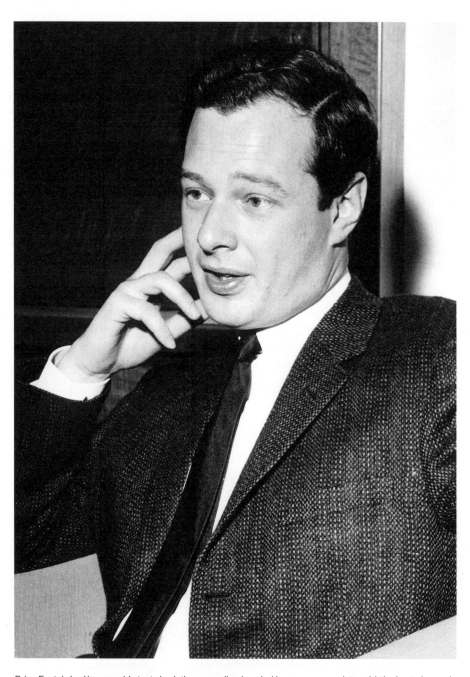

Brian Epstein had impeccable taste in clothes as well as bands. He was, an associate said, the best-dressed man in show business. (Alamy Stock Photo)

By the time Brian Epstein heard about the Beatles, they were the most popular band in Merseyside, having built up a considerable following playing crowded lunch sets at the Cavern for close to a year. Fans lined up around the block for their ripping shows—292 between 1961 and 1963. Freda Kelly, soon to be secretary of the first Beatles fan club, attended as many as 190 of them. The draw was the music, but their look was just as potent. "It was everything about them, it was the way they dressed, with all this leather gear," Kelly would say in a documentary covering her role in the Beatles' rise to the top. "I was just amazed by everything I saw."[1]

The group was also playing local dances and concerts, like the one promoter Sam Leach organized that year in Liverpool's north end. Their set list reflected a mix of musical genres, from country-and-western to rhythm-and-blues to show tunes like "Over the Rainbow" and "Till There was You." Recent additions like "Hippy Hippy Shake," sung by Paul, and "Will You Love Me Tomorrow," a chart-topper by New Jersey Black girl group the Shirelles on which John took the lead vocals, held audiences spellbound. In 1961, for the first time, the Beatles also started playing some Lennon and McCartney compositions: "Love of the Loved," "Hello Little Girl," and "Like Dreamers Do," all dating to the late 1950s.

Mersey Beat documented the group's steady ascent, as well as the fights that sometimes broke out at their raucous shows. The twenty-seven-year-old Epstein had recently begun a column, mostly focused on classical music releases, for the same Liverpool publication. He claimed not to have heard of the Beatles, never mind their coverage in *Mersey Beat* and the fact that the business he managed for his family, NEMS (a.k.a. North End Music Stores), was two-hundred steps from the Cavern on Mathew Street.

The now-familiar story is that a young customer piqued Epstein's interest by requesting a copy of "My Bonnie," a rocked-up version of the Scottish ballad produced by Germany's Bert Kaempfert and featuring the Beatles performing as back-up to lead singer Tony Sheridan. The group, credited as the Beat Brothers, had made the record in Hamburg during their return trip in the spring and summer of 1961. Epstein didn't have the record, but it was a point of pride to satisfy every customer's request. He began to research the group and was surprised to learn that they were right there under his nose in Liverpool. On a gray November afternoon, he decided to go see for himself what the fuss was about.

Pushing past the throngs of young office workers on the sidewalk, Epstein descended the Cavern's stairs. Assaulted by the acrid smell from overflowing toilets, he looked in vain for a place to sit. "There must have been 150 people packed into that tiny place, mainly teenagers. The girls wore the standard kit of short skirts, and beehive hair, but the boys were very much less fashionable, some even in working clothes," said Alistair Taylor, Epstein's personal assistant, who accompanied him that day. "Brian and I felt horribly out of place in our business suits. I'm sure the lads thought we were police in plain clothes. All we wanted to do was find a table somewhere at the back and listen to the group, but there wasn't a table in sight."[2]

The Epstein family's stature and influence in the community was such that Brian's very appearance in the dark, smoky, and smelly former vegetable cellar was sufficient to compel the lunch hour crowd to put down its cheese and butter sandwiches and gape. The Epsteins were retail royalty in Liverpool, owners of several stores, including the one where Paul's father had purchased the family piano. The Beatles often loitered around the Epstein family's record shop. Bob Wooler made sure the crowd knew a VIP was in the room, portentously announcing over the Cavern's PA system that Mr. Brian Epstein had graced them with his presence. Even the Beatles paused briefly to look in his direction before carrying on as before, refusing to be impressed.

When the show began, Epstein was mesmerized. Dressed in their leathers, the Beatles smoked cigarettes and chewed sandwiches between songs, laughed at private jokes, and hurled sarcasm and abuse at the audience, which gleefully lapped it up and begged for more. As an impeccably dressed, upper-crust Jewish businessman with clear varnish on his fingernails and aspirations of becoming a dress designer, Epstein was discomfited by the Beatles' appearance. They were "ill-clad . . . their presentation—well, it left a little to be desired, as far as I was concerned,"[3] he wrote in his 1964 memoir, *A Cellarful of Noise*. But "their music, their beat, and their sense of humour, actually, on stage," was potent and exciting.[4] What others might have described as uncouth behavior Epstein recognized as the Beatles' authenticity and total lack of pretension.

His assistant, Taylor, thought the Beatles were "too damned loud," "a bunch of five-chord merchants," and sinister to look at.[5] But Epstein immediately fell in love with the tough-looking group. He decided the Beatles

needed only a little spit and polish to get out of hell-hole clubs and into the mainstream, and he decided there and then that he would be the one to make it happen.

A master of self-presentation, Epstein had studied at the Royal Academy of Dramatic Arts in London in the early 1960s, briefly but long enough to develop a deep appreciation of how dress, or costume, can create a compelling illusion and project an idea. His own mode of dress—tasteful suits, Italian leather shoes, perfectly knotted neckties—radiated elegance and good manners. Epstein dressed to impress. In Liverpool, he stood out, in George's words, as "some very posh rich feller."[6] Added an associate: "He was expensively groomed, with carefully cut, slightly wavy hair and polished and manicured fingernails. His suit was hand-made, he had a costly and well-tailored camel coat worn with a dark blue silk scarf with white polka dots, and shiny black shoes, again almost certainly custom-made. Brian Epstein was the first finely cut and polished diamond I had ever met in the music business."[7]

Epstein could not help but feel envious that the Beatles all looked comfortable in their own skins and unafraid to be themselves. He was a deeply closeted homosexual, irresistibly drawn to the rough-looking men he sought out around the Liverpool docks. It was a true case of looking for love in all the wrong places and it sometimes left him beaten and robbed. At least one individual tried to blackmail him, forcing Epstein, after consulting a lawyer, to confess his private life to his upright family. He went to his family doctor hoping to cure himself of his sexual predilection, to no avail. Part of his attraction to the Beatles was sexual: "They were extremely amusing and in a rough take-it-or-leave-it way very attractive," Epstein declared.[8] He was especially taken by John's swagger and flinty-eyed gaze, his no-bullshit persona, and the bulge in his pants. It was hard to miss. John performed with his legs wide apart.

Over repeat visits to the Cavern, Epstein's admiration grew. Though their original manager, Allan Williams, had warned him not to go near "the bastards" with a barge pole,[9] Epstein would not be deterred. He believed in the Beatles. "I knew they would be bigger than Elvis. I knew they would be the biggest in the world," Epstein said.[10] It all came down to honing an image. He took it one step at a time.

After first proposing the merger in December 1961, Epstein convinced the Beatles to sign a five-year contract with him as their manager. This

initial deal gave him 10 per cent of their income up to £1,500 and 15 per cent above £1,500.[11] Several years older than the Beatles, he drove a Ford Zodiac and had endured, barely, National Service. They knew he was queer but that was beside the point. The Beatles thought him mature and worldly and believed he could lead them. "Brian was the expert," John explained. "He had the shop. Anybody who's got a shop must be alright. And a car and a big house . . . we thought he was it."[12] Elaborated Paul: "At that age, we were very impressed by anyone in a suit or with a car."

The Beatles understood that the attraction was reciprocal. "Brian was impressed with us," Paul added. "He liked our look. Black leather."[13] Epstein commissioned Liverpool wedding photographer Albert Marrion to take pictures of the young and savage Beatles within weeks of first meeting them. It was the group's first "professional" photo session, on December 17, 1961, ostensibly for advertising and promotion purposes. At Epstein's request, the Beatles showed up in their tough-looking clothes, which had evolved since Astrid shot them in Germany. She, again, was their inspiration. Among her more daring fashion choices were tight and sleek leather suits. The Beatles swooned over the look and put their own stamp on it. They had tight black leather trousers custom-made for them by a St. Pauli tailor. The trousers were paired with black velvet shirts and round-collar T-shirts for an outfit worn both on stage and off.[14] The piled-on animal skins and black palette rendered the Beatles still more feral and sinister-looking in the public eye. When they arrived at the photographer's bridal-white studio, they lived up to the image, misbehaving and upsetting the shoot. "I took about thirty photographs," Marrion bitterly recalled, "but discarded all but sixteen negatives because many showed Lennon and McCartney acting up and spoiling the pose."[15]

Epstein cleaned up their act. He secured consensus for a complete visual makeover that would take the Beatles out of their thigh-hugging street clothes and into tidier duds more suited to the stars he desired them to be. It was not unlike the window dressing that had increased sales at NEMS, the family store. As the group's biographer Alan Clayson put it, the goal was to convert the four louts "into what a respectable London agent or record mogul in those naïve times expected a good pop group to be, deciding from the onset that the Beatles needed a smarter, more corporate image."[16]

"Brian's mission," concurs Beatles historian Mark Lewisohn, "was to ensure that the people they needed to impress didn't recoil from their

appearance or habits. They might be able to do anything once they were accepted, but to begin with they had to get through the door. It was no more complicated than that."[17]

The Beatles embraced the change. "He quite wisely said, 'If I get a huge offer, they won't take you in leather,' and I didn't think it was a bad idea," Paul said.[18] John confirmed: "He said our look wasn't right, we'd never get past the door at a good place. He'd tell us that jeans weren't particularly smart and could we possibly manage to wear proper trousers."[19] The black-leather Rocker look had started to look passé even in the Beatles' eyes. "Outside of Liverpool, when we went down south in our leather outfits the dance-hall promoters didn't really like us," John said. "They thought we looked like a gang of thugs."[20]

Andrew Loog Oldham, who would later work with Epstein to promote the new-look Beatles before going on to manage the Rolling Stones, said the group didn't take much convincing: "They wanted to be in show business. They wanted to be at the top, so they played the game."[21]

The Beatles were permitted to keep their tousled hairdos. Epstein asked only that they be regularly trimmed by barber Jim Cannon at Horner Brothers, a Liverpool tailoring shop with a hair salon in the basement.[22] In an era without celebrity stylists, he urged the band members to take an active role in their makeover. He wanted them to explain how they saw themselves and give him ideas about the styles they preferred.

The transformation was gradual, starting with the addition of matching white cotton shirts and dark knitted pullovers, bought at Burton, a Liverpool High Street clothing retailer[23] and paid for by the Beatles with what they had left over after paying Epstein his commission. Next came bespoke menswear, a significant upgrade of their image. To ensure they felt comfortable with this sartorial leap, Epstein took the Beatles to his own tailors at Beno Dorn, a high-end shop in Birkenhead, across the water from Liverpool on the Wirral peninsula. "We were the best tailors in the northwest—we had cloths other tailors hadn't even seen, and we had exclusive rights on several brands. This brought in a very good clientele and Brian Epstein was a regular customer, as was his brother Clive," said senior tailor Walter Smith. "One week Brian said to me, 'I'm going to bring you four lads in next week, musicians. I'm managing them.' He said they were called the Beatles, which I thought was a damn stupid name, associating them with the insect. But we had girls working upstairs and they said the Beatles were fab."[24]

The Beatles were excited about the ferry ride to the Wirral. They had mentally surveyed the local music scene in advance and noticed that many of the groups dressed alike in suits, often with glitz and gimmickry sewn into their clothes. As Mark Lewisohn has noted, "Rory Storm did his thing in vivid turquoise and his Hurricanes flaming red, Gerry and the Pacemakers had their royal blue blazers with a G/P crest and gold buttons, Faron's Flamingos had royal blue velvet jackets with black corduroy trousers, the Undertakers dressed in funereal suits and top hats, black and heavy."[25] The Beatles were determined to be different.

After studying various options, the Beatles settled on a refined three-button single-breasted blazer with wide shoulders, a narrower-than-usual lapel, and nipped waist. They ordered slim-cut trousers to go with the boxy jacket, not unlike the drainies that they were accustomed to wearing. They asked that the trousers be extremely tapered, right down to the ankle. No turned-up hems. Smith recalls that it took many alterations for the suits to achieve the lean silhouette the Beatles were after.

Essentially, it was a Mod look, an urbane style that succeeded the Teds' mode of dress as "a natty reaction against the starched blandness of post-war British life."[26] Mods liked form-fitting suits, box jackets with nipped waists, skinny ties, and draped trousers. It was a neat, clean, and tidy look, soon to find mass popularity. Tailoring shops in London's East End, where there was a strong Jewish community with small factories and workshops connected to the clothing industry, churned out Mod suits with short three-button "bumfreezer" jackets and tapered flat-front trousers for the masses.

The Mod trend was an import from the continent, Italy in particular, where fashion manufacturing, bolstered by substantial post-Second World War investment in new weaving and knitting machinery, produced high-quality, novel textiles like the mohair and silk/wool mixes used for suitings. The embodiment of *La Dolce Vita* style, Italian double-vented short jackets were ideal for sitting on a Vespa, and escaping the straightened conditions of British middle-class existence. The tight trousers, skinny knitted ties, and black polo neck sweaters went well with the cigarettes and espresso consumed in huge quantities in the new beatnik cafes and jazz cellars proliferating across London and other urban centers. The fashion reflected the general opening of postwar menswear to fresh influences and inaugurated a new era of male preening and look-at-me

posing—what would eventually become known as the Peacock Revolution, a fashion movement defined by its extravagant colorings and sleek body shapes for men. Epstein approved their suit choice and guided the Beatles to select a luxurious cloth in a classic color that would allow the simplicity of the cut to shine through. The final consensus was for dark-blue mohair that the Beatles paired with white round-collar dress shirts and inch-wide black ties with collar pins, also from Beno Dorn.

Lengthening the line of their form-fitting suits were pointed-toe black leather boots with elasticized sides and stacked heels, footwear associated with flamenco. The tight-fitting, calf-high boots had become an integral part of the Beatles' wardrobe. George said that they first saw the boots on a London band and immediately wanted something similar.[27] While window shopping in London, John and Paul found exactly what they were looking for at theatrical shoemakers Anello & Davide on Charing Cross Road.[28] John got the shop's number and the next day ordered four pairs of its Cuban heel boots for all the Beatles to wear, first with their leathers and later with their skinny-legged mohair suits. The Beatles customized their stock boots, extending the toe and increasing the heel height to make them distinctly their own. The Beatle boot, as it became ubiquitously known, soon became a major trend. Fashion manufacturers knocked off copies of the Beatle boot, feeding popular demand. It was a defining look. The high heel boots and bespoke suits lent the Beatles an air of edgy elegance, a visual counterpart to their rock-and-roll harmonies. It was an enticing combination of lightness and good manners, unruly hair and tight clothes, and it re-invented the Beatles in a fascinating and attractive manner. "I didn't *change* them," Epstein said. "I just projected what was there."[29]

Not everyone approved. The group's early promoter, Sam Leach, felt the Beatles lost something when they traded the leather for mohair. "When you saw them on stage in their leather jackets, back in the early days before they were managed by Epstein, they were the best rock-and-roll group on the planet, I thought, and was convinced they would be real big. Unfortunately, Brian took away the hard, raw wildness of them and made them more presentable, yes, but that thing they had was unbelievable. Brian groomed it out of them."[30]

The disciplined new look, in fact, came with a restructuring and rationalizing of the Beatles' stage set. Leaning on his theater background, Epstein was full of advice on proper comportment, poise, and professional

stage conduct. He issued the Beatles typed notes stipulating what they could and could not do when performing: eating, swearing, and smoking filterless cigarettes were out; punctuality, a defined set list, and a precisely choreographed bow at the end of each performance.

The Beatles themselves questioned their cleansed image, John especially. While he understood that dressing in suits would make the Beatles more appealing to producers of radio, television, and records, he tended to regard the look as a betrayal of the group's rock and roll roots, a stifling of its raw energy. "Paul was keen on the changes and George was happy to accept them," said Cynthia Lennon. "But it wasn't easy for John. When Brian asked them to wear suits and ties John growled for days. That was what the Shadows—the group John most despised— did. John felt it was selling out, that it wasn't what the Beatles were about."[31]

John eventually came around to Epstein's way of thinking without altogether compromising his essential rebelliousness. He wore the new suits with his tie loose and the top button of his shirt undone out of defiance.[32] He tried to get George to do the same but no go. "I don't think John particularly liked wearing a suit—nor did I—but we wanted more work, and we realised that's what we had to do. Back then, everyone was more straight. The whole business was."[33] Sellout or not, it was a way to the top and all the Beatles desperately wanted to be there. "We all changed to the straight image,"[34] Paul said. "It wasn't just me. We all loved those suits."[35] The payoff was immediate.

The Beatles were eager to burst out of the Liverpool scene and gain national recognition. That's what had made them sign with Epstein in the first place. He delivered. "The gigs went up in stature and though the pay went up only a little bit it did go up," Paul said. "We were now playing better places."[36] This upgrade in status justified the new look even in the eyes of a skeptical John Lennon. "I'll wear a fucking balloon if somebody's going to pay me," he said. "I'm not in love with leather THAT much."[37]

Other bands immediately recognized how important style was to the Beatles' growing success and began copying them. Among their first imitators were the Merseybeats, a new group on the Liverpool scene led by seventeen-year-old Tony Crane and fifteen-year-old Billy Kinsley. They adopted the Beatles' slim-cut suit and skinny ties and parts of their repertoire and were soon playing to an enthusiastic following at the Cavern Club. Epstein made bookings for them and encouraged Pete Best to join them

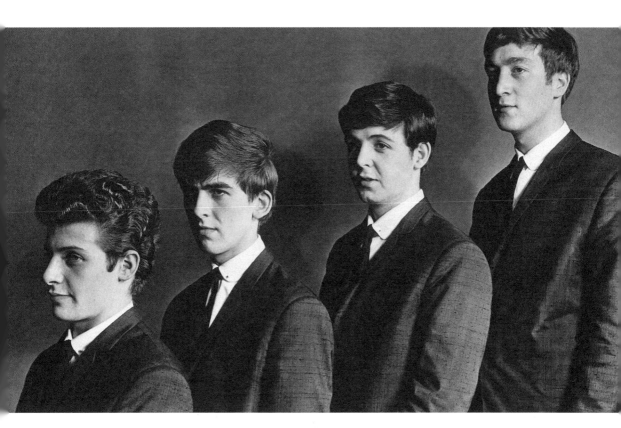

The Beatles (here with their first drummer Pete Best) liked the new suits made for them by Epstein's own Liverpool tailor, Beno Dorn, and proudly showed them off. (Media Drum International)

after he was ousted from the Beatles, perhaps because he already looked the part.[38]

Their manager's biggest coup for the Beatles was an invitation to audition for Decca in London. It was the moment they had all been grooming for. On New Year's Eve, the Beatles drove south to the capital, bringing their new suits with them. They wanted to make a great impression. But the next morning, at the appointed hour, tired, nervous, and hung over from a night of carousing, the Beatles delivered a sub-par performance. They ran through their usual set list of covers and Lennon-McCartney originals—fifteen songs in total. Decca flatly turned them down. Epstein took it on his clean-shaven chin, hiding the bad news from his "boys" as long as he was able.

Desperate to get them an all-important recording contract, Epstein paid £15 to have the disappointing Decca audition put on tape. He carried it around with him, tucked under the arm of his tailored overcoat, and played it for any label executive who would answer his calls. Rejection followed rejection. His persistence eventually led him, in a roundabout way, to George Martin at Parlophone, a subsidiary of EMI. Eager to work with a pop group after years of making spoken-word records, Martin agreed to give the Beatles a listen. He, too, almost declined to sign them.

"I wasn't too impressed with the tape Brian Epstein had played me," Martin told the BBC's *Desert Island Discs* in 1996. "What I said to Brian was, 'If you want me to judge them on what you're playing me, I'm sorry, I'll have to turn you down.' He was so disappointed. I felt really sorry for him, actually, because he was such an earnest young man. So I gave him a lifeline. I said, 'If you want to bring them down from Liverpool, I'll give them an hour in the studio.'"[39]

Epstein hid this act of mercy from the Beatles, wiring them in Hamburg, where they were playing yet another return engagement, that he had arranged an important London "audition." To give his little falsehood a veneer of truth, Epstein had Bill Harry in Liverpool run a story in *Mersey Beat* alleging that the Beatles had an EMI recording contract. They didn't. Not yet. But Harry printed the story exactly as instructed, believing, as everyone did at the time, that a suit—especially one of quality—didn't lie.

1962
GOLD-COLORED CUFF LINKS

"There were many suits and shirts and shoes and shopping sprees."
— RINGO STARR

About to take the world by storm, the Beatles were not fashion copycats. They represented something fresh and new, and their slim-fit modernist look would soon become widely imitated. (Alamy Stock Photo)

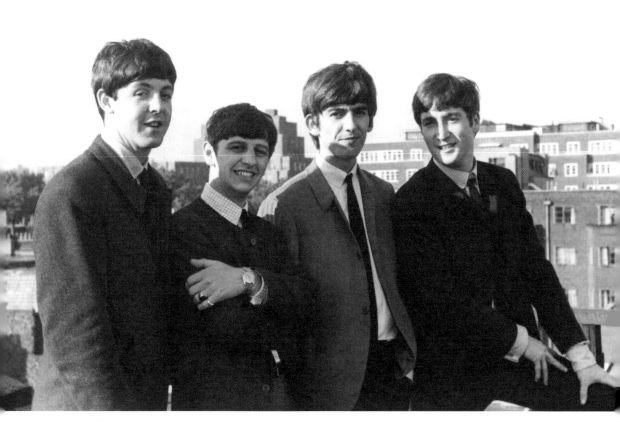

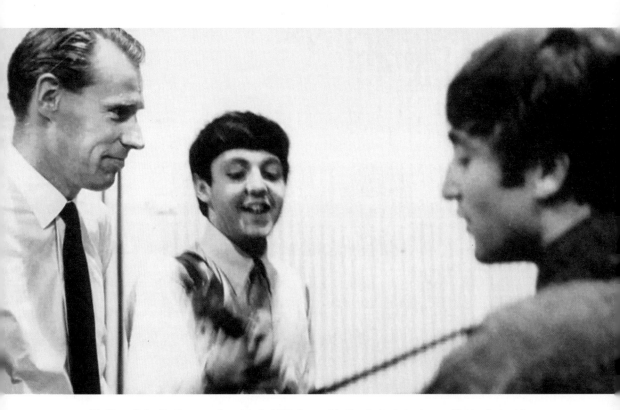

Working with the Beatles was a departure for EMI's George Martin, who had a background in classical music and comedy albums.

On the evening of April 5, 1962, a special concert billed as "The Beatles For Their Fans" was held at the Cavern. It would mark the group's last performance in Liverpool before yet another seven-week residency in Hamburg. The Beatles played their first set in familiar jeans and leathers then went to the band room to change clothes, not giving anything away. To heighten the drama, Epstein asked Bob Wooler to announce: "The Beatles will be appearing in their *new suits!*"[1] And there they were, resplendent in mohair. The girls screamed their approval, the boys stomped their feet. Phew. The transformation had worked its magic. "They looked so handsome," said Beatles fan Barbara Houghton, one of 650 people in the audience that night. "I still liked them in the leathers but the suits were good."[2]

Epstein was still working hard to expose the band to the rest of England. Before leaving for Germany, they had their BBC radio debut on *Here We Go,* a live-to-air pop show with an estimated 2.7 million listeners. The Beatles rehearsed in their jeans and leather jackets before changing into their suits and Chelsea boots to perform for a studio audience. They quickly won over the crowd, no doubt helped by additions to their repertoire—"Twist and Shout," "I Remember You," "Mr. Moonlight," and "Peggy Sue." There were also new original compositions including "Do You Want to Know a Secret," inspired by John's late mother, Julia, and "Love of the Loved," a Paul song played at their Decca Records audition. The BBC asked the Beatles to come back, booking them on *Here We Go* two more times that year. In June, they performed "Ask Me Why," the first Lennon-McCartney song to be nationally broadcast.

For the George Martin/Parlophone audition in London on June 6, 1962, the Beatles suited up, mindful of presenting a sharp image. Even so, they failed to make a good impression. "They looked very thin and weedy, almost under-nourished," said John Skinner.[3] As head of security, he had warily eyed the musicians as they hauled their unpainted wooden amplifiers and other dodgy equipment up the stairs of the tradesman's back entrance at 3 Abbey Road in St. John's Wood. Once in EMI's Studio Two, a wood-paneled inner sanctum with warm acoustics and a piano for décor, the Beatles set more tongues clucking. "Oh God, what do we have here?" sound engineer Norman Smith mumbled as he watched the Beatles set up.

Smith's colleague, Ken Townsend, also in the control booth that day and wearing the regulation white laboratory coat required of all EMI recording engineers, had a different perspective. He was almost a decade

older than the Beatles yet attuned to the growing influence of youth culture—what *Vogue* that year had identified as a new dynamic social movement shaping the future direction of clothing and other aspects of popular culture. "The whole structure of the business has changed," the fashion magazine reported. "Young clothes must make their impact through a line and an air; the intricate decoration of the old guard is irrelevant."[4] Townsend, later to become a legendary producer, saw pop groups as artists and invited an exchange of ideas. That set him apart from more rigid colleagues. He also liked the Beatles' Italianate suits, narrow lapels, and slender modish lines. "They were dressed quite smartly," he observed, "but they just looked so different to anything we had seen before."[5]

Not expecting much, and probably kicking himself for going against his instincts, George Martin went for tea in the canteen, leaving others to watch "the Four Herberts," as he dismissed them, banging away at their guitars. At age thirty-six, a former Royal Navy flyer who had used his war veteran's grant to study oboe at the Guildhall School of Music and Drama, Martin was confident in his judgment. As soon as the audition ended, he expected to dismiss the Beatles with little regret. He returned to the studio only after Smith, hearing one of the Beatles' own compositions and thinking it showed promise, urgently called him back. Martin gave the song a listen and agreed there was something there. Still, these awkward young men who didn't even know how to position themselves around an omnidirectional studio microphone needed a talking to. He called them upstairs to the lofty confines of the control room and, in a posh accent that hid his humble North London origins, told the Beatles what they were doing wrong.

At one point in his harangue on studio technicalities, Martin seemed to catch himself. He stopped lecturing and asked the Beatles if they had anything to say. "Yeah," George Harrison said, "I don't like your tie."[6] There were shocked looks all around and a moment of real tension. Martin, who wore conventional trousers with the hems turned up, liked his tie. It was a Liberty's purchase with a posse of red horses gamboling over a black background. He paused before deciding to see the humor in the situation and permitting himself a burst of laughter.[7] It no doubt helped that Martin had made his name recording the likes of Peter Sellers and Spike Milligan, British comedy stars who skewered pretentiousness and were appreciated by the Beatles for their irreverence. Martin could take a joke. On the spot, he decided to give the band a chance. He liked their personalities,

their palpable charisma. He didn't like their drummer, however, and told Epstein that he'd have to get rid of the erratic Pete Best before he'd have the Beatles back for a recording session in September. Done.

When the session rolled around, Martin chose Mitch Murray's "How Do You Do It" for the band to record. It was a bouncy tune made for the charts. Martin had purchased it, Tin Pan Alley style, from a London music publisher, certain it would be a Number One hit (and it was when Gerry and the Pacemakers, also managed by Epstein, later recorded it). He had not been impressed by the Beatles' original work. "I felt that I was going to have to find suitable material for them, and was quite certain that their song-writing ability had no saleable future!" he later said, relishing the irony.[8] The Beatles detested the song Martin selected—George Harrison called it "really corny"—and insisted on recording "Love Me Do," a bluesy composition by John and Paul.[9] It was the song that engineer Norman Smith had liked on their first visit to EMI.

Rejecting a seasoned producer's suggestions was a bold move, but the Beatles were united in their belief that Martin didn't necessarily know better. He didn't have the right tie. How did he know he had the right song? Martin argued with them, politely and persistently. The Beatles held their ground and got their way. Martin was impressed that the Beatles, so early in their career, knew what best suited them.

Released on October 5, 1962, "Love Me Do," one of the first pop records to feature a harmonica, rose to the seventeen on the UK singles chart, initially selling 5,000 copies and another 100,000 by year's end, the bulk of them in the Liverpool area. With "P.S. I Love You," another Lennon/ McCartney original, on the B-side, the record did surprisingly well for a first release. It went a long way in convincing Martin and others at EMI that they had signed the right band. The Beatles represented a new sound.

Everything changed for the band with "Love Me Do." Epstein used the record as a battering ram to break down all resistance to his boys. He hired Tony Barrow, a fellow Liverpudlian then writing record reviews out of London, as the group's first press officer. Barrow churned out three press releases announcing the group's arrival on the national scene: "I called 'Love Me Do' an infectious, medium-paced ballad with an exceptionally haunting harmonica accompaniment that smacks home the simple tune and gives the whole deck that extra slab of impact and atmosphere so essential to the construction of a Top Twenty smasher."[10]

Journalists who picked up these florid releases struggled with how to describe the foursome in their own articles. The band was not easy to pigeon-hole. Some reporters found it useful to explain that the Beatles were *both* a vocal group and an instrumental group and that, unusually, they wrote their own hits. Others focused on the band's appearance, zooming in on their longish hair style and what Derek Runciman, writing in the weekly ballroom trade paper *Dance News*, called their "different unEnglish clothes."[11]

Those clothes were spotlighted in a series of black-and-white publicity stills that Epstein ordered taken off the band in Liverpool. He hired local photographer Les Chadwick to do the job, commanding him to "provide photographs that would match the unique Beatles sound."[12]

Ingeniously, Chadwick posed the Beatles in their svelte suits amid the rubble and poverty of their hometown, highlighting them as something fresh and authentic rising from the ashes of a city struggling to recover from the Second World War. The ghostly wreckage of Nazi bombing campaigns can be seen in the background of some of the shots. Chadwick also positioned the boys in an industrial wasteland close to the Liverpool docks where they seemed almost to glow amid the dirt and brick. And he posed them in the docks themselves, standing in sharp contrast to the stevedores in shirt sleeves and unbuttoned collars with their short clipped, greying hair greased back as though it were still the 1950s. None of this was gimmickry. Gritty Liverpool was the band's reality. Chadwick's photographs spoke to the Beatles' lack of artificiality and proud association with their northern, mostly working-class city while also making them look like a new generation.

The day was cold and rainy. Ringo, now a full-time member of the band, shivered in his bum-freezer jacket. For some of the shots, he, like John and George, donned a thigh-length leather car coat to protect him from the weather. Paul alone braved the elements, refusing to cover up his smart suit, pressed shirt, and skinny tie while smiling for the camera. Of all the Beatles, he worked hardest to project a strong image.

Determined to get his group more national exposure, Epstein had invited a contact at Granada television in Manchester to see the Beatles on their home turf earlier in the year. The Granada scout took in one of the Beatles' uproarious Cavern shows and came away impressed. At the time, Granada had a show called *Know the North*—about northerners and

for northerners. The Beatles, as northern lads, would fit right in. Granada sent a camera crew to Mathew Street on August 22, two weeks after Ringo had joined the band, and filmed the group at lunch hour. The Beatles dressed alike in dark tight-fitting trousers, white shirts, black knitted ties, high-heeled leather boots, and, incongruously for the dog days of summer, sleeveless woolen pullovers. "We were asked to dress up properly," George said. "We looked quite smart. It was our first TV appearance. It was big-time, a-TV-company-coming-to-film-us excitement. And John *was* into it."[13]

With sweltering temperatures and poor air circulation, the Beatles suffered in their pullovers but showed no sign of discomfort as they tore through a blistering version of Richie Barrett's "Some Other Guy." Their black-and-white scheme made for compelling television (color TV was still a few years down the road). Their hair looked darker, their clothes inkier, and their shirts brighter than in real life. They were noirish rockers filling the small screen with crackling energy. They seemed made for the medium.

The day after taping the TV debut, John married Cynthia Powell who was two months pregnant (the baby would arrive in April 1963). He would later quip that he wanted to make "an honest womb of her."[14] It was a quick registry office wedding. Epstein was best man. Paul and George were in attendance. Ringo, new to the tight-knit world of the Beatles, didn't know about it. The bride wore a purple-and-black-check fitted jacket with a splash of pink lipstick and a white blouse kindly lent her by Astrid Kirchherr. John, Paul, and George wore their dark suits. Cynthia thought they were dressed for a funeral.[15]

It was an end of a life for Cynthia. Epstein didn't like the Beatles appearing in public with their women, fearing it would undermine their image as desirable young rockers. While Cynthia had been a regular at their Cavern shows, often going with Paul's squeeze at the time, Dot Rhone, her pregnancy kept her mostly housebound in the months following the wedding. Pregnancy was not the only reason for Cynthia to lay low. Beatles fans could be jealously protective of their idols. Some female followers were known to waylay girls who had caught the Beatles' eye during their Cavern shows, attacking them in the ladies with face scratching and hair pulling.

In October, the band performed on the radio for the first time with Ringo, plugging "Love Me Do." That same month they appeared on the

Sunday Spin program for the community station Radio Clatterbidge. It wasn't a performance but a broadcast interview, the Beatles' first. Host Monty Lister introduced them to listeners as an "up-and-coming Merseyside group." A photograph taken that day shows Lister with his fair hair slicked back in the old Tony Curtis style, conventionally dressed in a loose-fitting tweed sports jacket, straight collar shirt, and wide patterned tie. The Beatles, in their form-fitting suits, tab collar shirts, and finger-thin ties, look edgy, futuristic, almost alien next to him. "The Beatles are a very off-beat team," observed the *New Record Mirror*. "They don't wear pointed shoes or have layers of grease on their hair. Chelsea boots, suede coats, and long flat hair styles are more of their mark."[16]

It was around this time that the mainstream press began to notice that menswear was subtly but assuredly changing. "The trend was started by young men who," *The Daily Telegraph* reported in 1962, "had the sense . . . to see there is nothing necessarily masculine about wearing drab baggy suits and old school ties."[17]

Newspapers and magazines were now regularly featuring fashion spreads dedicated to menswear. In 1961, English journalist Angus McGill began to interpret the new dandyism for a mass audience with the launch of the "Mainly for Men" column in the *Evening Standard* newspaper. Editor Charles Wintour, father of *Vogue's* fashionista-in-chief Anna Wintour, intended to make the *Evening Standard* the most fashionable daily in London. He gave McGill complete freedom when covering menswear, rightly discerning its importance as a new societal movement.

That Britain's baby boom generation was now coming of age and earning good salaries in a burgeoning post-war marketplace provided more fuel for the menswear trend. So, too, did the election of American president John F. Kennedy who looked smashing in neat two-button suits. All these forces combined to establish men's fashion as an untapped market and an opportunity for savvy brands. Designers who had previously made their mark in womenswear began crossing the floor into male clothing. In 1960, Pierre Cardin, a protégé of Dior known for his bubble dresses and other futuristic female fashions, launched the first men's ready-to-wear runway show and the first men's fashion and accessories department in Paris, the first French couturier to do so. Even establishment designers like Hardy Amies, dressmaker to the Queen, were exploring fresh directions in menswear. He staged a men's fashion show at London's Savoy Hotel, showcasing

some of the styles he had been making for mass retailer Hepworth's. They were designed "to make the customer feel younger and richer than they were, and more attractive," Amies wrote in his autobiography.[18] "Fashion today is to be classless. . . . The whole point is to be sexy."[19]

The Beatles would have agreed. That autumn, galvanized by the steady climb of "Love Me Do" in the charts, they started to order custom-made suits from a London-based tailor with a reputation for eye-catching menswear. Dougie Millings had been making bespoke clothing for pop groups since landing his first commission, a white sharkskin suit for then-up-and-comer Cliff Richard, in 1958. He went on to create Billy Fury's gold lamé suit and Roy Orbison's black suits with concealed zip fastenings, sealing his reputation as "the tailor to the stars." The clothes might have been a bit flashy, but they were beautifully crafted and well-made. Born in Manchester, Millings had been the chief cutter for Austin Menswear on Shaftesbury Avenue, before heading up his own D.A. Millings & Son shop close to the clubs. "He was our tailor of choice," said Jeff Dexter, a London disc jockey and Mod clothing fanatic who had pushed to get "Love Me Do" played in the city's dance halls. "He was on the ball."[20]

Epstein, who had already delivered Gerry and the Pacemakers to Millings, felt the Beatles, too, would benefit from the quality of his made-to-measure suits. He made the appointment for them at 63 Old Compton Street. He encouraged them to arrive armed with their own thoughts. Judging by the estimated 500 suits Millings would make for the Beatles in the next several years, they had no shortage of ideas. But this was a first meeting and in keeping with their new subdued stage presence— a minimum of body movement with a tidy bow at the end—the group asked Millings to create something smart but not ostentatious. They wanted to look "a little bit different" than the other groups who had come to his premises. "We don't want to look like the Shadows," Millings recalled John saying that day.[21]

The result of their first encounter was chic and elegant, a three-piece chocolate brown suit with velvet collar, a detail reflecting the New Edwardian influence in men's clothing that had been inaugurated by the Teds. The Beatles wore the hand-stitched garment with pink-and-white gingham penny-collar shirts with Portofino cuffs adorned with gold-colored cufflinks. They completed the look with inch-thick black ties and their leather Cuban heel boots. They were still following Continental style—the

body-conscious suits with shortened jackets, tapered legs, and luxurious fabrics—but the rush to sophistication was noticeable, and perhaps not unexpected with them spending increasing amounts of time in the capital, meeting the press, making the scene.

The part of the scene that interested the Beatles most was right around the D.A. Millings & Sons shop in London's Soho district. The area was home to an established fashion industry that was then in the throes of forming a symbiotic relationship with pop music.[22] Musicians wanted to look cool and the new men's clothing establishments answered the call, often setting up shop where the guitars were playing. The 2i's coffee bar on Old Compton Street opened in 1956 with the import of a Gaggia espresso machine and was soon the epicenter of an exploding pop scene. Named for original owners, the Irani brothers, the 2i's had a small eighteen-inch-wide stage in the basement where washboard groups and rock-and-roll bands played for mostly teen audiences. It served as the launching pad for Tommy Steele and for the Shadows, Cliff Richard's backup group. It's where Rod Stewart and future members of the Rolling Stones and the Beatles went for live music.

Millings took premises right next door, up the stairs from Sportique, a boutique opened by John Michael Ingram expressly to capitalize on the symbiotic relationship between music and fashion. By opening a clothing store in the pathway of a seminal rock venue, Ingram established a creative geography that has been imitated ever since. (Tommy Roberts' boutique Kleptomania would follow a similar trajectory when in 1966 it opened next door to the Bag O'Nails, one of Swinging London's most popular late-night nightclubs and a favorite drinking spot of the Beatles.) The anarchy heard in the music coming out of the adjacent club found a visual identity in clothes imported by Ingram: Levi's in every color, MacDouglas quilt-lined leather jackets, and men's shirts in such fabrics as gingham and sheer Swiss voile with penny-round collars and detailed stitching.[23] Ingram put the garments on artful display in well-lit windows that could not help but grab the attention of the players and patrons at the 2i's. It became known as the "hippest, chicest shop in the world,"[24] and in time, outfitted not only the Beatles but members of the Who, the Small Faces, and the Stones.

John Stephen was another fashion trailblazer. The Glaswegian-born retailer built his reputation on Carnaby Street, a former Soho backwater that he revitalized with a string of brash new male fashion boutiques with names like Donis, Domino Male and Male West One. The boutiques blared

out pop music, turning shopping for men's clothes, once a serious business, into an exciting, sensuous experience. The pop groups arrived along with their fans, turning Soho into a mecca of cool. The Beatles soon were regulars.

Recalls Robert Orbach, who worked for John Stephen on Carnaby Street: "It was around five o'clock and I am looking at the cash register towards the end of the day, checking the figures and the money and all that, and I looked down and all of a sudden the Beatles are standing there in the shop, right in front of me. It was a strange thing. I looked up and there they were. They had run in and were browsing around, picking up loads of things—jackets, shirts, all manner of stuff. Then off they went. They were from the back country then, still a bit hickish. But they learned very quick. When exposed to the best that any city can offer, like London, then you are going to pick up on it or else you may as well go back home."[25]

The Beatles weren't going backward. They were going forward, fast. Each time they performed on national radio, their new single climbed higher in the charts, an indicator of how their image bolstered their music. Their weekly pay packet grew as well, tripling from £80 each at the beginning of 1962 to £250 (after Epstein had taken his 15 per cent commission), by year's end.[26]

Epstein ramped up his efforts with the press. Grenada TV, frustratingly, had yet to broadcast the Cavern clip. There was a complication, having to do with a brass band that was also appearing on the program by way of juxtaposition with the Beatles. The Cavern tape would be shelved until 1963. Grenada liked Epstein's group, however, and offered an alternative, an October 17 appearance on *People and Places,* a magazine-style evening show. They performed "Love Me Do" live at the station's Manchester studios, returning twelve days later to tape a second appearance that was held for broadcast until November 2, when the Beatles were again back in Hamburg playing at the newly opened Star-Club.

John had recently purchased a new pair of dark-framed glasses in the style of Buddy Holly. He wore them for the *People and Places* rehearsal on October 29. Vanity forbade him to wear the glasses in public and so he performed almost blind for the actual show. He squinted at the audience, making him look fearsome and arrogant. He stood with legs open, guitar held high against his chest and mouth almost touching the microphone, a pose directly inspired by Lonny Donegan, another early rock inspiration.

Dougie Millings became the Beatles' tailor around the time of "Love Me Do." He would eventually make more than 500 outfits for them. (V&A Images)

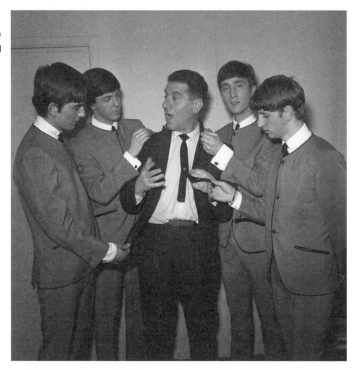

Menswear, once a non-topic, caught momentum when designers like Hardy Amies, couturier to the Queen, crossed over to make clothes for the male gaze. (Alamy Stock Photo)

With his aquiline nose and expressionless ovoid face, he appeared inscrutable, like a Brancusi sculpture.

By contrast, Paul, "the sunny boy" of the band, as their Hamburg minder, ex-boxer Horst Fascher, used to call him, presented a cherubic face to the camera. With his perfectly arched eyebrows, toothpaste smile and dark pools of eyes, he looked more innocent than he was. Of all the Beatles, Paul was the one most likely to dance about, looking as if he genuinely dug the music they played. He emanated commitment.

George tended to play off to one side, which made him seem mysterious. But he was a looker with high cheek bones, a square jaw, and a sexily crooked grin. Fans nicknamed him "Georgeous" and rarely took their eyes off him. Ringo, perched high at the back, had hangdog eyes, a prominent nose, and an easy laugh. Children liked Ringo the most. He was clown-like. Harmless. Utterly relatable. Epstein played up these character traits and aspects of their physical appearance in publicity portrait photographs commissioned that year. In one, Ringo, dressed in a slim-fitting suit and folded into a crown-like chair, can be seen wearing four rings, one more than he had before. He had a touch of flamboyance about him.

Flamboyance, of course, is relative, and Ringo's paled in comparison to Little Richard's, the original rock-and-roll screamer who in 1962 had traveled from his native the United States to perform for the first time in the UK and Germany. It was something of a comeback tour. In the late 1950s, Richard Wayne Penniman, as he had been born, had renounced the devil's music, along with alcohol and drugs, to become a Seventh-day Adventist preacher. He had lustily bounced off the wagon by the time the Beatles met up with him in Liverpool. Epstein had squeezed them onto the bill for Little Richard's show at the Empire Theatre, the city's most prestigious arts venue. Other shows followed, in New Brighton in October and in Hamburg in December, the latter featuring Little Richard's sixteen-year-old keyboardist, Billy Preston. The Beatles would form a lifelong relationship with Preston following their time together in Germany. But Little Richard they could never befriend. They idolized him way too much.

"We were almost paralyzed with adoration," said John. Little Richard was their rock hero and the Beatles made no secret of being besotted.[27] They had several of Penniman's songs in their set list, including "Lucille," "Good Golly Miss Molly," and "Tutti Frutti." Paul would later say he owed his style to the Georgia-born star.[28] In Little Richard's gilded presence,

the Beatles were the ones now begging for photos to be taken, of each of them holding their idol's hand while grinning maniacally at the camera. They're backstage, in a theater lounge, after one of the Liverpool shows. John and George have already changed out of their stage attire into everyday clothes, leather, and a black corduroy jacket, respectively. Paul and Ringo still have on their suits and they gleam beneath the overhead lights. Little Richard's suit, made of lustrous sharkskin, is shinier, establishing at a glance his superior star status. The ambisexual performer, with his sculpted pompadour and pencil-thin mustache, is also wearing makeup, something the Beatles would also emulate after Epstein booked them into more national performance halls.

Among these was the Embassy Theatre in Peterborough, in the east of England. The Beatles were made aware that they looked pale beneath the overhead lights. They asked Ted Taylor, of the Ted Taylor Four, another act on the same bill, to show them how to use makeup to sell their look. Taylor told them about Leichner 27, a pancake-like foundation applied to the face with a little sponge. It created the illusion of a suntan. "And put a black line around your eyes and lips," Paul remembered Taylor adding, to draw out one's features.

"That's a bit dodgy, isn't it?" the Beatles asked. Taylor assured them it wasn't.

George has described their first attempts at applying makeup as disastrous. "We looked like Outspan Oranges," he said. "There were photos taken of us, and John is also wearing eyeshadow and black eye-liner."[29]

But nothing could dilute their desirability. In November, the Beatles broke into the *New Musical Express* annual poll. Readers from across the nation voted them the fifth most popular British Vocal Group and eight most popular British Small Group.[30] They had come a long way since upgrading their appearance a few months earlier.

Back in London, George Martin had been carefully following the Beatles' progress. Any reservations he had about their marketability had all but vanished now. In November, he invited them back to Abbey Road. He wanted to make a new record with them. He tried one more time, bless him, to get them to record "Why Do You Do It," but, as he expected, the Beatles turned him down flat. They had a new song up their sleeve, "Please Please Me," another Lennon/McCartney original. It was offered as a substitute, despite Epstein's reservations about the almost blatantly sexual lyric.

Would this hobble their popularity? No one paid him a mind. Martin heard the falsetto harmonies, the raucous guitar riffs, the call-and-response yelps inciting hysteria, flicked on his microphone in the upper control room, and congratulated the group on having made its first Number One. The Beatles, this time, didn't argue with him. An LP, Martin continued, would follow immediately in the new year. The Beatles were dumbstruck. It was their wildest dream come true.

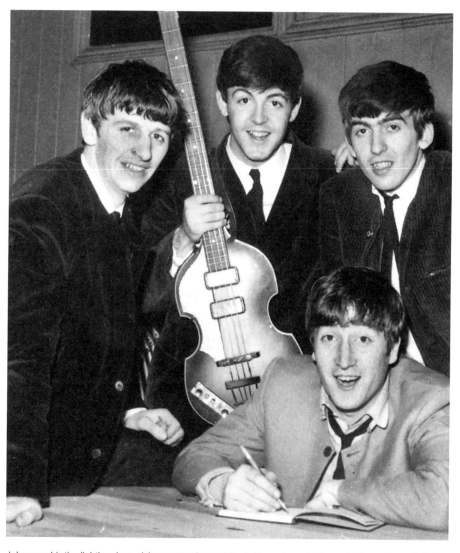

John wore his tie slightly askew, giving expression to the rebellious character beneath the surface polish of his new clothes. (Alamy Stock Photo)

1963
UNCOLLARED
"To a degree we can make a trend popular."
— JOHN LENNON

Among the items that gave the Beatles their sleek silhouette were customized versions of the black leather Cuban heel flamenco boots they found at London theatrical shoemaker Anello & Davide, the prototype for what ubiquitously became known as "Beatle boots." (Alamy Stock Photo)

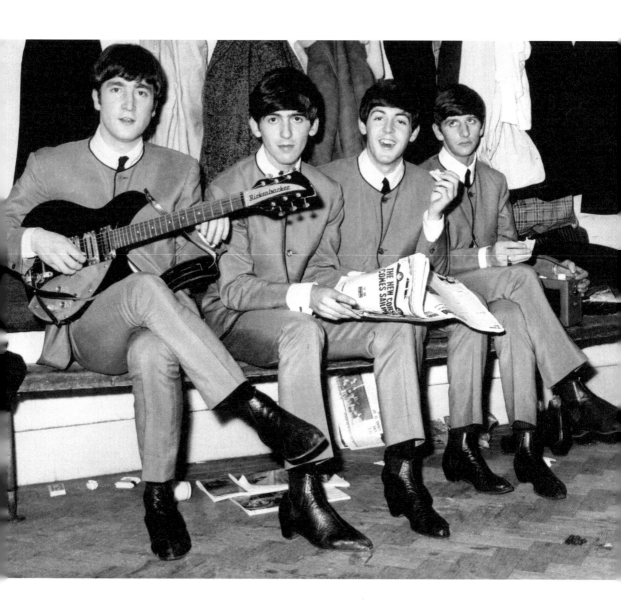

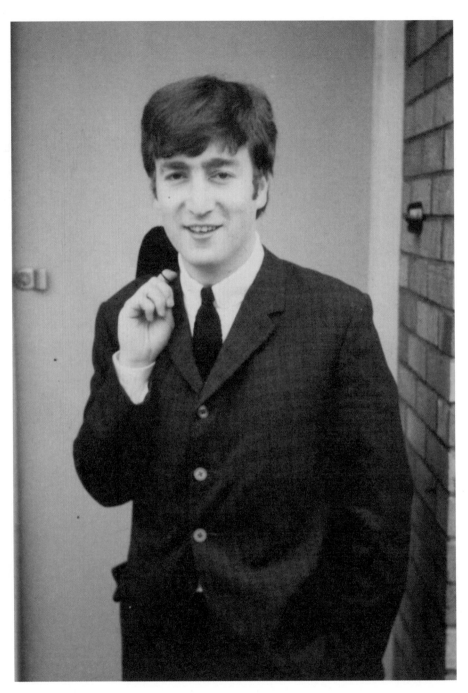

John enjoyed wearing a suit as much as his band mates and worked closely with Dougie Millings on cuts and luxurious fabrics when designing his clothes. (Alamy Stock Photo)

Angus McBean, a London theatrical photographer known for his portraits of celebrities like Laurence Olivier and Vivien Leigh, snapped the Beatles for the cover of *Please Please Me*, and did so in a hurry. Time was of the essence. EMI had wanted to capitalize on the group's popularity before the sand in the hourglass ran out. Their debut album was recorded over a demanding, twelve-hour marathon session. The Beatles belted out songs taken directly from their live playlist, six covers plus eight new Lennon and McCartney compositions ranging from the melodious "P.S. I Love You" to the introspective "There Is a Place" and the thrilling "I Saw Her Standing There." Paul's exhilarating "one-two-three-*fawh*!" lead-in opened the LP with a rush of energy and John's throat-shredding performance of "Twist and Shout"—what George Martin later described as "a linen-ripping sound"—closed it with a bang. It was the closest thing to hearing them play live. The Beatles had given their all to the record and were begging for bottles of cold milk to soothe their larynxes after all had been sung and played. But no one wanted to coddle them. To their record company, the Beatles were just another band to be marketed, pro forma, like any other, which is why they gave McBean all of five minutes to get his shot.

Arriving at EMI's Manchester Square headquarters on February 11, McBean placed himself at the bottom of a winding angular staircase and called out to the Beatles who jauntily responded by hanging over an upper banister. McBean had first met them a few weeks earlier. They had been dressed in the very same Dougie Millings, chocolatey, velvet-collar suits with pink gingham tab shirts. The photographer knew exactly what he wanted: an image of a group on the rise. To get it, he laid flat on his back at the foot of the stairwell, photographing the grinning Beatles from below. He asked them to look right, then left, and finally straight down at him, rapidly clicking the shutter on his portrait camera, one-two-three, before suddenly pronouncing, "That'll do,"[1] as he sprinted back out the door. And it did do.

The album was released on March 22, 1963, with McBean's shot of the four happy, harmless, handsomely dressed Beatles on its cover. It surpassed everyone's expectations. *Please Please Me* immediately soared to Number One on the UK charts, a position it held for thirty weeks. It would go on to sell an astonishing million copies, more than any other previous album in Britain apart from the cast recording of *South Pacific* by Rodgers and Hammerstein, the musical theater songwriting duo after whom Paul and John had modeled themselves.[2] The same-named single,

released earlier in January, also grabbed hold of the Number One position, as Martin predicted, cementing the Beatles' reputation as Britain's premier pop group. It had been a long climb from cellars to dance halls to proper theaters and a recording contract, and then fame hit like a runaway train. Their music, unusual haircuts, and made-to-measure suits energized fans throughout the UK. Girls (and sometimes boys) went berserk in their presence, screaming, crying, and fainting. Beatlemania would enter the lexicon before the year was through.

EMI, eager to sell records while the group was hot, quickly organized a UK tour. Or tours. From February 2 to March 3, the Beatles traveled England as the fourth of eleven acts on a package headlined by sixteen-year-old British singing sensation Helen Shapiro. Five days after that tour ended, the Beatles joined another headlined by American singers Chris ("Let's Dance") Montez and Tommy Roe, whose hit at the time was "Sheila." The Beatles were being booked by the Arthur Howes Agency into Gaumont and Odeon cinemas across the nation. But it was far from glamorous. They would spend most of the year on the road, playing night after night, sometimes in two cities on the same night, pushing themselves (and their nervous systems, as George Harrison would later say) to the limit.

To reach all the gigs on their jammed schedule, the Beatles drove day and night in a purchased red-and-white van (eventually scribbled over by fans declaring their love along with their phone numbers). The seating was inadequate and the heating nonexistent. The luxury of hotels had to wait until later in the year when their celebrityhood really took off. Meanwhile, they slept on top of each other in the van for warmth, clutching bottles of whiskey. They further bonded on the road, laughing and arguing and playing together like brothers who only had themselves for company.

Things could get rambunctious. George once skidded the van off an icy northern road while speeding, busting the gas tank open against an embankment. Fuel gushed out. The Beatles clogged the hole with the T-shirts they wore under their dress shirts and moved on to play yet another show. It was a mad rekindling of what they had experienced in Hamburg—the seemingly endless lineup of high-octane shows—except this time the Beatles were better dressed. The year-long slog should have exhausted them. It didn't.

The Beatles never crumbled, and neither did their suits, which traveled everywhere they went across England, Scotland, Ireland, and Wales. Their

custom-made clothes had become an integral part of the act. They even had their own minders.

Mal Evans, a gentle giant of a man who had worked as a bouncer at the Cavern, joined the Beatles' entourage in 1963. He was hired to help Neil Aspinall, their roadie, who packed the van and often drove it. As the Beatles began to play bigger venues, Aspinall found himself pulled in too many directions, required to do the lighting and set up the band's equipment, including Ringo's complicated drum kit, often while another group was playing out front. He was also in charge of the suits, which needed tending following each performance to keep them clean and smart looking for the next day.

Millings had made replicas of the velvet collar suits to ensure the Beatles always looked fresh but that meant more work and more bags to carry, which is where Big Mal came in. Aspinall assigned him to lift the amps and drive the van so that he could devote more of his energies to maintaining the Beatles' wardrobe. And that wardrobe was growing along with their renown. The Beatles now traveled with four versions of the same Millings custom-made suit whereas before they each had only one, which was a visible sign of their advancement.[3]

Brian Epstein continued to ensure the Beatles got the attention he felt they deserved. Through his association with Dick James, the London music publisher who would make a killing on the publishing rights to Beatles' songs, he got them onto *Thank Your Lucky Stars,* then Britain's most important weekly pop music television program. They performed "Please Please Me" to millions of viewers, many of them seeing the Beatles for the first time. They wore their Millings suits with white shirts and dark ties, switching back to pink shirts when they appeared again on the show just over a month later. The Beatles sported the same ensemble live on the *Saturday Club* radio broadcast on March 16, the first of many appearances they would make on the influential BBC Light Programme.

On that day, they performed six songs before clambering back into the van to drive 160 miles north to Sheffield where they rejoined the Tommy Roe and Chris Montez tour, appearing again in the brown suits. It had become a set look. The Beatles could repeat it as often as they did in 1963 because their image had not yet reached a level of mass saturation as to make them look hackneyed. Photograph after photograph through the first half of the year showed them similarly attired from Lancashire to

Wembley. It was a branding strategy, a way to burn the Beatles' image in their audience's collective psyche.

"Whether you like them or not, you've got to admit that the Beatles are just about the most talked-about group on the British beat scene," declared Britain's weekly music newspaper, the *Record Mirror*. "If you don't like their sounds, you like their looks—most probably you like both."[4] And the kids did like their looks. "I remember watching The Beatles doing 'Love Me Do' on a programme called 'Scene at 6:30,'" said Steve Plant, an early fan. "I was fourteen, and had a quiff although I wasn't a Ted. The next day I was at school and everyone was like, 'Did you see that group last night?' So we started combing our hair down. From there it escalated, things changed every week."[5]

To give fans more of what they wanted, Epstein hired Sean O'Mahony (writing as Johnny Dean) to create *The Beatles Book Monthly,* the only authorized magazine devoted to everything John, Paul, George, and Ringo.[6] In text and photographs, the publication covered the Beatles on stage and behind the scenes, focusing on their lifestyle habits, fashion choices, and latest records. An early form of social media, *The Beatles Book* came with a monthly Fan Club Newsletter that gave followers an outlet for expressing their feelings and opinions about their favorite band.

The first issue came out that August, two months before Beatlemania officially became a national contagion. It ran profiles of each Beatle. Ringo spoke of his drumming, John of his ambition to write a musical one day, Paul of his love of songwriting and surfeit of ideas, George of his incredible new buying power: "Now the money is coming in, I can indulge myself that bit more than before. But I'm not a big spender. I'd like to buy a big house somewhere quiet but for the meantime I just buy whatever I like in the way of clothes and records."[7]

The Beatles' trendsetting look was mentioned in almost everything written about them. "The four young Merseysiders . . . have set a new trend in hairstyles, clothes and music," reported the *Aberdeen Evening Express*.[8] One of the first newspaper pieces to attribute the Beatles' success to their appearance appeared in the *Evening Standard* on February 2. In "Why the Beatles Create All That Frenzy," Maureen Cleave, a talented young reporter who would become a favorite of the Beatles, wrote: "I think it's their looks that really get people going, that start the girls queuing outside the Liverpool Grafton at 5:30 for 8 p.m. Their average age is twenty and

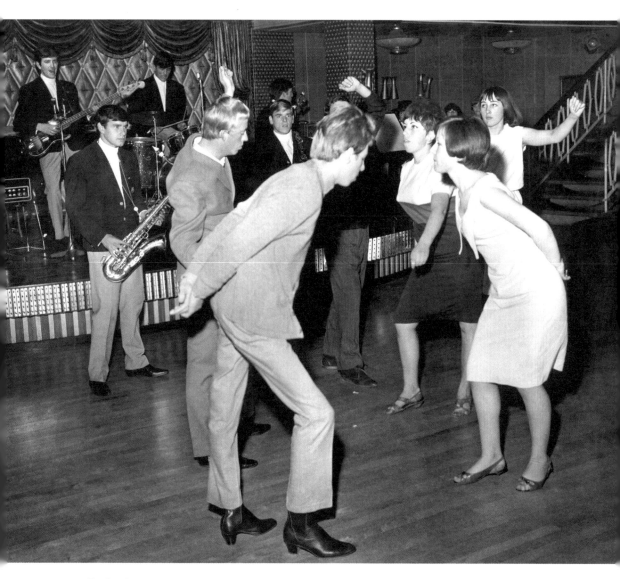

The Beatles were the new look and the new sound. Overnight collarless jackets and Beatle boots became the fashion. (Alamy Stock Photo)

Appearances deeply mattered to the Beatles who fussed over their hair, clothing and stage makeup, aware that their image was a key component of their success. (Everett Collection)

they have what their manager likes to call 'exceptional taste in clothes.' They look scruffy, but scruffy on purpose. Their shirts are pink and their hairstyles are French. Liverpool lads of twelve and upwards now have the small bouffant Beatle heads with the fringe brushed forward."[9]

The fashion press, too, was taking notice. One of the first was London-based *Honey,* a woman's magazine touted as being ahead of the trends.[10] In February, it sent one of its photographers, Michael Ward, to Liverpool to capture the Beatles on home turf. Ward liked to do street photography and so the first thing he did was take the Beatles outdoors. On a cold winter's day he photographed them, looking buttoned up yet chic, at various city locales. John and Ringo had on woolen coats while George and Paul wore fashionably cut leather.

Ward also shot the Beatles indoors at the Cavern in their velvet collar suits, rehearsing for the show they would play later that night. These were among the last photos ever taken of the Beatles at the club that had launched their career in Britain. Their final shows would take place later that year in April and August, after which the Beatles would never return. They had grown too big for that small stage.

The *Liverpool Echo* hired Dezo Hoffmann, an Eastern European photo-journalist then shooting for the *Record Mirror,* to trail the Beatles on their London rounds for a supplement to be called *A Day in the Life of the Beatles.* The shots were taken July 2, 1963, at various city locations, including Millings' Old Compton Street tailoring shop. Hoffmann knew the Beatles liked clothes. Earlier in the year, he had photographed them browsing the clothing racks at Cecil Gee's men's clothing shop at 39 Shaftesbury Avenue, where they ended up after an April 4 recording session at the BBC's Paris Studio, located nearby.[11]

Their command of the charts combined with the publicity they were generating now made the Beatles the group kids wanted to see to the exclusion of everyone else. When they met up again with Montez and Roe, it became painfully evident that they had stolen the Americans' thunder. Witnessing the pandemonium that greeted the Beatles each time they appeared, the tour manager told the Beatles they were being promoted to headliners. They would close out the evening performances.

Montez protested, threatening to walk off the tour, but thought better of it. He had glimpsed the future. In mid-tour, he began to wear his hair like the Beatles, brushed forward instead of greased back as before. Montez

realized that to survive as an entertainer, he had better pay attention to his new British rivals.

In May, while playing back up to the great Roy Orbison on his tour, the Beatles again were promoted after their screaming fans made it almost impossible for anyone to follow their act. Until then, said John, "we'd never topped a bill. You can't measure success, but if you could, the minute I knew we'd been successful was when Roy Orbison asked us if he could record two of our songs."[12]

Their songs were increasing in number so it was possible to give some away, not just to Orbison but to the Rolling Stones, an up-and-coming blues band whom the Beatles would befriend in 1963, supplying them with their first hit, "I Wanna Be Your Man," a song John and Paul had originally written for Ringo. The best songs they kept for themselves. "From Me To You," their third single and the first to top all of the UK charts, came out on April 11, with "Thank You Girl," another Lennon and McCartney composition, on the B side.

Then came the juggernaut, the hit song with the repeated "yeah yeah yeah!" refrain, one of the most recognizable hooks of all time. It would echo around the world as the sound of a new era. "She Loves You," custom-made as a single, was released in the UK on August 23. "I'll Get You," written in late 1962 but recorded at EMI on the same July day as "She Loves You," formed the B side. The record bolted out of the gate to become an instant Number One, spurred by 500,000 advance orders by fans eager to get their hands on the latest release by the Beatles. It entered the charts on August 31 and remained there for 13 weeks, setting, and then breaking, several UK sales records.

The start of Beatlemania is generally dated from the release of "She Loves You." On September 15, the Beatles performed the song at London's Albert Hall as part of the Great Pop Prom 1963, which they headlined. The Stones appeared on the same bill. Afterwards, the two bands gathered in bright sunshine to pose for pictures and indulge in a shared sense of pride, "all in our smart new clothes with the rolled collars," Paul has recalled, "and we looked at each other and we were thinking, 'This is it! London! The Albert Hall! We felt like gods! We felt like fucking gods!'"[13]

The sleeve of "She Loves You" had a photo showing the Beatles dressed in a Millings, suit as shot by Hoffmann, now one of their favorite photographers. But it wasn't the brown velvet-collar job. It was a collarless

creation, a brand-new look timed to coincide with the release of a record that likewise broke fresh ground. Millings' son Gordon witnessed a brainstorming session involving his father and Paul McCartney, who originally proposed the collarless suit idea. It was modeled on an original design by Pierre Cardin but tweaked to make it a distinctively Beatles' garment.[14]

The cylinder suit was futuristic fashion, described as such when Cardin first presented it at a pioneering men's fashion show at the Hôtel de Crillon in Paris in 1960. Not long after, the Cardin round neckline infiltrated women's wear, which is how the Beatles learned about it. Soon after they met the group in Hamburg, Astrid had dressed Stuart Sutcliffe in a collarless design for women, handmade from corduroy and based on the latest French fashion. Stu, her lookalike lover, wore the strange jacket for a Beatles concert in Liverpool as early as 1961.

Stu's collarless look raised eyebrows, even within the band. "Oh, have you got your mum's jacket on?" Astrid recalls John saying the night he first wore the corduroy at the Top Ten Club in Hamburg.[15] But after Stu's tragic death from a brain hemorrhage on April 10, 1962, at age twenty-two, the Beatles revisited the look he had first dared to embrace, a sartorial paean to his fearlessness.

The Beatles purchased their own corduroy Pierre Cardin-style collarless jackets from Cecil Gee in 1962, eventually taking them around the corner to Millings in Old Compton Street as patterns for the customized performance wear. Millings was familiar with the style after having worked in a factory during the war that made short jackets without collars or lapels for cruise ship workers. "He had cut that style many years earlier," his son Gordon said, "and it was part of the reason why the collarless jacket was what the Beatles eventually wore."[16]

To ensure the suit looked unique to them, the Beatles directed Millings to adapt the Cardin design to their specifications. Millings replaced the original matte corduroy fabric with resplendent wool and Italian mohair mix both elegant and comfortable for the stage. He also reduced the number of buttons from five to three and added slit pockets angled at the hips (the original Paris suit had none). As well, Millings beveled the sleeves and inserted two small vertical slits to the backs of the jackets to make them easy to move in during concerts. The edges he outlined in black or brown piping, depending on the color of the fabric—beige, black, navy, and silvery

sharkskin. The resulting collarless suits looked minimalist, measured, and moderate. They imbued the rockers with a palpable sense of cool. It was more a variation than an original design, but it established the Beatles as fashion forerunners.

The Beatles began wearing the collarless suits for live performances in June; they also wore them for the filming of *The Mersey Sound*, a thirty-minute BBC documentary exploring the origins of the Liverpool beat and the rise of Beatlemania. They performed "She Loves You" in an empty theater. Footage of teen screamers, taken from the group's performance at the Southport Odeon on August 26, was edited afterward. Otherwise, the Beatles would not have been heard on the audio tape.

Directed by Don Haworth and aired on October 9, John's twenty-third birthday, *The Mersey Sound* firmly established the collarless suits as a fashion sensation in the UK. "Round-neck jackets dominated teenage fashion for a year," pop culture chronicler Nik Cohn has observed.[17] Mods wore facsimiles of the Beatles' collarless jackets on the streets and in the clubs of London. The Beatles' rivals, Gerry and the Pacemakers, took to wearing them too. The look spread to Rome, where, significantly, what was essentially a French look became known as the new English style on account of the Beatles having made it popular. This most iconic of the Beatles' outfits then went mainstream thanks to widely distributed products like the Simplicity Sewing Pattern Company's pattern guide 8116 which provided an opportunity for the "fashionable collarless jacket for boys" to be made frugally at home. Butterick put out its own collarless pattern the following year, marketing its "Yeah Yeah Yeah" jacket to women. Waxwork dummies of the Beatles in collarless suits soon after became a new attraction at Madame Tussauds museum in London.

Frank Simon, a buyer from Bloomingdale's in New York, traveled to the British capital in 1963 and met with Richard Canning, then a leisure-wear designer for Jaeger, to discuss the latest trends. "I thought we were going to talk about the up-market stuff that Bloomingdales sold," Canning would later recall, "but the first thing he asked was, 'Now tell me all about Carnaby Street. Who are The Beatles? What are the mods?' I knew then that the whole business was changing."[18]

Boyfriend, a popular British magazine for teenage girls, sent out one of its reporters to get "an exclusive scoop" on the four lads from Liverpool. The writer discerned a tough-mindedness beneath the Beatles' polished

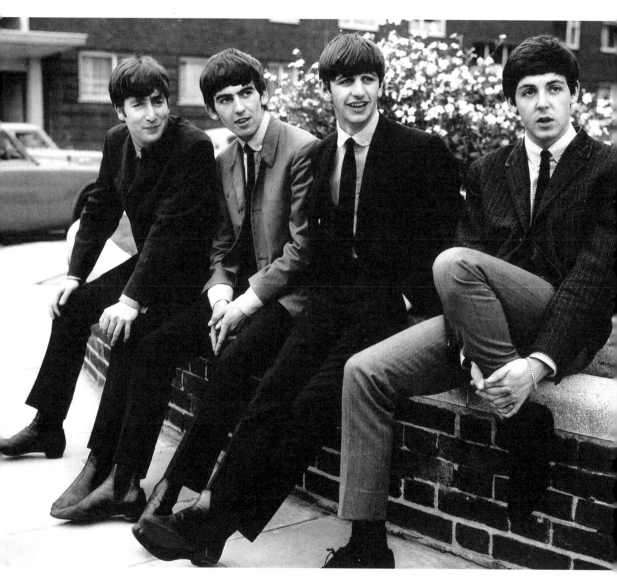

Once the Beatles hit London, the rush to sophistication was noticeable: Carnaby Street penny round collar shirts, Italianate bum freezer jackets, and pocketless trousers cut just the way the Beatles liked them – tight. (Alamy Stock Photo)

façade. Their sound was "novel," and the Beatles themselves were "more modern than modern." But their appearance was so new, at least compared to other groups at that time, that it disoriented and fascinated as something transgressive. The Beatles, the anonymous writer breathlessly concluded, were the "frightening" primogenitors of a new scene. "They look wicked and dreadful and distinctly evil, in an eighteenth-century sort of way. You almost expect them to leap out of pictures and chant magic spells."[19]

And leap they did, right out of *Boyfriend's* pages in Fiona Adams' accompanying photograph. The setting was a demolition site on London's Euston Road. Adams climbed down into a bombed-out cellar and trained her lens up at the dynamic foursome as they hurled themselves skyward, arms outstretched like wings, legs dangling over the rubble of old Britain. The shot concisely captured the energetic originality of the Beatles, a Cuban-heeled band on the way up. When Britain's National Portrait Gallery exhibited Adams' seminal picture in 2009, it called the photograph "the one that defined their early look."[20] John was so enamoured of Adams' explosive image, he pushed to have it on the cover of the Beatles' "Twist and Shout" EP, released mid-summer.

Boyfriend continued to spotlight the Beatles. That fall, amid its usual fashion and career tips and pop news, it again featured the band, this time in an article about four lucky readers who won the magazine's contest to meet the group in the flesh. The winners lunched with the Beatles in a London restaurant. Over glasses of iced Coke, the boys chatted about their recent concerts and their taste in clothes. They took turns talking about fashion and trends before deciding that they liked "military-style suits" the best. Paul declared a fondness for "laced-up boots." John laid on the table a sketch of new stage shoes and suits sent to him by a fan. "George was wearing a dark navy suit," the article noted. "Ringo a dark suit with a dark shirt, and John a navy suit with a lavender gingham shirt." Paul wore a tweed coat, gray shirt, and black knit tie.

While the Beatles enjoyed their clothes and understood the importance of projecting an image, they had never set out to be fashion icons and were surprised that so many people wanted to dress like them and follow their every sartorial move. They were especially reluctant to be seen as precious or elitists. They were careful, in some of the photos taken in 1963, to combine elements of their made-to-measure stage wardrobes with jeans and casual

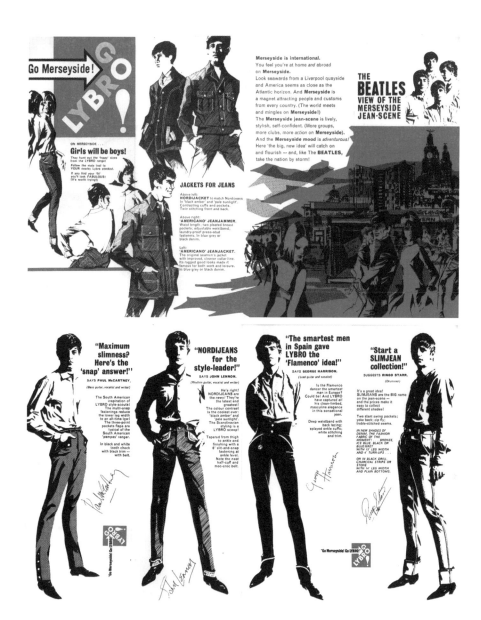

As a sign of their growing association with fashion, at Epstein's request the Beatles modelled a new line of Lybro jeans but later regretted it, feeling they had sold themselves out to a brand not their own. (Alamy Stock Photo)

woolen pullovers—a deliberate dressing down. "We were the first working-class singers," said John, "that stayed working-class and pronounced it and didn't try and change our accents, which in England were looked down upon."[21]

This more casual wear featured in a number of commercial spinoffs arranged by Epstein. The Beatles agreed to be part of an advertising campaign for a new line of jeans designed by Liverpool denim company Lybro. It was the first and last time the Beatles would use their popularity to endorse a fashion product not their own. Lybro was competing with Levi's for the attention of youth in Merseyside, but the company's thin Empire denim was inferior to the American variety. The Beatles quickly regretted their involvement with a lousy, inauthentic product and made sure the advertisements never saw the light of day. "Lybro made four different jeans for the band," said Tony Bramwell, a school friend of Paul and George then employed by Epstein to oversee the group's public relations. "Paul's were dog-tooth, John's striped, Ringo's were black, and George's Royal blue. The band hated the jeans. They were hideous."[22]

More successful was the black polo neck sweater, a copy of the type the Beatles wore offstage with jeans or suit trousers. Marketed as Beatlewear, a new fashion category, the garment was made of fine merino wool exclusive to Australia. Available by mail order, it first surfaced in advertisements placed in the metallic silver souvenir programs for the Beatles' two shows at Dublin's Adelphi Cinema in November. It was described as a "high fashioned black polo sweater in 100% botany wool specially designed for Beatle people by a leading British manufacturer."[23] The makers, in fact, were Epstein's cousins, Peter and Raymond Weldon, who went on to sell 15,000 of the sweaters worldwide.

Other businesses knocked off the Beatles' boots and jackets. These included the Essex mail-order fashion company La Mode, which sold Cuban heel footwear, and the London-based Arbutrim, which offered modified copies of collarless suits. "Boys be a hit!," read the company's ad in *New Musical Express*, "in this latest Beatle style jacket in popular black cavalry twill with fancy lining."[24]

The Beatles' influence began to alter people's notions of British style, long considered hopelessly staid. "In fact, it would be true to say that the English look is now more popular on the Continent than at any time since the high old days of the eighteenth-century dandies," wrote *Gear Guide*,

a hip pocket road map to London's now swinging fashion scene. "The English have been known on the Continent for horsy styles more connected with country houses and grand leisurely living in the past but this is all changing. The new colourful English scene is all the rage."[25]

Andrew Loog Oldham noticed at the time how the Beatles had become "the epitome of upwardly mobile youth style." One particular chance encounter with Paul and John in the streets of London in 1963 drew his attention to their distinctively tailored look: "I was wearing my customary John Stephen blazer over gingham shirt and grey flannel trousers, while John and Paul were fabulous in their three-piece, four-button bespoke Dougie Millings' suits. With Paul in lighter and John in darker shades of grey, their gear was a Mod variation of the classic Ted drape jacket, set off by black velvet collars, slash pockets, and narrow, plain-front trousers."[26]

Oldham was impressed at how the Beatles' suits made them stand apart. But he noticed something more. Even dressed up, the Beatles exuded a "fuck you, we're good and we know it attitude." Oldham had watched how the band sneeringly repelled anyone who tried to get near them back-stage at a 1963 taping of *Thank Your Lucky Stars*. This was consistent with the "frightening" dimension of the Beatles' noticed by *Boyfriend*. The group conspired to create "an intentionally intimidating image," said Beatles' friend Barry Miles.[27] They did that by dressing alike, even after hours, in black polo neck sweaters, earthy corduroy jackets, and long suede coats purchased in Hamburg, outfits that made Mick Jagger green with envy when he saw them on the Beatles at the Crawdaddy Club, just outside London, that year. Jagger called them the four-headed monster.[28]

With people everywhere copying their looks, the Beatles searched for ways to stay ahead of the pack. They varied their stage outfits, which now included pinstripe suits and velvet jackets, with accessories, shirts, espe-cially bought by the armful after they all moved to London in mid-1963. John, George, and Ringo found digs in Mayfair. Paul took up residence in the home of his new girlfriend, the titian-haired seventeen-year-old British actress, Jane Asher. One establishment they frequented belonged to bespoke shirtmaker Katy Stevens. A Hungarian by birth, she had opened a shop on London's Archer Street after working for menswear designer and retailer John Michael Ingram. Meticulous hand-stitching combined with innovative touches like squared-off collars established her shirts as distinctive one-off fashion items and she quickly gained the loyalty of

London's Mods. The Beatles wanted some for themselves and dropped in unannounced to her Star Shirtmaker premises the day before they were set to record their fourth appearance on the BBC's *Saturday Club* on June 24:

> The Beatles came up to us, on the top floor, but we didn't know who they were. They were just four scruffy boys who came up the stairs to see us. Ringo had a terrible figure, and I had to pin his shirt, because we did made-to-measure shirts, but he said, "No, no, don't pin it. I am satisfied." George said to me, "Have you got any stock shirts? We are going to the BBC, and I haven't got anything to wear." I sold a shirt to George for £2, 10s, which was a lot of money. He bought it and was very satisfied. I then showed them our sample book and they ordered fifty shirts each! But, after they left, I told my husband, A. Maknyik, "Oh no, I don't think they can afford it." I really didn't believe they could afford it. I told my husband, "Just do one each, and we'll see what happens." But we did do them the fifty shirts. And we were working like hell. Our cutting table was full of shirts. And when they came to collect the shirts . . . they paid in cash! They seemed satisfied. . . . I joined John at the window and I asked him, "What is happening to the street because it is so crowded!" The street in Archer Street was swarming with young girls. John said to me, "Oh nothing. It's just because we are here." I then, naturally, had to ask them, "Who are you?" And he said, "We are the Beatles."[29]

It might have been one of the last times they had to explain themselves. In Britain, the Beatles now had their own BBC radio show, *Pop Goes the Beatles*, launched in June 1963. On September 12, *Queen* magazine assigned celebrated British fashion photographer Norman Parkinson to shoot the group recording *With the Beatles*, their second album, which came out on November 22. It was a working day. The playlist included "Hold Me Tight," "Don't Bother Me," "Little Child," and "I Wanna Be Your Man." The foursome performed the session songs dressed smartly but not identically as they did on stage, save for Paul and John both wearing the same gingham-checked penny-collar shirt. They had read each other's minds.

Next up was British *Vogue* whose December issue described the Beatles as "a totally irreverent, frenetic foursome from Liverpool [who] have made a sound into an institution." The non-bylined writeup also emphasized the

group's youthful allure: "The Beatles never try. They open those enormous plaintive, sloping eyes, shake their mushroom-shaped heads, project the Christopher Robin image and stay at the top."[30]

American *Vogue* quickly followed, giving the Beatles a full page that confirmed their ascendancy in style circles even before they had stepped foot on US soil. British photographer Peter Laurie's black-and-white image presented them sitting almost on top of each other, their bodies overlapping with no spaces in between. Paul, dressed in tight-fitting corduroy trousers and a boxy tweed jacket, held Ringo's deadpan face up to the camera as George leaned in to say something; John, foregrounded, quietly observed his bandmates while wearing a custom-made leather cap, which had lately become his style signature. He was the only one among the Beatles to wear a hat and it marked him as the one to watch, the Beatle who marched to his own beat.

In the *Vogue* photograph, the Beatles appear as a tight-knit unit, intimately and visually connected, although it can also be read as an image of a group whose celebrity has begun to entrap it. The text that accompanies the photo suggests as much: "The singers, young, male, alive and lovable, live in a mobile prison of adulation, guarded by the police, their protectors, from mobs eager to tear at the Beatles, to touch them, to snip off pieces of their clothing."[31]

This was the start of a growing feeling that the Beatles were paying a price for their fame. On October 13, they headlined *Sunday Night at the London Palladium*. Their four-song concert and pre-taped dressing room preparation were seen by close to fifteen million people. The volume of screaming at the Beatles' shows had been building for months, but on this night, it was deafening. John at one point shouted at the audience to shut up. Outside the theater, a platoon of sixty police officers jostled with unruly fans who pushed against the stage door; several of them were crushed under foot. The pandemonium made the morning papers. "Screaming girls launched themselves against the police," reported the *Daily Herald*, "sending helmets flying and constables reeling."[32] When the Beatles tried to leave the venue, they were told it was too dangerous. They were held hostage in the theater for hours until the madness died down.

The excitement was better contained in November when the Beatles appeared as part of the *Royal Command Performance*, in the presence of Her Majesty, the Queen Mother, Princess Margaret, and Lord Snowdon

in the Royal Box.[33] The charity show, at the Prince of Wales Theatre, featured the group performing "From Me To You," "She Loves You," "Till There Was You," and "Twist and Shout." The Queen Mother rocked along. She seemed to enjoy the Beatles more than Marlene Dietrich, Burt Bacharach, and Maurice Chevalier, who were also on the bill, along with fifteen other acts.

In advance of the command performance, Derek Johnson of the *New Musical Express* speculated about what the Beatles would wear. Were their round-collar suits suitable for the occasion? The Beatles played it coy, refusing to tip their planned wardrobe, leading to the headline, "Beatles Keep Royal Suits Secret."[34] Possibly because there had been so much speculation about the collarless suits, the Beatles abandoned them completely, not wanting to be predictable. They would not perform in them again, save as a joke later in their career.

They went on stage at the Prince of Wales Theatre in matching blue-grey flannel jackets with velvet collars—another Millings creation—along with white point-collar dress shirts and knitted ties. Their flat front trousers, tapered at the ankle, skimmed the slippery surface of their pointed-toe leather boots. Their hair, brushed down over their foreheads, gleamed beneath the overhead lights. They looked expensive.

Despite their high gloss appearance, the Beatles projected guileless charm. They appeared comfortable in their tailored clothes, wearing them with the ease and confidence of the English gentleman. They smiled their way through a pressure cooker of an evening making light Liverpudlian-accented jokes at the expense of the audience. With a touch of impudence, John told the people in the cheaper seats to clap along. The diamonds-and-mink guests in the better seats were invited "to just rattle your jewelry."

Cheeky, fresh, and self-assured, the Beatles seized the moment. They were in complete control. Fleet Street fell over itself reporting on their coup. "You have to be a real sour square not to love the nutty, noisy, happy, handsome Beatles," said the *Daily Mail*. *The Evening Standard* went further, declaring 1963 the "Year of the Beatles."[35] It was a reasonable assessment of the group's immense popularity. When a taping of the *Royal Command Performance* was broadcast to the nation on November 10, it was seen by an estimated 21.2 million viewers. Days later, the Beatles' new single, "I Want to Hold Your Hand" soared to the top of the UK charts where it stayed for five weeks. Impressive numbers. But they would be surpassed by what happened next.

1964
WELL HELLO MOP TOPS

"We came out of nowhere with funny hair, looking like marionettes or something. That was very influential."
—PAUL MCCARTNEY

What made the Beatles captivating, fascinating and enormously attractive was the clash of decorum and unruliness projected through their bespoke clothes, angelic harmonies, long hair and loud electric guitars. (Alamy Stock Photo)

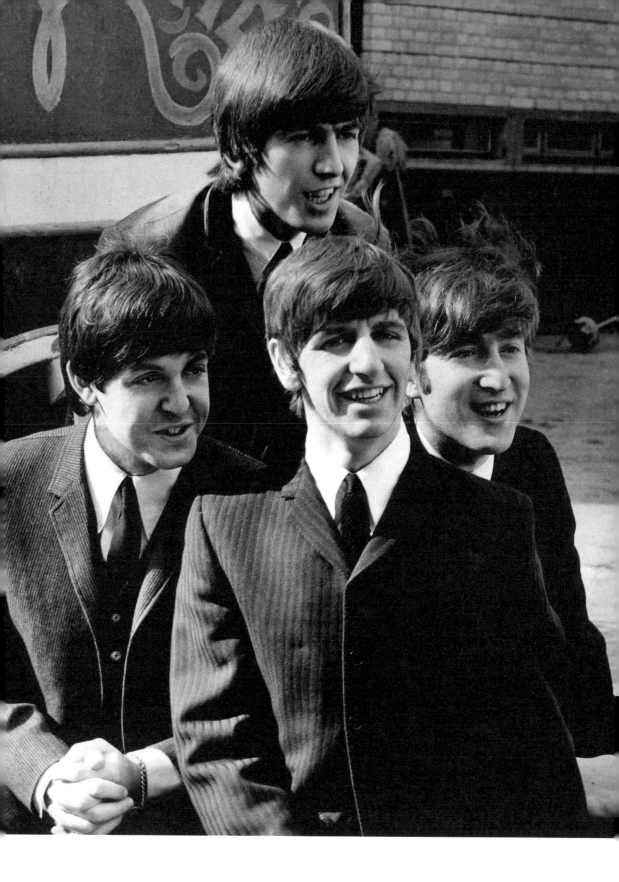

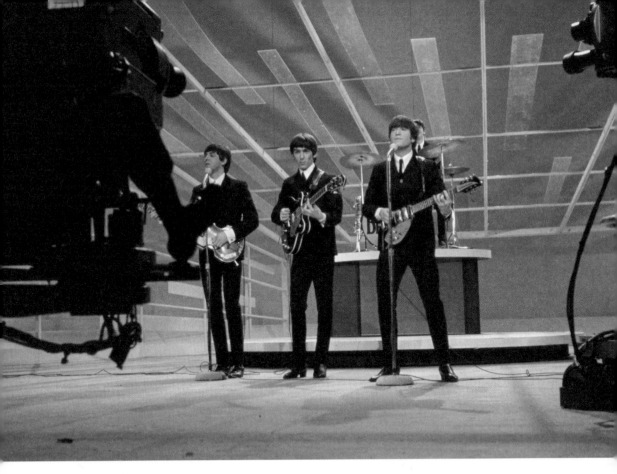

The Beatles made their sensational US television debut in made-to-measure suits by Dougie Millings. Legions of fans would soon buy up copies of the British style. (Alamy Stock Photo)

The Beatles' forehead-covering hair became a national obsession.

As Beatlemania raged in Britain through the summer of 1963, Brian Epstein signed a contract with French promoter Bruno Coquatrix to present the band at the famed Olympia Theatre in Paris in the new year. The three-week residency, January 16 to February 4, would be the longest the Beatles would play in any one venue outside the Cavern in Liverpool and the Top Ten in Hamburg.[1] Word about the English group had crossed the Channel in advance of their arrival in the French capital. French media probed the secret of their success and concluded that, *bien sûr*, their French haircuts separated them from all the other rockers. Parisian department stores stocked Beatle wigs, anticipating demand.[2] Expectations ran high but the opening night was a disaster.

Behind the scenes at the Olympia, a brawl had broken out as Fleet Street reporters collided with a gang of French photographers who had stormed the stage door to be the first to corner the Beatles in their dressing room. Beatles' press officer Brian Sommerville was hit in the jaw when he tried to get them all kicked out. The gendarmes were called to protect the band, not from fans, but from aggressive and unruly journalists.[3]

The audience, by comparison, was dead that night. Dressed in evening clothes as if for the ballet or the opera, they clapped politely when the Beatles appeared before them and then fell silent when the power suddenly blew.

Unbeknownst to the Beatles, a French radio station had plugged into their PA system in an effort to record their show without permission. The electricity crashed three times in total. George Harrison yelled that the photographers were to blame; they had sabotaged the show.

Not surprisingly, given the chaos, opening-night reviews were less than enthusiastic. *France Soir* dismissed the Beatles, attired in a new set of slim-cut black Dougie Millings suits, as nothing a bunch of *"zazous,"* the French equivalent of Teds. British journalist Vincent Mulchrone, an active participant in the backstage melee, wrote in the *Daily Mail* that Beatlemania might not be exportable.[4] Not true.

The Paris shows, both matinee and evening, were sold out for every performance of the three-week run. French fans soon couldn't get enough of them, shouting *"un autre! un autre!"* at the conclusion sets featuring raucous performances of *"Long Tall Sally"* and *"Twist and Shout"* (two French favorites) as well as *"She Loves You"* and *"Boys,"* the latter sung by Ringo whom the Parisian boys really did go for, calling out his name and chasing after him in the streets after each show.[5]

English style became the rage in France. The Beatles' boy fans carried umbrellas, the most British of accessories, to mark their allegiance to *"les anglais."* French photographer André Lefebvre, shooting for *Paris Match,* photographed the Beatles at the luxurious George V, where they were staying. He captured them attending to their *toilette* in front of the hotel's marble-framed bathroom mirrors: their image double magnified. Beatlemania thrived on foreign soil.

More proof came on that first disastrous Paris night in the form of a telegram telling them that "I Want To Hold Your Hand" had rocketed to Number One in the January 25 edition of American *Cashbox,* just two weeks after debuting at eighty. The Beatles were bowled over. They had done it. They had achieved what no British pop group before them had been able to do, breaking America's notorious resistance to talent from across the water with a perfectly crafted pop song. They would travel to America just as soon as their Paris engagement was over by which time they had three singles in the *Billboard* charts, all vying for the top spot. The Beatles-led British Invasion had begun.

Epstein ordered Capitol Records, majority-owned by EMI in England, to commit a then-astonishing $50,000 to the promotion of the Beatles on US soil. Some of the money was spent in Los Angeles to get celebrities like Janet Leigh to cut their hair like the Beatles and pose for photographs in the new brushed-forward style.[6] "And so the whole moptop thing started there," Paul said. "And it did get us noticed."[7]

Radio also played an instrumental role. Deejays, among them Murray the K of New York station WINS, counted down the number of "Beatles hours" and "Beatles minutes" until the group arrived. When, on February 7, Pan American Airways Flight 101, a Boeing 707, finally touched down at the newly renamed John F. Kennedy International Airport, close to 4,000 delirious fans, squished behind plate-glass windows, hanging over rooftop railings, screeched a deafening welcome.[8]

Two days later, on February 9, they performed on *The Ed Sullivan Show*, CBS's top-rated Sunday night variety program, their American television debut.[9] As the broadcast drew near, CBS received over 50,000 requests for just seven hundred available seats. Ed Sullivan joked on air that even he couldn't get a ticket to what was being hyped as the biggest show on earth. When he stood before the cameras to announce, "Ladies and Gentlemen, the Beatles!" and swung his arm for dramatic emphasis, the screamers let loose.

The Beatles made a powerful first impression in black mohair Chesterfield suits with black velvet half lapels. Millings had made the suits expressly for the group's first US visit, adding a set of shiny gray sharkskin suits with extra-large black velvet collars for the concerts that followed in Washington, DC, and New York's Carnegie Hall. The Chesterfield is a classic design dating to 1840 and named for a British aristocrat. Millings spiced it up by cutting the trousers to fit snugly on the body, enhancing the Beatles' desirability. Chris Hutchins, writing in *New Musical Express* on the eve of the Beatles' much-ballyhooed departure, predicted that the "startling suits" would "set as big a trend in the US as their famous Beatles collar jacket did at home."[10] Gordon Millings, who worked with his father on the design, said that the suits seldom made it back from the dry cleaners, necessitating an extra half dozen be made for each Beatle to offset theft by their fans on the tour.[11]

Teen idols from Frank Sinatra to the Everly Brothers had worn suits as part of their stage acts. The Beatles modified that tradition by donning bespoke creations of European elegance topped with their signature unruly long hair, a unique combination of seemingly antithetical elements, tough yet harmonious, hard but sensuous. It was a visually potent package, a beguiling import not only from another country but seemingly from another era. Wrote American literary scholar Albert Goldman, later the author of a controversial John Lennon biography:

> Accoutered in dark, tubular Edwardian suits that exaggerated the stiff, buttoned-up carriage of these young Englishmen, the Beatles resembled four long-haired classical musicians, like the Pro Musica Antiqua, playing electric lutes and rebecs and taking deep formal bows after each rendition.[12]

Something else that stood out: the Beatles did not look conventionally masculine. It started with the clothes. Many staples of the Mod wardrobe were first popularized by what was euphemistically known as "the theatrical crowd." In addition to its fashion and music scenes, Soho was the heart of London's gay community. Local boutiques such as Vince Man's Shop on Newburgh Street sold tighter, zestier, and more sexually suggestive garments than what straight Englishmen were wearing at the time. Vince proprietor Bill Green, and other like-minded clothiers were pushing the

limits of masculinity, attracting both positive and negative attention from outside the gay fraternity. Fashion-aware heteros with a rebellious streak, including the Beatles, found the looks subversively erotic and appealing. They would help to bring the so-called gay style mainstream.

The Beatles' unmistakably effeminate quality went deeper than the clothes, the pointy high-heeled boots, and the slender bodies. The way they wore their hair, brushed forward on the forehead and haloing the eyes, feminized them, which for many was both shocking and thrilling to see. It was also reflected in their compositions. While in some songs the Beatles played the part of the adoring boyfriend, appealing directly, intimately, to their female fans, professing to want to hold their hands, the lyrics to "She Loves You" addressed male listeners in a girlfriend-confidential manner. As early as 1961, the Beatles had been experimenting with the call-and-response musical patterns used by the American girl groups they loved, the Ronettes, the Marvelettes, and the Shirelles. In performance, they sang falsetto and moved in close to each other to sing their harmonies, looking intimately into each other's eyes. Their willingness to unselfconsciously borrow style elements from the ladies bestowed upon the Beatles an androgyny that enhanced their allure.

In their private lives, the Beatles had less progressive ideas on gender roles. John and Paul, for instance, pressured their girlfriends to bleach their hair and dress in tight skirts to look like their favorite pinup, Brigitte Bardot. Ringo, then romantically linked with Liverpool hairdresser-trainee Maureen Cox, demanded that a hot meal be on the table as soon as he came home following a late-night gig or recording session. On stage, however, largely because of their svelte dress and meticulous grooming, their juxtaposition of bohemian hirsuteness and a structured silhouette, pointed in another direction entirely. They balanced masculine with feminine, respectable with raucousness, and appeared simultaneously attractive and subversive. "I wouldn't even say it was about trying to be cool," said author and filmmaker Jerry Levitan, who grew his hair and got an uncle, a Jewish tailor from the "old country," to make him a Beatles' collarless suit soon after he first saw the group perform on *Ed Sullivan* at age ten. "It was more a matter of, 'That's what I want to identify myself with: something joyous, upbeat, and carefree in a very expressive way.' I just wanted to be like them. I wanted to be a part of them, and that was my attraction from the beginning."[13]

© David Bailey

The Beatles weren't conventionally masculine, but they were secure in their sexuality, and this heightened their allure. (Alamy Stock Photo)

A history-making 73 million people watched the Beatles perform live that night, almost 45 per cent of the US population.[14] People had heard the songs and tuned in to see what the Beatles actually looked like. After drawing the biggest TV audience on record, the Beatles' hit single "I Want to Hold Hour Hand" sold 2.6 million copies in America alone in just two weeks.[15] The song held the Number One spot for seven weeks until displaced by "She Loves You," a late entrant on the US charts.

"I was all in, as were millions of other teenagers around the world at the time," said Canadian fashion entrepreneur Joe Mimran, the creative force behind Club Monaco, Alfred Sung, and Joe Fresh international lifestyle brands, who was twelve at the time. "It wasn't just the music that I loved, but the influence their fashion had on me. Sitting in our family living room watching them on a black and white TV set, fascinated by their skinny suits and mop haircuts, I vividly remember asking my mom to make me a skinny hound's-tooth suit, which she did, from beautiful French 100-per cent worsted wool. I begged for a pair of black side zip Beatle boots and the look was complete. I became hooked on fashion."[16]

Of course, some other television viewers found their gender-bending appearance disorienting and disdainful. "I think the Beatles are sissies!" a reader said in a letter to the editor of the *Christian Science Monitor* soon after the group's first US appearance. "They . . . have queer hair-dos," complained another to the *Chicago Tribune*. "The world is fast descending into a bedlam of chaos."[17]

Reviews of the Beatles' live TV performance, especially from establishment publications where short hair and defined gender roles ruled, were predictably scathing. *The Washington Post* called the Beatles "asexual and homely." *The New York Times* dismissed them as a "fad." The *Herald Tribune* ran the headline "BEATLES BOMB ON TV," ridiculous in retrospect. *Newsweek* lambasted their music, calling it "a preposterous farrago of Valentine-card romantic sentiments," adding that "visually they are a nightmare: tight, dandified, Edwardian beatnik suits and great pudding-bowls of hair."[18]

Hair was a major sticking point; many American observers just couldn't get past it. "What made the Beatles seem so foreign," noted Denise Schomberg in a published essay about the debates that raged broke out in US homes like hers after that first *Ed Sullivan Show* broadcast, "was their long hair, high-heel boots, strange clothing, and the way they performed.

Parents were offended by their hairstyles because boys at that time just didn't grow hair over their ears. Americans were used to flattop haircuts and penny loafers."[19]

The controversy was heightened when legions of adolescent males grew out their locks in imitation of their idols, to the dismay of parents. Some longhairs, as they became known, faced beatings at home from buzz-cut fathers who loathed their sons' Beatles-inspired looks, regarding them as a sign of latent homosexuality. "Long hair is a violation of what people are used to," opined a *Los Angeles Times* columnist. "Our culture has distinct notions of an obvious separation between the sexes. Long hair tends to confuse that separation."[20]

American anthropologist Margaret Mead, then writing for the popular women's magazine *Redbook*, analyzed the Beatles' haircuts from a supposedly scientific point of view, declaring them symbolic of "an empty life," a "poorly developed sense of the self," and a "desperate artificial answer to the question, Who am I?"[21]

Trivial as the issue may seem in retrospect, the right to long hair, as inspired by the Beatles, became a trigger point in a cultural revolution that would soon rock American society to its core. Hair was a crucial symbol in the student activism and Vietnam War protests that erupted in the sixties. "It seemed to me a definite line was being drawn," said Bob Dylan, who would alter his folkie Americana image soon into something more Beatlesque after meeting the group in New York and gifting them reefers.[22] "It was outrageous and I kept it in my mind."[23]

Some American high schools implemented dress codes specifying appropriate haircuts for boys. Those who styled their hair like the Beatles were threatened with expulsion, among them fifteen-year-old freshman Larry Robinson. A resident of New Jersey, he made national headlines when his Hackensack high school suspended him for coming to class in a Beatles suit and wig.[24] Other long-haired students expelled from their schools resorted to the courts, where in some instances they won the right to wear their hair how they wanted.[25]

The Beatles were bemused by the controversy swirling around their shaggy-haired image in the US. From their perspective, the Yanks were lucky they had come over to rescue America from being forever lost in fashion oblivion. "When we got here you were all walking round in fucking Bermuda shorts and with Boston crewcuts and stuff on your teeth," said

John to *Rolling Stone* founder Jann Wenner. "There was no conception of dress or any of that jazz. I mean we just thought, 'What an ugly race.' It looked disgustin'. And we thought how hip we were."[26]

Some agreed with John, US clothing retailers especially. Declaring the Beatles to be the hottest thing on the fashion scene, Carl Rosen, the CEO of Puritan Fashion, a Manhattan manufacturer of basic dresses, secured the license to make Beatles T-shirts, knit sweaters, and sweatshirts, selling them to American mass retailer J. C. Penney.[27] In Canada, The Hudson's Bay Company, the nation's oldest retailer dating back to the fur trade, opened Beatles boutiques in select stores across the country. "Beatles Selection Is Better At The Bay," read a 1964 advertorial highlighting the company's offering of Beatle-inspired shirts, jackets, and tailoring, "Yeah! Yeah! Yeah!"[28]

Catering to imitators of the Beatles style became big business. There were Beatle pyjamas and Beatle dresses, Beatle rings, Beatle lunch boxes, Beatle tennis shirts, and five-inch Beatle bobbleheads with painted-on dark Dougie Millings suits and glued-on tufts of life-like hair. Remco Toys had initially produced 100,000 of the fashion-conscious novelty items with another 500,000 on order as soon as the real Beatles came to town.

"US. teen-agers in the next twelve months are going to spend $50-million on Beatle wigs, Beatle dolls, Beatle egg cups and Beatle T-shirts, sweatshirts and narrow-legged pants," the *Wall Street Journal* reported.[29] Rickenbacker and Gretsch guitars along with Ludwig drum kits—instrument brands associated with the Beatles—also saw sales soar as fans looked to emulate the group in every way they could.

Unfortunately for the Beatles, they did not profit from this aspect of their popularity. Epstein might have been good at dressing the Beatles up and taking them places, but he was, by many accounts, a lousy businessman. Not knowing what to do with the merchandising side of the Beatles' phenomenon, he signed away countless millions, if not billions worth of potential income for the Beatles when he brought in British socialite Nicky Byrne to handle the growing number of merchandising requests from novelty companies in America. Byrne's company, Seltaeb (the Beatles spelled backwards), profited handsomely at the Beatles' expense, said John Fenton, a member of the consortium who purchased the Beatles' merchandising rights for a song:

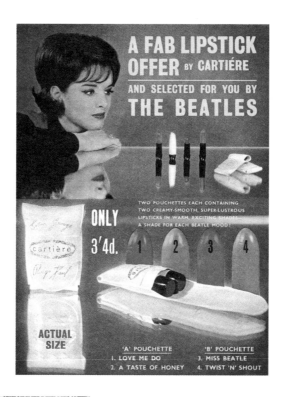

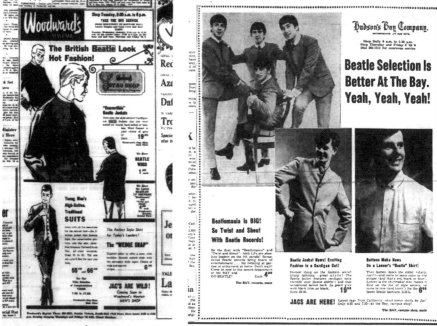

Manufacturers of cosmetics and other fashion products rushed to cash in on the Beatles' popularity. (Alamy/ Piers Hemmingsen)

In New York we had the whole sixth floor of the Drake Hotel, and we each had the best apartments money could buy. We went through a fortune. We started with 13 authorised products and ended up with over 460 different pieces of merchandise. We were on 20 per cent of retail and the Beatles had accepted 2 per cent. It was Epstein's one big fuck up.[30]

Among the biggest money makers were the Beatles wigs licensed to the Lowell Toy Company which manufactured them at an astonishing rate of 35,000 per day. "Teenagers who once considered a GI crew cut the height of adolescent fashion are letting their locks curl down their necks and over their ears and across foreheads," reported *The New York Times*. "Twenty thousand [Beatle] wigs have been sold."[31] Another half ton of the wigs was flown to the UK to meet demand.[32] Million more were sold in Japan.

The wigs were foregrounded at the Beatles' first American press conference held at the airport's Pan Am lounge on February 7. The group encountered a cynical press corps looking to draw blood. But the Beatles were no fools. They remained quick-witted even after the long flight and effortlessly batted away annoying questions. "How many of you are bald that you have to wear those wigs?" shouted a reporter in the crowd. John, not missing a beat, replied, "Oh, yeah, we're all bald, and deaf and dumb too," provoking even hardened news hounds to burst into laughter.[33]

"We can put away the spray guns," a newspaper man said. "The Beatles are harmless."[34]

The press liked that the Beatles could give as much as they got and came to respect their grit and gumption. Journalists soon took to writing about them as emblematic of the American dream where hard work, combined with determination, could lead people of even humble origins to scale the heights of ambition. Al Aronowitz covered the New York press conference for the *Saturday Evening Post* and outlined the rags-to-riches biographical details of each Beatle for his audience. After describing Ringo's dirt-poor upbringing "amid the grimy row-house streets of Liverpool," he detailed the many silver and gold rings the drummer wore as an outward sign of his material success. Ringo was the Beatle the American public loved the most. As in Paris, the fans called out his name. He took it in stride and was described as down to earth, a Beatle the average Joe could relate to. "I hate phonies," Aronowitz quoted Ringo as saying, "I can't stand them."[35]

Shot in black and white to give it a newsreel
feel, *A Hard Day's Night* distilled the essence
of the Beatles at the height of Beatlemania.
(Alamy Stock Photo)

The Beatles all mistrusted sycophants and hangers-on who tried to ride on their fame. They told Epstein not to accept invitations from the many dignitaries who formerly had detested their type and now wanted to know them. They loathed the hypocrisy. But one such event could not be avoided. They were guests of honor at a black-tie charity ball at the British Embassy in Washington. They attended after their performance at the Washington Coliseum on February 11, their first live public US concert. Dressed in their gray sharkskin stage clothes with exaggerated black velvet collars, they were pawed by the well-heeled crowd as soon as they entered the ambassadorial home of Sir David Ormsby-Gore. Autograph books were shoved under their noses. Photographs were demanded. The working-class superstars felt belittled by many at the party that night, snobs in the Beatles' eyes, evidence that Britain's class system remained entrenched. The rudeness peaked when a young woman, standing behind Ringo, took out a pair of nail scissors from her evening bag and snipped the curls falling over the back of his shirt collar.[36] "That was a stupid incident," lamented Ringo, "wanting to cut a Beatles' hair."[37]

The American filmmakers Albert and David Maysles captured the feeding frenzy surrounding the group in their 1964 documentary, *What's Happening! The Beatles in the U.S.A.* The 16-mm film spliced together footage from their *Ed Sullivan* appearances, both in New York and Miami Beach, with the group's Washington DC concert, which had been staged in a boxing ring. The brothers had boarded the train that carried the Beatles between gigs and their handheld camera work moved in and around the photographers and newspaper reporters who had also squeezed onboard, conjuring a claustrophobic world. The Beatles don't have a moment to themselves. When they chance to look pensively out the train window, the screaming fans are there, pressed up against the glass, crowding into their very thoughts.

In one segment, Paul looks to have had enough and refuses to smile when asked. Ringo, by contrast, is always entertaining, fishing for laughs. He feverishly does the Twist at New York's Peppermint Lounge (where the dance craze originated), dressed in another made-to-measure Millings suit and thin tie. John smokes at a nearby table, wryly observing it all. A demure George dances, while Paul, now over his funk, winks, and mugs for the camera, belatedly cementing his reputation as the Cute One.

These early images of the Beatles would become fixed in the public imagination, bolstering the perception that the four were indeed

"harmless," likable lads out for a good time. One US publication said that the Beatles were "the very spirit of good clean fun. They look like shaggy Peter Pans, with their mushroom-haircuts and high white-collar shirts."[38] The group would work hard to live down this boyish portrayal.

American-born filmmaker Richard Lester claims not to have been aware of the Maysles' film when he set out to make a life-like movie about the Fab Four. But there were similarities. Like the Maysles movie, Lester's intended to come close to reality. One is a documentary and the other is what became known as a mockumentary, among the first of its kind. Taken together, both films provide a snapshot of the Beatles' look, sound, and cataclysmic force in those years. Lester's would end up being the more noteworthy, emerging as a sustained (and smart) meditation on their collective image. Today, *A Hard Day's Night* is considered a cinematic classic.

Filming commenced in London on March 2, about two weeks after the group's return to Britain from the United States. United Artists' producer Walter Shenson, a fellow American living in England at the time, had conceived it as a day-in-the-life of the Beatles (though it ended up being more like two days plus a night). The impetus was to build on the proven success of the Beatles' public persona and get a soundtrack of six original songs from it.[39] After discussing the idea with Epstein and the Beatles themselves, the consensus was that *Beatlemania!,* as the film was originally titled, should be a comedy. Shenson believed Lester, director of the Goon show and other Spike Milligan and Peter Sellers comedic projects, was the one for the job. The Beatles agreed. They were all fans of Lester's anarchic humor.

Once he had been approved as the man to make the Beatles' first feature-length film, Lester began his research. In the fall of 1963, he commissioned playwright and actor Alun Owen, then enjoying success as the creator of the Liverpool-based TV play *No Trams to Lime Street,* to shadow the Beatles on some of their tours as an aid to writing a script. Owen palled around with the Beatles for three days in Belfast, Dublin, and London, seeing up close up how wild they were, and also how hemmed in. His script, later nominated for an Academy award, would probe with Goon Show-like humor the social and cultural dynamics of their public image, portraying them as prisoners of their fame.[40] It would also show how genuinely funny and unpredictable they were. Owen would use some of their own lines spoken in the heat of a press scrum, or in sarcastic response to some old fogey outraged by their hair and anti-authoritarian attitude for *A Hard Day's Night.*

The title was a Ringo malapropism, one of many the naturally drole drummer uttered in the presence of the other Beatles, reducing them to stitches.[41] John recycled a few for the book of nonsense verse, prose and humorous line drawings he completed while the Beatles were in New York. *In His Own Write,* as surreal as some of the humor in *A Hard Day's Night,* would be published on March 23, while the group was making Lester's film.

Lester had the choice to shoot his movie in color but opted for black-and-white to lend his mockumentary the feel of a newsreel. He wanted the Beatles to appear energetic and timeless, and as authentically themselves as possible. Clothing and hairstyles were keys to creating an air of verisimilitude.[42]

Lester insisted on monochromatic hues in the clothing that would read well in black-and-white. He specifically requested a set of navy-blue suits with knitted ties, which costume designer Julie Harris located at English department store Harvey Nichols. The Beatles agreed to wear the store-bought clothes but otherwise were difficult to deal with. They were boisterous on set and disinclined to take direction.

On the first day of shooting, they showed up in black roll-neck (or turtleneck) sweaters and were reluctant to take them off even when asked. John was especially stubborn on this point. He appears in the British Railways train scene in a white point-collar shirt and he's still wearing it in the car whisking him and the other Beatles away from the station, but for the scene which immediately follows he's in his black sweater. He also insisted on wearing his leather cap on set. On the day they were filming at Gatwick Airport, John had forgotten the cap at home. He halted production until a crew member could drive back to the city to retrieve it. "They did not understand about continuity," Harris later said, "so they didn't know why they couldn't walk into the wardrobe in the morning and say 'Oh, I'm going to wear that today,' because yesterday they'd worn another suit and they had to wear the same thing."[43]

To bring them into line, Lester allowed the Beatles to bring in Dougie Millings to create garments for them and to perform a cameo role as their real-life put-upon tailor. When not getting his measuring tape cut in half by a scissors-wielding John Lennon, Millings made whole suits out of the same dark fabric in addition to mix-and-match separates like single-breasted jackets with flared single-button sleeves (his signature) and tapered trousers so narrow his son Gordon later wondered how the Beatles

ever managed to get into them. The broken-up suits augmented the visual contrast effect Millings had been going for when designing the Beatles' wardrobe for *A Hard Day's Night*. Aware that the film would be seen in black and white, Millings cut the clothes from dark quality fabrics with a visible weave—herringbone and pin-dot Birdseye for instance—to make their plain gray and charcoal colors look textured when viewed on screen. The performing suits seen in the live concert scenes were made from a fine wool and mohair fabric that Millings sourced from venerable British cloth maker Holland & Sherry. The sharkskin suits resembled what the Beatles had worn on *The Ed Sullivan Show*, a light-reflecting single-breasted jacket with four mother-of-pearl buttons, black velvet collar, and blue satin lining. The flat-front trousers with a zipper and eye-and-hook closure had no pockets to ensure a clean line. Other details such as back pleats in place of double vents at the backs of the jackets—a menswear innovation—were made apparent by Lester's roving handheld camera work, which allowed for rare in-the-round views of the Beatles' stage clothes and how well they wore them. The Beatles looked deliciously attractive in their close-cut suits and their sex appeal was an overt element of the film's visual style. That their image inflamed young passions is clear from the footage of screaming adolescents of both genders calling out their favorite Beatle's name from their seats in London's Scala Theatre where the live concert scenes were filmed.

An undercurrent of lasciviousness ran through the movie as a whole, rendered with winks and nudges. The Beatles were objects of desire, but their own desires were on display as well. They picked up showgirls and ogled bosoms and legs. There were also funny scenes of seduction and temptation with the Beatles as both pursuer and pursued. When Ringo runs away from the group and is out alone on the streets during his "deserter" sequence of scenes, he is chased by girls who instantly recognize him. He slips into a rag-and-bone shop where he finds an old flat cap and dirty, formless overcoat, fashioning a disguise. Back out on the street, he walks past a young woman in a buttoned-up blouse and modish leather jacket and is ignored.[44] Amazed, Ringo runs back to flirt with her and is delighted when she fails to recognize him and shoos him away. He has gained anonymity with his musty old clothes and a temporary respite from the Beatles' fawning fandom.

The scene is played for laughs, but it is also a statement on the obvious importance of appearance to the Beatles' fame and success. Without

the signature Beatles' haircut and slim silhouette, Ringo goes unnoticed and, in this context, it's not necessarily a bad thing. Yet the real Ringo was hesitant for the movie Ringo to wear second-hand clothes. "What are you trying to do, spoil my image, or change my image?" Julie Harris recalled him saying. But the scene, along with the coat, "was wonderful," she said, "because it was well away from Beatleism."[45]

Lester has recounted how the first day's shooting, which had gone terrifically well, was almost entirely destroyed by an incident of real-life Beatlemania. "At the end of that first day, after we'd been down to the West Country on the train and then returned to Paddington, we lost half of our work because fans thought the young lad carrying all the undeveloped film was a Beatle," Lester later said. "He had a Beatle haircut, so they chased after him, he panicked, dropped some of the tins, and because it was negative stock the light got in and ruined it . . . it got better after that."[46]

A Hard Day's Night does a splendid job of capturing the whole of the Beatles' identity. It gets the clothes they wore and the way they styled their hair but also how both those things, combined with the Beatles' razor-sharp wit, distinctive personalities, and working-class populism delivered with a languid Northern accent, created a mystique fascinating to kids and adults alike.

When *A Hard Day's Night* hit cinemas in early July, audiences on both sides of the Atlantic raved about the Beatles' irrepressible wit and boundary-breaking style. Critics, now completely besotted by the group, made comparisons to the Marx Brothers, Charlie Chaplin, and Orson Welles, highlighting the Beatles' theatrical genius and potent charisma Andrew Sarris, writing in New York's *Village Voice*, called the Beatles' film "the *Citizen Kane* of jukebox musicals," admiring how it beautifully "established the emotional unity of the performers and their audience."[47] He was right. The feeling of connectedness, or identity, the group inspired was manifest in music and appearances that young viewers especially valued. In their eyes, the Beatles loomed as giants of cool. To quote from *A Hard Day's Night*, they were an early sign of the new direction. "I had a short haircut. I was dressed kind of 'fraternity-boy' style," the late film critic Roger Ebert has recounted, "and I came out with my idea about how to carry and express myself really influenced. I started to let my hair grow. While I was watching that movie, my hair started to grow."[48]

An early clue to the new direction? George embodied the answer. (Alamy Stock Photo)

Musician Roger McGuinn has recounted how in 1964, when he first saw *A Hard Day's Night* with friend and bandmate David Crosby, he fixated on elements of Beatles style as something to know and emulate. Going to see the movie was a reconnaissance mission, a way to study the Beatles as the embodiment of modern rock-and-roll. "We checked out the clothes, we got the clothes," McGuinn said, underscoring the impact of the Beatles on the Byrds.[49]

These comments convey a simple truth. The Beatles triggered a sea change in contemporary culture, how people viewed themselves, and how they wanted to be seen. A two-month world tour commenced in June followed by a return visit to the North American continent in August and September. By the end, the Beatles were firmly established as the supreme trendsetters of their era. They had come, they had conquered. But they weren't done just yet.

Before the year was through, the Beatles would release their fourth album, the cheekily named *Beatles for Sale*. Released on December 4, just in time for Christmas, it featured another eight new Lennon and McCartney compositions, many of them country-and-western and Bob Dylan influenced, a nod to their recent overseas experience.

British photographer Robert Freeman, who had traveled with them on their US tour, met up with the Beatles late that fall in London's Hyde Park by the Albert Memorial to shoot the album cover. In the spirit of *A Hard Day's Night*, whose poster and cover he had photographed, Freeman asked them to show up as they were, with no fuss or muss. They were now so tight and so in sync with each other that they showed up dressed the same without intending to. "We'd all go to the same shop," Ringo said. "I'd get the shirt in blue, and someone would get it in pink, and someone would get it in button-down. If you look at all the photos, we are all dressed in the same style because that's how it happened."[50]

On this day, they all appeared wearing black coats and scarves (black was their favorite color, as John said), and the dark hue united them as they huddled amid the autumnal leaves. Their hair was longer and fuller than it had been at the beginning of the year. It fell over eyes that now showed signs of fatigue. It blew in the breeze, making them look like what the French called them—*les quatres garçons dans le vent*. The foursome riding the winds of change.

1965
KINGS OF CORDUROY

"After all we did for Great Britain, selling all that corduroy and making it swing, they gave us that bloody old leather medal with a wooden string through it."
— GEORGE HARRISON

Cord boots and shoes emerged as a
fashion statement for men as soon as
Help! debuted in cinemas in the summer
of '65. (Alamy Stock Photo)

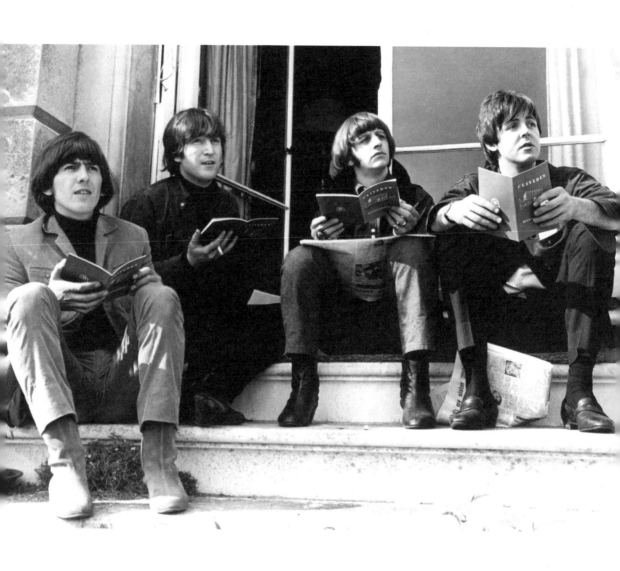

The British Invasion unleashed by the Beatles in America paved the way for designers like Mary Quant (left) to sell their youth style fashions overseas. (Alamy Stock Photo)

In 1965, the Beatles realized the extent of their influence when Britain's prime minister, Harold Wilson, nominated them for the MBE, an honor usually reserved for war heroes, industrialists, and aristocrats. The Labour Party leader represented the Liverpool suburb of Huyton at Parliament and so had a vested interest in promoting the band that had succeeded in turning their industrial city into an unexpected capital of cool.[1] Since coming to office, Wilson had made a habit of muscling his way into photo ops with the Beatles to advance his reputation as a politician with a populist touch. "I saw the Beatles as having a transforming effect on the minds of youth, mostly for the good," he later said, explaining why he thought they deserved national recognition and why he should share in their glory.[2]

Wilson was not the only political leader who understood the Beatles to have an influence greater than their chart-topping music alone. His rival on the right, Edward Heath, had seen the wider cultural and economic importance of the Beatles' phenomenon. As president of the Board of Trade in 1963, he declared the Beatles "to be the saviours of the corduroy industry" upon seeing sales of the fabric spike in Britain after the group was widely photographed wearing the fabric in public.[3] It wasn't a gimmick.

The Beatles loved corduroy clothing, announced John in the premiere issue of the *Beatles Book Monthly*.[4] Other fan magazines reported on John's corduroy coat and peaked fisherman's cap and Paul's dark corduroy jacket during the Beatles' black-with-everything Cavern period. There were collarless jackets, car coats, and trousers, as well, all done in Left Bank black corduroy. It quickly caught on. "It was the first time in Britain anyone had the black polo-neck, black corduroy, existentialist look," said Celia Mortimer, then a seventeen-year-old student at the Liverpool College of Art. "I instantly took their lead and started to make hip black corduroy things to wear."[5]

Known as the poor man's velvet for the soft hand feel of its sheared surface nap and underlying weave, corduroy was shunned by the upper classes until designers in the mid-twentieth century transformed the fabric into an item of revolutionary chic in menswear. Pierre Cardin had seen stylish young Frenchmen adopt workers' garb to convey a proletarian manliness, pairing the corduroy with military surplus duffle coats and dockers' caps. For Cardin, corduroy evoked a "street-level existentialism,"[6] which he wanted to embody in his radical menswear. He turned to corduroy for his original cylinder suit of 1960.

It took the Beatles, however, to transform the pedestrian fabric into something truly fashionable and desirable. As their fans copied their look, corduroy sales rose, reviving Britain's textiles industry and boosting the national economy. Following their first tour of America in 1964, the Beatles, through records sales and earnings, had added an astronomical £800 million to Britain's balance of trade, greatly offsetting losses. "The Beatles are now my secret weapon," declared Wilson's predecessor, Sir Alec Douglas-Home. "If any country is in deficit with us, I only have to say the Beatles are coming."[7]

For the investiture ceremony at Buckingham Palace on October 26, 1965, the Beatles shelved the corduroy and donned similar but not identical navy-blue serge wool lounge suits custom-made for the occasion by Dougie Millings. The four-button, double-breasted jackets had notched lapels for an air of jaunty refinement. The Beatles wore suits with white button-down shirts and thin, straight dark ties known as "slim jims," an elegant interpretation of Mod dress. There were noticeable variations on this theme. Ringo's jacket, for instance, had buttons decorating the curve of the cut while George's featured ornamental epaulets and a jetted pocket, the latter detail usually seen only on tuxedos. A member of the rock press asked George why he wore "the blue serge suit with shoulder tabs" to Buckingham Palace, to which he replied, "It was the only one that was pressed."[8]

The Beatles dressed smartly for the occasion because they wanted to relish the honor, but they were still rakish enough to rankle those members of the British establishment who regarded them, with their long hair and tight-fitting trousers, as symptoms of a growing degeneracy in society. It was inevitable that their vigorous challenge to the norms of middle-class respectability and masculinity would provoke a vitriolic response. Some war heroes returned their medals to the Queen in protest of the Beatles' investiture.

Not everyone was outraged. The Beatles had supporters across all segments of society. "They have helped to correct the foreign vision of Britain as a country entirely populated by middle-aged conservatives of all sorts, e.g. stockbrokers, wildcat strikers, Beefeaters and Pembrokeshire coracle fisherman," wrote Charles de Houghton, a descendent of an ancient British family, in a letter to *The Times*.[9]

"Their efforts abroad to keep the Union Jack fluttering proudly have been far more successful than a regiment of statesmen and diplomats," said

Pop stars were now the fashion; the whole scene was a-changin.' (Bridgeman)

the *NME*'s Andy Gray. "We may be regarded as a second-class power in politics, but at any rate we now lead the world in pop music!"[10]

As the new conquerors of America, the Beatles spearheaded a so-called British invasion that in 1965 included the Rolling Stones, the Animals, Donovan, the Kinks, Herman's Hermits, the Dave Clark Five, Petula Clark, Tom Jones, and the Who, all of them flying high with top-selling singles on the US charts that year. It had never happened before. "When they went to America, they made it wide open for us," Keith Richards said. "We could never have gone there without them."[11] The Brits had so radically redrawn the pop culture landscape that many American recording artists and local acts felt shut out of their home markets.

The onslaught from overseas was multifold. Along with the music, English fashion also crossed the Atlantic, capturing the imagination of the US consumer. Strongly influenced by the strong clean lines of the *moda italiana,* the new clothes coming out of London were fun, individualistic, and humorous, linked to record buying and collecting Lambrettas. British designers who had successfully Anglicized the Italianate style grew in influence after the Beatles began wearing British-made clothes

on the world stage. All eyes were on them, absorbing the cut, color, and cachet of their hip English fashions. Their clothes, as much as their music, became synonymous with the era's youth-oriented sensibility. "The British Look disseminated greatly with the Beatles," says Andrew Loog-Oldham. "There was a pop biz before they came on the scene—Quant, Sassoon, Terry Donovan—but until the Beatles, few outside the U.K. knew much about it. They opened the gates."[12]

The Beatles and their modular London clothes were "IT," declared Diana Vreeland, the legendary editor-in-chief of *Vogue* who, in 1965, coined the word "youthquake" to highlight the inspirational force of the young on all aspects of culture, but music and fashion especially. The old couture houses of Paris no longer dictated the course of fashion, said Vreeland, who reinvigorated her august publication with spreads featuring the British "look" and the key players then making it famous, the Beatles chief among them. What was fashionable increasingly came from the pop charts and the street, from the young people whose increased spending power and openness to the influence of mass media on their lifestyle purchases set trends. The kids changed everything, said Nik Cohn: "a whole new style made possible."[13] The growth of pop culture and the booming youth market added up to $25 billion in annual sales to the American economy, according to *Newsweek* in 1965.[14]

The French called the synergistic interplay between pop and fashion *yé-yé*, a Gallicized version of the Beatles' "Yeah, Yeah, Yeah!," foregrounding the group as catalysts of the upheaval. *Yé-yé* was predominantly a sensually fashionable mode of female dress popularized by France's girl groups and singers, among them Sylvie Vartan, the kittenish blonde with whom the Beatles had performed when they played the Olympia in Paris. Characterized by body-conscious dresses and eye-skimming hair styles, *yé-yé* style also caught the attention of young American women who wanted the foreign counterculture style for themselves.[15]

Another way in which the influence of the Beatles on the fashions of the day spread to womenswear was through female fans who read everything they could about them and homed in on the band members' girlfriends and wives as a way of discerning what kind of women they liked. Paul's flame Jane Asher wore Mary Quant, as did George's Pattie Boyd. "What I really liked about Mary's clothes," Pattie said, "that not only were they short and adorable, but the colours were spectacular."[16]

This kind of attention paid dividends for London designers like Quant, whose Chelsea boutique the Beatles and their women patronized. The London-born designer had been in business nearly a decade before the Beatles burst onto the scene, selling short, swingy, affordable clothes to leggy young women in Chelsea. But it was the success of the Beatles, as roving ambassadors of British fashion that helped spread her fame. Quant became her own revolutionary force, "the Beatles of the fashion industry."[17] She is credited with popularizing miniskirts along with hotpants and other youth style innovations. Quant stormed America along with British pop bands. J.C. Penney, then the biggest department store chain in the United States, approached her in 1963 to design a ready-to-wear line of short, colorful dresses that would give its stores an up-to-date image. Quant's quarterly capsule collections for J.C. Penney repeatedly sold out, prompting the US retailer to seek out more British design talent with whom to partner. There was a large pool to pull from. Among those chosen were Marion Foale and Sally Tuffin whose namesake Foale and Tuffin label, launched in 1961, helped satisfy the increasing American demand for modernist London fashion.

The designers who followed Quant's path were recent graduates of Britain's art colleges where fashion courses had been taught since the 1950s. The colleges replaced the vocational aspect of the trade schools with an art-and-design curriculum that fostered creativity, a hallmark of British 1960s fashion.[18] Since few coming out of the art schools had been apprenticed to the fashion trade, their designs were not rule-bound or tied to tradition. They had the advantage of familiarity with new synthetic fibres such as polyester and spandex, which had more stretch and better shape memory than cotton and wool and answered the growing demand for a more body-conscious silhouette. They could also let their imaginations run wild with color thanks to new screen printing and blocking technologies that allowed for quick and economical applications of patters and dyes.

Foale and Tuffin, students of Janey Ironside, the Royal College of Arts' influential professor of fashion, opened their first boutique near Carnaby Street in 1965. They sold simple dresses sporting classical lines and no gimmicks. Fellow graduate Ossie Clark, another of Ironside's gifted protégés, went in the opposite direction, specializing in richly patterned diaphanous gowns influenced by Hollywood glamor. Moya Bowler, another RCA alum, used embroidered materials and lizard for her shoes. She sold her wares at London's more avant-garde boutiques in addition to her own Chelsea

shop, M.B. Shoes Limited, which opened in early 1965. Bowler had originally studied dress design but switched to shoes when the London fashion scene grew crowded.[19] It ended up being the right move. Within a few years, Bowler counted Paul McCartney among her many customers.

This new wave of designers shared an affinity with the day's pop stars, many of whom also came out of the art schools: Keith Richards, Charlie Watts and Ronnie Wood of the Stones, Pete Townshend of The Who, Eric Clapton of Cream, and Ray Davies of the Kinks, to name a few. John Lennon was part of this arty fraternity. Quant said that he bought a black leather cap at Bazaar,[20] similar to the one seen on the cover of *In His Own Write*.

Barbara Hulanicki, educated at the Brighton School of Art, was another designer of note with ties to the Beatles. In 1964, she and her husband Steven Fitz-Simon opened the Biba fashion boutique in London's Kensington district, with a Beatles record blasting out into the street. The music drew in young women who eagerly bought out the entire Art Nouveau-inspired store within two hours. Pattie Boyd shopped there, and Paul McCartney later engaged Biba's store designers—Steven Thomas and partner Tim Whitmore—to furnish his corporate office in the 1970s. Hulancki's offerings eventually included menswear and children's clothing, the latter designed as miniature replicas of their parents' velvet threads. Biba's Postal Boutique delivered total wardrobes through the mail to customers across the UK, delivering the London Look to the wider populace. It was a form of fashion democratization the Beatles would seek to emulate when they opened their own fashion boutique later in the decade.

The Look was disseminated further by British TV shows like "The Avengers," a hit spy series broadcast in ninety countries. Designer John Bates made low-slung hipsters along with black-and-white geometrically patterned mod outfits for Emma Peel, the lead female character played by Diana Rigg in 1965. Sexy, sleek, and revealing, the clothing was custom-made for a female empowerment figure—a martial arts expert and science whiz—who knocked them dead. Bates's epoch-defining fashions became hugely popular once he licensed his designs to several manufacturers under the Avengerswear label.

Bates had his own London shop where he often sold his wares under the Frenchified name of Jean Varon. Beatles friend Cilla Black was married in one of his designs. Dusty Springfield, Cleo Laine, and the fashion model Verushka were other high-profile customers. British *Vogue's* Marit Allen

was an early champion, crediting Bates, not Quant, with having invented the micro-mini, an example of which, made of white gabardine and silver PVC, she wore on her wedding day. His designs adorned the pages of numerous other fashion magazines, including those in America, making his midriff-baring modish fashions ubiquitous and symbolic of the London Look as a whole. The reception given to him and other British designers in lucrative foreign markets instilled a sense of nationalistic pride in their accomplishments. Britain was dowdy no more.

"Britain's capital has been given a completely new image at home and abroad," pronounced London journalist Jonathan Aitkin, a keen observer and chronicler of the emerging London scene, "and the fact that the clothes worn by young Londoners have made such an immensely successful impact all around the world, has given the wearers, as well as the creators, a certain kind of patriotism, an international pride in clothes and in the spirit that the clothes have helped to create."[21] It is remarkable that the change was spawned in Britain's art colleges, at one time thought to be the refuge of the academically challenged. Their young graduates brought great and unexpected honor to their country and in the process silenced its critics.

Taking advantage of the new momentum, the Society of London Fashion Designers, with the support of the Board of Trade, hired the RMS *Queen Elizabeth*, a luxury ocean liner operated by Cunard, to present four spring fashion shows to North American buyers while sailing to New York in 1965. The event generated several millions of dollars in sales and garnered coverage in newspapers and on television.[22] British fashion had gone on tour, just like the country's pop musicians. The media blitz helped to double British fashion sales in 1965 to the tune of £50 million.[23] The British ambassador to Washington, Sir Patrick Dean, got in on the sales drive, taking British fashion, together with electronics and aircraft engines, across America as part of a 1965 consulate-sponsored road show of trade fairs intended to boost Britain's commercial interests in the United States.[24]

Fashion Group House of London, founded in 1954 to promote British designers internationally through London Fashion Week, had rarely witnessed such widespread enthusiasm for its product. By the year's end, the New York boutique Paraphernalia, a new collaboration between Puritan's Carl Rosen and J.C. Penney buyer Paul Young, was stocking Quant as well as Foale and Tuffin, selling the latest British fashions to young Americans as part of the company's "Youthquake" division.[25]

Striking out on his own, Gerald McCann, another RCA graduate who early in his career designed for Topshop, manufactured in the United States under his own label. His impeccably tailored womenswear was so successful that he was named a top ten American designer despite his British nationality. "We had the music didn't we, so that set the stage and then we gave it form," McCann later said. "We produced the clothes that epitomized the 'look.'"[26]

By spring 1965, *Newsweek* was reporting giddily on "America's current love affair with people and things British."[27] London, the magazine said, had emerged "as a new world tastemaker in pop culture. The once-stodgy city seems to possess the most dolly girls, the most gear combos, and the most switched-on singers, artists, actors, designers, models and photographers. No matter that the blue-jean dress and rhythm-and-blues music was originally exported from America. England has taken them over, added a fresh dimension, and shipped them back."[28]

That fresh dimension was Mod, a style Americans liked even if they didn't quite understand it. Publications such as *GQ* and *The New York Times* attempted to explain the imported look in sociological terms. "The Englishmen who care most about clothes and spend more of their time and money acquiring them are not aristocrats in Savile Row suits but youngsters from the working class," read one. "The British public became aware of them when the Beatles were first popular."[29] The claim made good copy but wasn't quite true.

Mod, as most Britons knew, had predated the Beatles. And while the group came to epitomize Mod by wearing the style in the years coinciding with their initial conquest of America, the Beatles were not defined by Mod. They belonged to no fashion tribe but their own. They liked Mod style and in 1965 were often photographed wearing it. Ringo wore Mod clothing, for instance, when he married his eighteen-year-old girlfriend, Maureen Cox, an early Beatles fan from the Cavern Club days, on February 11, 1965. Standing next to his pregnant bride (son Zak Starkey would be born eight months later, on September 13), Ringo wore a sky-blue suit with a boxy jacket, high-waist belted trousers, and a navy-and-white penny dot shirt, a quintessentially Mod look. On his hands were the many rings that gave him his nickname and inspired *Help!*, the Beatles' next film.

Director Richard Lester conceived *Help!* as a zany spoof on the James Bond franchise of sexy thrillers, complete with bad guys with funny

accents and mad scientists with lasers not unlike those in the recently released *Goldfinger*. Ringo's large rings formed the basis of the madcap plot, hatched by scriptwriters Marc Behm and Charles Wood, in which members of an Eastern religious cult, devotees of the blood-thirsty goddess Kaili, select the Beatles' drummer for human sacrifice after discovering he is wearing the sacred ruby ring—a gift from a fan— required of all their victims. The rest of the story involves the other three Beatles figuring out how to extract the deadly piece of jewelry from Ringo's hand to safeguard the band. The film is a comedy but its storyline, involving acts of violence against the Beatles, uncannily portends the dark side of the Beatlemania phenomenon. Extreme fandom can turn into a destructive force, as the fan attacks on John and George in later years would tragically demonstrate.

Shooting commenced just two weeks following Ringo's nuptials and continued, at various locations, throughout the winter and into spring. Some of the locales were foreign, including Bahamian beaches and the Austrian Alps. But the overall look was British. Swinging London, to be precise. As the Beatles romp in Obertauern's snow, Ringo is wearing a buzzy checkerboard print, George a polo neck sweater with a boxy pin-stripe jacket, John a houndstooth newsboy cap, and Paul a zip-front fur bomber. Costume designer Julie Harris, fresh from winning an Oscar for the Chelsea Set clothes Julie Christie wore in John Schlesinger's 1965 film *Darling,* shopped the new London boutiques for many of the Mod outfits the Beatles wore on set. Lester had been "very specific" about the kinds of Mod looks he wanted for the Beatles, Harris later said. He took her around Carnaby Street in a hired car to hunt down the latest in patterned shirts along with Nehru collar tunics and kaftans.[30] By 1965, London had several small "ethnic" shops selling clothes made from imported Indian silk textiles – Rajah tunics over churidar pants, evening dresses made from saris and bead-encrusted bags. There was also a beautiful people fashion for wearing Ottoman empire kaftans – the real antique thing bought in Turkey or the continuation of it still made in Morocco. Lester was clearly attuned to the trends. In *Help!* he stylistically fused East and West, an early form of what might now be called culture jamming.

The store-bought looks also included denim. The Beatles wore jeans, chambray shirts, espadrilles, and a skin-tight black T (on a buff-looking Paul) in many of their scenes shot in the Bahamas. The mix of English,

American and other imported fashion styles highlighted the band's prodigious eclecticism and shape-shifting proclivities. No one look could define them. They were proud Brits who actively supported their nation's fashion industry. But as the leaders of the 1960s British Invasion, they also venerated what they discovered, and rediscovered, on foreign soil.

The Beatles had taken America and had also taken back with them to England some of that country's clothes and musical influences. When in Dallas for the first time the year before, they had sent Neil Aspinall to the local Neiman Marcus department store to buy them cowboy hats, shirts, and boots to wear at home, even as British-made Mod was still the fashion.[31] This shouldn't be surprising. Growing up in Liverpool, the Beatles gorged on American music and street fashion. American cultural products had inspired them as much as anything in Europe and Britain. By wearing jeans and T-shirts in a film ostensibly meant to showcase the Beatles as the embodiment of the London Look, the Beatles paid visual homage to the impact people like Gene Vincent, Marlon Brando, Tony Curtis, Bill Hayley, Elvis Presley, and all those cowboys in the Hollywood Westerns of their youth, had on their mode of dress.[32]

To ensure what they wore was never imitative but unique to themselves, the Beatles often customized their store-bought garments with their own hands. George modified his jeans, lightening them with bleach, long before acid-wash denim became a global trend in the 1980s. He was taking his cue from 1960s California surfer culture, going for a lived-in faded look but ending up with a patchy blue color when he erroneously poured the bleach on the denim instead of diluting it first in a tub of hot water. Still, the blunder resulted in a fashion novelty that furthered the Beatles' status as innovators. George took a workaday item of clothing beyond the ordinary and made it his own. Others noticed. At the time of *Help!*'s US release, a keen-eyed radio interviewer asked George to explain how he produced the mottled patterns on the jeans seen in the film's Bahamas sequences. George happily detailed the process and, warming to the topic of how he personalized his clothes, offered additional information to fans interested in how to dress like a Beatle. "I always buy jeans two sizes too small," he said. "And I chop the top off the part where you put the belt, so that the top ends at the top of the zip, so the loops on lower, and then you've got hipsters . . . okay kids? There ya' go!"[33]

What a Beatle wore today others would be wearing tomorrow. (Alamy Stock Photo)

Other looks were made-to-measure by Millings expressly for the film. They included the many dark single-breasted jackets in which Ringo was doused with buckets of red paint in preparation for sacrifice. There were camp versions of military-inspired clothes that the Beatles wore for their scenes on the Salisbury Plains, near Stonehenge. These custom-made corduroy suits came with a key innovation: matching boots. George's are sage-green, the same color as his tunic jacket with stand-up Nehru collar. Gordon Millings said his father had the boots made by a cobbler on Clapham Road where he went himself to hand-deliver a swatch of the corduroy fabric he had used to make George's outfit. Fans took notice of the footwear, crediting George with having thought of it first. "The boys are wearing all sorts of fantastic clothes for their film and they introduce a very new, unusual gimmick," it was reported in the June 1965 issue of *The Beatles Book Monthly*. "If they're wearing corduroy for example, then they have corduroy boots to match. If they're seen in velveteen suits, then they're coupled with velveteen boots. George first thought of the idea two years ago, but when he put the idea to a local bootmaker, he told him it couldn't be done. Well, that's one cobbler that's been proved wrong."[34]

Cord boots and shoes emerged as a fashion look for men almost as soon as *Help!* debuted in cinemas, in Britain on July 29 and across North America on August 16. Fashionable rockers like Steve Marriott of The Small Faces and Pete Townshend of The Who were soon seen in the streets of London wearing cord boots with their tight-fitting Carnaby Street suits. The handmade footwear, softer than leather, afforded comfort when dancing in clubs and jumping around on stage. It made young men who dressed like the Beatles feel "with it" and freed them from convention. "I don't know what it is," *Help!* producer Walter Shenson told *The New York Times*, "but somehow they're on the same wave length with the young people. Their anti-establishment, anti-authority style seems to work magic."[35]

The "good, clean insanity" of *Help!*, as film critic Bosley Crowther put it,[36] was made to order. To protect the band's image, Epstein reportedly instructed Lester to avoid anything that could be construed as realism. The truth was grittier. In 1965, a typical day in the life of the adorable Mop Tops consisted of groupies and illicit weed, all in huge quantities. "We were smoking marijuana for breakfast during that period," said John. "Nobody could communicate with us. It was all glazed eyes and giggling all the time. In our own world."[37]

In *Help!*, where the Beatles mixed British and American clothing styles, denim had not yet become an ubiquitously worn fabric and was perceived as something of a novelty. George bleached his, prefiguring the acid wash jeans trend which proliferates to this day. (Bridgeman)

The growing tension between their public and private selves led John to start wearing his street clothes in scenes calling for him to dress in costume like the other Beatles, messing up the film's continuity and requiring Lester to re-shoot entire sequences. One garment stood out, a dove gray and mauve striped jacket with narrow lapels, a store-bought garment of the kind John Stephen sold at his Carnaby Street boutiques. John can be seen wearing it in photographs dating to the Beatles' 1964 tour of America. He loved the jacket and wore it often until Florida resident Mark Vidalis, an eighteen-year-old extra on *Help!*, stole it as a souvenir.

Vidalis believed a superstar like John, with his closets full of the latest fashions, would never notice it missing. He underestimated how attached a Beatle could be to his clothes. Vidalis returned the beloved garment after seeing a distraught Lennon turning the Beatles' quarters upside down in search of it.[38] Once he got the cotton blazer back, John rarely took it off. He wore it for the photo on the back cover of *Help!*, released as an album on August 6, and at various press conferences later that year.

Another personal item of clothing John wore while making *Help!* was a brown suede Wrangler-style jacket he had purchased from Cecil Gee. British clothing retailer Lloyd Johnson heard the story from a store salesman that John had seen the jacket in the display window and had returned a couple of weeks later to buy it. But the window-soiled jacket had been banished to the stockroom. The salesman explained that the jacket had been pulled from the sale. "To cut a long story short," Johnson said, "John ended up buying the jacket and the jacket appeared on the *Rubber Soul* LP cover."[39]

Why would a famous Beatle so badly want a dirty, faded suede jacket when he could have bought any jacket in the land? Possibly because it bore a striking resemblance to Bob Dylan's signature four-button chore coat seen on the cover of his 1963 breakout album, *The Freewheelin' Bob Dylan*. The Beatles all loved that album and listened to it incessantly after a French deejay had given them a copy in Paris the year before. They allowed Dylan's edgy influence to permeate their music and look.

To the Beatles, Dylan spoke the truth, not caring if his bluntness alienated fans, a no holds barred stance John envied and later emulated. Dylan's "message music," heard in songs like "Blowin in the Wind," "A Hard Rain's A-Gonna Fall," and "I Shall Be Free," kindled in John a desire to become more realistic in his own songwriting.

As early as 1964, his lyrics were starting to become weightier and more introspective, with songs like "I'm a Loser" and "You've Got to Hide Your Love Away" echoing some of Dylan's own self-conscious despair. The American musician's influence persisted in the making of *Rubber Soul*, released in December 1965. It featured John's Dylanesque composition "Norwegian Wood," a poetic narrative about an affair. "That's me in my Dylan period again," John later said. "I am like a chameleon, influenced by whatever is going on."[40] Paul, too, took inspiration from Dylan. His soulful ballad "Yesterday," whose melody came to him in a dream, was one example of a new interiorized approach to creating hits. "We'd had our cute period," said Paul, "now it was time to expand."[41]

Dylan would eventually record his own version of Paul's classic. He admired the Beatles as much as they did him and craved their popularity.[42] In 1965, Dylan grew his hair like the Beatles and started playing electric guitar, for which he was famously booed at the Newport Folk Festival. Traveling frequently to Britain, Dylan immersed himself in the London scene and picked up new musical ideas along with clothes, including black high-heel Beatle boots and British-made corduroy trousers.[43]

The Beatles immensely profited from all this cross-fertilization. In 1965, they grew as artists, moving away from the comic book antics of *Help!* at the beginning of the year to the liberated sounds and exploratory lyrics of *Rubber Soul*, the Beatles-in-transition album. Robert Freeman's distorted cover photo, showing all the Beatles in differently styled suede jackets, mirrored what the photographer said was "the changing shape of their lives."[44] They were accelerating away from beat music to embrace folk-rock, then rising in America, and new (to them, anyway) instruments like the sitar and gadgets like the fuzz box and guitar capos. Their willingness to experiment and explore new ideas, to not repeat themselves, extended to their appearance, which had become looser, shaggier, and more eclectic than just the year before. They were advancing into a new creative territory and gaining even greater credibility as "the fabulous 'with it' ambassadors of Britain to the youth of the world today," as *Rave* magazine described them.[45]

In the eyes of the world, Britain, largely because of the Beatles, now seemed the most modern nation on earth. Acclaimed fashion photographer Richard Avedon captured the mood while guest editing an issue for *Harper's Bazaar* that year. His dynamic spreads featured Paul McCartney

in an astronaut's flight suit and Ringo as an ancient Roman emperor with a laurel wreath crowning his Beatle head. The message was unequivocal: the Beatles, and the London fashion scene they represented, were cosmic, regal, and out of this world.

Indeed, thanks to their gold records, films, and record-breaking world tours, the Beatles now existed on another planet of extraordinary prestige and wealth. They were the world's biggest box office draw. Just a year earlier, Ed Sullivan had paid them $10,000 for all three appearances on his show. In August 1965, they earned $160,000 for just one thirty-minute set before 55,000 people at Shea Stadium. It was a record payout and the biggest audience for a pop show in the United States. The Beatles struck it rich again when Northern Songs, their publishing company, went public on February 5. By the end of April, the company had made a profit of $1.7 million from royalties and sheet music sales, "nearly $200,000 above earlier predictions," and the stock had risen considerably.[46] The Beatles had the golden touch. They were the wealthiest pop stars in the land.

What did they do with their earnings? In 1965, they purchased fast automobiles: an enormous all-black Rolls Royce Phantom V for John; Aston Martin DB5s (the James Bond car) for Paul and George; a red Facel Vega sports car, reputed to be the speediest in the world, for Ringo. John also spent money on jewelry, dropping £600 at Asprey, the venerable British jeweler on New Bond Street, during the brief time the Beatles shot a mad-dash scene there for *Help!*[47] The Beatles were now luxuriating in a playboy lifestyle few outside their circle could afford but it didn't affect their popularity: what they bought and wore became aspirational, serving as a source of aesthetic pleasure and an expression of personal magnificence.[48]

An interesting cross-continental Beatles dynamic was at play as 1965 came to a close. The band and its London Look had emerged as the standard for youthful dressing in the United States, promulgated by marketing ploys such as *The Beatles,* an animated TV series first broadcast on the ABC network. The Saturday morning cartoon launched on September 25 with "Can't Buy Me Love" as the opening theme. Series creator Al Brodax, together with producer George Dunning and animator Ron Campbell (the same team that would later make *Yellow Submarine*), presented the group in circa 1963 modish collarless suits, polo neck sweaters, Beatle boots, and pudding bowl haircuts. As a result, the Beatles were visually frozen in the

Beatlemania era that had helped make Mod popular in North America just as the style began to lose currency in England.

Meanwhile, in the motherland, the Beatles returned from their summer 1965 North American tour with fresh musical styles, ideas, and clothing, including sunglasses with tinted lenses and Wells Fargo deputy badges affixed to made-to-measure militaresque jackets with stand-up Nehru collars. Their new cross-cultural look, disseminated across England on the Beatles' 1965 UK tour, their last, gradually displaced Mod from the center of British fashion. The band was leaning more bohemian and eccentric, as exemplified by Paul's floral tie, purchased from London luxury department store Harrods and worn that year with a dark button-down collar shirt at a Beatles press conference. They were inching towards psychedelia. Their late 1965 single, "We Can Work It Out" was issued as a double A side with "Day Tripper" and its intentional drug reference.

By the end of 1965, corduroy no longer defined the Beatles' look. New textures, prints, and patterns loomed on the horizon and by incorporating them into their evolving esthetic, the Beatles, harbingers of a new psychedelic era, would once again be trendsetters.

1966
FROM MOD TO ODD

"It wasn't like we were following a trend;
we were in the trend."
— PAUL MCCARTNEY

The Beatles were the trend. They made it hip for men in creative industries to flaunt a love of eccentric clothes; they connected the dots. (Alamy Stock Photo)

George Harrison and Pattie Boyd both wore custom-made Mary Quant fur coats on their wedding day. (Alamy Stock Photo)

When George married the very pretty London fashion model Pattie Boyd on the morning of January 21, 1966, nearly two years after first meeting her on the set of *A Hard Day's Night*, he spent lavishly on custom-made wedding clothes from King's Road, fulfilling all expectations of a hipster of means.

At her new husband's insistence, the bride, frequently seen in *Vogue*, did not wear white to her wedding at the Epsom Registry Office in Surrey. George wanted her to wear the latest London fashion. "I bought a Mary Quant pinky-red shot-silk dress, which came to just above the knee," wrote Pattie in her memoirs, "and wore it with creamy stockings and pointy red shoes."[1]

As part of her winter wedding ensemble, Pattie also wore a Mary Quant red fox fur coat that George had purchased for her as a wedding-day gift. The style-conscious Beatle liked it so much, he asked Quant to design a fur coat for him, as well, made from curly black Mongolian lamb, cut above the knee. Gorgeous George did look gorgeous in it and was most pleased. He loved that puffball of a fur coat. It became a favorite garment. He would wear it through the remainder of the decade and at significant Beatles events including the making of the *Strawberry Fields* and *Get Back* films, both of which were shot outdoors in the cold. Whenever the temperature dropped, he was in his sheepskin.

Soon after the nuptials, George and his young wife left chilly England for Barbados, where they could honeymoon undisturbed. Brian Epstein knew where they were and allowed photographer Harry Benson access on one particularly balmy afternoon. Benson captured the happening young couple canoodling on the beach. Pattie had on a bra top and capris, and George a red cap and short-sleeved crocheted T-shirt that, as one writer observed, "exemplified the new feminine influence in men's fashion being pioneered by the boutiques of London's Carnaby Street."[2]

As much as George knew fashion, or thought he did, his new wife knew it better. Pattie traveled in stylish circles and developed close relationships with some of Britain's leading fashion players. After becoming enmeshed in the Beatles' close-knit world, she brokered introductions between the group and some of the emerging designers and boutique owners then taking British fashion in fresh directions. At the vanguard was up-and-coming English designer Ossie Clark, whose bias-cut dresses and see-through pant suits for women, all done in eye-exploding colors and prints created by wife Celia Birtwell, had early on marked him as a fashion genius. Pattie counted

Ossie as a friend and often served as his muse; he named a popular dress style after her. Ossie, too, was a Liverpudlian and Pattie was certain he and the Beatles would get ing along. She was right. After meeting him, John, followed separately by Paul, became a fixture at Ossie's theatrical London fashion shows. George also attended, often to watch Pattie model Ossie's sensuous chiffon creations. He later became an Ossie Clark business associate while the designer was affiliated with Quorum, Alice Pollock's trend-setting boutique just off King's Road.

The Beatles were genuinely interested in the fashion world and there was much to explore in 1966. Editor Millicent Bultitude's pocket guide-book *Get Dressed, A Useful Guide to London's Boutiques* listed dozens of shops that year that had not existed the year before. "Boutiques are the current in places to buy clothes and accessories," declared *Rave* magazine in an eight-page spread devoted to the phenomenon. "The people who run them, with flair and fashion sense, know exactly what YOU like to wear and how it should be worn."[3] The Beatles paid close attention and eventually involved some of the new fashion stars in a complete makeover of their Mop Top look.

The Beatles were in transition, maturing both as men and artists, eager to retire their "cute and clean" image in favor of something more forward-looking and contrarian. They took full advantage of the wide range of choice in men's clothes abetted by the boutique boom, wanting to try it all, from Carnaby Street to cowboy chic. The variety of their dress had become dizzying: flared trousers worn low on the hips with big belts and Western-style denim jackets (John's was white); Liberty print silk shirts; crushed velvet trousers; two-toned Edwardian-style jackets; hand-painted ties. It was the kind of sartorial excess only money could buy. "Hardly anyone is richer than the Beatles," reported *GQ* that year, "and their Rolls-Royces are as big as any duke's."[4]

That the Beatles had become a luxury brand did not dampen their determination to improve themselves. In 1966, the Beatles read more books, saw more theater and art, and spoke to more people about the pressing issues of the day. Paul approached the philosopher Bertrand Russell to talk about the nascent peace movement and the Campaign for Nuclear Disarmament (CND).

Their new sources of knowledge and an endless supply of mind-altering drugs helped the Beatles expand creatively. Around this time, they had

become devotees of Lysergic acid diethylamide, or LSD, and the new gospel of hallucinogens preached by Timothy Leary, the American psychologist and author. Leary's "turn on, tune in, drop out" mantra rang through 1966 as a subversive slogan of change. The Beatles answered the call. The importance of acid to their art cannot be overstated. LSD, said George, "is the key that opened the door and showed a lot of things on the other side."[5]

In a 1966 *Life* article, media theorist Marshall McLuhan, investigating what he called the dawning of a new Electric Age, said LSD "releases people from ordinary acquired verbal and visual habits. It promises instant, condensed and total experience, which is what people want right now instead of rational, sequential ones."[6] Points of view, McLuhan elaborated, could no longer be fixed. The world was in flux, and perceptions were shifting along with clothing, language, and accepted codes of morality. The Beatles were hip to that.

Their own shifting perspective could be heard on *Revolver*, released in August, the most critically acclaimed Beatles LP to date and the one defined by a defiant desire to burn their old public image and raise a more authentic identity from the ashes. Reflecting the group's recent experiments with electronica and acid, most of the songs on the only album the Beatles would release that year were meditations on their developing relationship with LSD, a radical departure from their usual boy-loves-girl lyrics. "Oh, I get it," said Bob Dylan after Paul played him one of the album's psychedelic creations for the first time. "You don't want to be cute anymore."[7] The cover artwork, a photomontage designed and executed by Hamburg friend Klaus Voormann, corroborated Dylan's snarky but perceptive comment: visually, psychically, and artistically, the Beatles had changed.

Using the band's longer-hair as a jumping-off point, Voormann's pen and ink drawing (winner of the 1966 Grammy for the best album cover) presents the Beatles as four heads connected by endlessly flowing strands of hair into which photographs of them in 1964 and 1965 (mostly taken by Robert Freeman) have been cut up and interspersed in a Beardsleyesque collage: the Beatles as they were. The present tense Beatles were on the back, in a black-and-white Robert Whitaker photograph of the foursome in the studio rehearsing "Paperback Writer" and "Rain," songs on the only single they released that year. John and Paul sport long-collared

paisley cotton shirts, the latest fashion for men. George has on a velvet jacket and Ringo a sharply tailored dark suit with high-collar white shirt and sleek black tie. Their clothes are similar but not the same, ditto the tinted specs they all wear, a look the Beatles had brought back with them to England from their American tour.[8] John's are rectangular and amber; Paul's are round and brown. George's round and gray. Ringo's oval and blue.

The Mop Tops are gone, put to rest in 1966 when at Pattie's suggestion the Beatles axed Dougie Millings as the tailor who, since the beginning of Beatlemania, had designed all their image-defining stage clothes. The Fabs did not want to look prefab anymore. They wanted to look plugged in.

Replacing Millings was a new breed of suit-maker cutting a swath down the bohemian avenues and laneways of Chelsea, a two-minute walk from Brian Epstein's NEMS office on Argyll Street. None was Mod. That look was over the minute *Time* paid tribute to "London, the Swinging City," with an April 15, 1966, cover story describing "the switched-on fashions making the happening scene."[9] The British were bemused more than flattered. The general perception was that Americans were behind the times. Another journalist, John Crosby, had declared London "the most exciting city in the world" in a *Telegraph Weekend* supplement published a full year earlier. He, too, had praised the seeming classlessness of the "swinging meritocracy" that had brought old-money aristos and new-money pop stars together in the same fashion boutiques and after-hours clubs.[10]

By 1966, Carnaby Street was losing its cachet, especially since John Stephen, who figures prominently in the *Time* article, had begun selling watered-down versions of his outré designs to mainstreet American stores such as Dayton's in Minneapolis and Carson Pirie Scott in Chicago. "As soon as the press took notice," Nik Cohn wryly observed, "tedium set in."[11] Like the Beatles, London fashion had moved on.

In Paris, designers like Paco Rabanne and André Courrèges were creating space-age fashions made of metal, plastic, and Mylar paillettes. In London, the pursuit of the new went in the opposite direction, towards a nostalgia-based aesthetic celebrating personal style. Some of the latest menswear boutiques had gone decidedly retro, selling velvet pantaloons and long nip-waist Edwardian-style jackets that flared over the hips. The Beatles lapped these up.

The new threads were still experimental, but in a backwards-looking sort of way, a reaction to the proposition that what is new is necessarily improved. Distrust in progress was perhaps inevitable with the threat of nuclear war casting a dark shadow. Fashion pushed back to what pop anthropologist Ted Polhemus identified as a period of reconstruction, a new aesthetic that recycled older styles and ideas about personal adornment.[12]

Hung On You opened on Cale Street in December 1965. The boutique relocated in the spring of 1967 to 430 King's Road at the rougher end of the street in an area known as World's End (Malcolm Maclaren and Vivienne Westwood would open their punk clothing boutique Sex at the same premises in 1974). The shop belonged to Michael Rainey, the stepson of a British lord who, before opening his own place, had worked for Alice Pollock and Ossie Clark at their influential Quorum boutique. He was a retailer, not a designer. But he was stylish—everyone said so. Rainey's business partner was Christopher Gibbs, a London antique dealer who in the 1960s wrote the rhapsodic copy on London's happening fashion and cultural scene for British *Vogue*. Both were boho-aristo scenesters of the highest order. Jane Ormsby-Gore, a daughter of Lord Harlech, British ambassador to the United States during the Beatles' first trip to America and one of Gibbs' colleagues at *Vogue*, married Rainey in 1966, using her blueblood connections to promote her husband as "the high-priest of a new dandy-peacock style."[13]

An unconventional dresser with an unerring eye, Lady Jane, as she is identified in the Stones' song, became an integral part of the business, helping the founders push back against the flashy Italianate styles of Carnaby Street with new imaginative wardrobes defined by vintage clothing.[14] It was a trend led by youthful members of the upper classes. In a feature article published in *Vogue,* Ormsby-Gore divulged the secrets of her distinctive style, saying that she and her aristocratic friends routinely rummaged through family attics in stately country homes to locate trunks of old stuff to wear with ethnic garments and flea market finds from Portobello Road. The same crowd traveled widely and brought back to England antique pieces of costume and unusual textiles, at first for themselves and later as boutique stock. The men in that set also had the confidence (along with the money and leisure time) to source novel apparel which they combined with traditional cricket and rowing blazers, Fair Isle sweaters, eccentric ties, capes and evening coats. It inspired Hung On You to draw from a variety of

sources for design ideas, including classics of English literature. "We were very influenced by Byron . . . those Byron shirts with frilly fronts and big sleeves," Jane told the Victoria and Albert Museum in 2006, "and literature: Spenser's *Faerie Queene* . . . that sort of mood, rather romantic."[15]

The resulting jewelry box of a clothing store, lined with William Morris prints, was stuffed to the rafters with "satin stripe shirts and racks heavy with jackets and trousers in ravishing pin stripes, blue, grey and marmalade."[16] It stocked frilly front shirts in an extravagant array of colors, boots made from old kilim rugs, "Great Leap Forward" Chairman Mao jackets, and other reworked socio-political fashion pieces made of fine fabrics sourced from London's East End Jewish tailoring establishment. The lush neo-Regency or proto-hippie look saw "ruffles foam over the fronts of the dinner-jackets and lace spill out of the sleeves. . . . There has not been such elegance, style and boldness in men's clothes in London since Oscar Wilde," wrote *The Observer*.[17]

The refinement had a subversive edge. "We were revolted by the ugliness of suits of the regular 'good' tailor," said Gibbs. "We encouraged friends to dig into their heirlooms, to wear old clothes, to turn their backs on ugliness and conformism."[18] Hung On You did not just sell clothes, in other words. It sold an attitude. The boutique was hip, and hot at the moment. "Its customers were the real departure from the routine for they were almost exclusively the new male dandies invented by the 1960s, a taboo-breaking mixture of social and rock aristocracy as never encountered before," *The New York Times* would report years later.[19]

As the de facto leaders of the new pop aristocracy, the Beatles shopped at Hung On You with a vengeance. They gobbled up Rainey's Smarties Suits in hues of raspberry pink, pistachio green, and butter yellow and wore them at international press conferences, sparking questions about their evolving style. "We never keep to a strict fashion," said Ringo who was photographed wearing a red and white candy cane striped suit also from Hung On You.[20] The style was based on the striped boating blazers that young men at Cambridge University wore for rowing in the mid-nineteenth century. Rainey tailored it close to the body with a more formal cut. The brightly coloured result, as seen on Ringo, was simultaneously madcap and classic, a bold look-at-me fashion statement.

The Beatles liked Rainey and his retrospective English fashions so much that when EMI urged them to put out their first ever compilation

LP, *A Collection of the Beatles Oldies But Goldies,* released for Christmas, they put Rainey on the cover, rendered as a debonair *Brideshead Revisited* dandy, dressed in brightly striped pants and a wide garish tie. Fans and followers of fashion alike took notice.

Jonathan Aitkin, then a reporter for *The Guardian,* saw the spoils of one of the group's buying sprees when he interviewed Hung On You's new eighteen-year-old sales associate Irving Fish, who had been lured across the Atlantic from his home in Connecticut by the shop's cutting edge reputation. "Evidently feeling he had not impressed me adequately," wrote Aitkin, "he brought into the room a large cardboard box with the solemnity worthy of an Israelite bearing the Arc of the Covenant. It contained twelve floral-patterned shirts. 'They're for the Beatles,' murmured Mr. Fish, with awe-struck reverence, 'and do you know, they even came in here themselves a few days ago to order them. They are the greatest.'"[21]

The group looked good in Rainey's raffishly elegant clothes, George especially. In 1966, together with Brian Jones of the Stones and Ronnie Lane (a.k.a. Plonk) of the Small Faces, he topped the year's British Best Dressed Pop Stars list. *Rave* ran a photograph of George in a Hung On You shadow stripe plum velvet blazer, tight black trousers, striped corduroy shoes, tiny blue-tint wire frame glasses and cloche hat, a louche look that became hugely influential.[22]

The Beatles deepened their connection with Hung On You when they ordered new custom-made suits for their 1966 tour of Germany, Japan, the Philippines, and select cities across North America. As they had done with Millings, they again took charge, dictating the design and the choice of fabric for two sets of identical suits Rainey made off-site.

There were two Hung On You styles of suit. One was a three-button single-breasted dobby weave in a light gray and orange pinstripe and the other a more formal-looking double-breasted black worsted wool with bottle-green moiré taffeta lapels and ten fabric-covered buttons down the front. The Beatles wore the suits with brightly colored high-collared shirts, including a vivid cerise for their controversial Nippon Budokan Hall shows in Tokyo on June 30, and a glossy yellow and lime paisley print for their last concert at San Francisco's Candlestick Park on August 29. Neil Aspinall described the clothes in detail when he spoke to British magazine *Fab 208* on the eve of the world tour:

London boutique Hung on You supplied the Beatles with retro-inspired performance wear for their last world tours of Europe, the Far East and select cities across North America. (Alamy Stock Photo)

When the Beatles' first started to tour the world, John wore a black leather mariner's cap that visually identified him as the group's leader. He subsequently had many versions made from a variety of materials such as corduroy, velvet and herringbone. The style became known as the John Lennon Hat and was widely imitated. (Alamy Stock Photo)

When we left for Munich at the beginning of the Germany and Far East tour on June 23 of this year, there was no need for any decision-taking on the subject of clothes. The boys had just taken delivery of two entirely new outfits made by one of London's newest boutiques, Hung On You. One set of Rainey suits had big round cord finish buttons and shiny lapels. Those were in dark green. The others were in a very light grey, with thin orange stripes running down them. To go with the new gear the boys chose an assortment of new shirts in a cool crepe finish. No ties this trip. The shirts were orange, yellow-striped, straw and maroon—colours which seemed to be suitably interchangeable with either set of suits.[23]

Subsequently, brightly colored shirts with spectacularly high collars grew in popularity. "I think there was a direct link," said Beatles publicist Tony Barrow, "between those hugely popular shirts of the late sixties and early seventies and the ones first worn in public by The Beatles during their final concert tours in the summer of 1966."[24]

Catering to the demand was the significantly named Granny Takes a Trip, another new London boutique that had caught the Beatles' attention in 1966. Open since February and located on King's Road not far from Hung On You, the boutique was the brainchild of graphic designer Nigel Waymouth, one half of the London psychedelic poster company Hapshash and the Coloured Coat, who had conceived it as an outlet for his vintage fashion collector girlfriend, Sheila Cohen, who bought from auction houses, charity shops and other used clothing markets. The original shop concept was to resell or remodel her ample finds. The search then extended to quality fabrics with a hint of the exotic, which then led to the sourcing of upholstery fabric for clothes, such as John Lewis velvets and William Morris printed curtaining on linen, for coats and jackets. Given the originality of the merchandise, the shop became fashion destination. The Beatles couldn't help but notice.

The shop had a regularly changing façade on which pop paintings of Hollywood glamor puss Jean Harlow and the Native American chiefs Low Dog and Kicking Bear, both of the Oglala Lakota nation, alternated with an actual 1947 Dodge saloon car that appeared to have crashed onto the street from the seraglio-like interior. On the inside the walls were decorated with African fezes, Victorian feather boas, antique swords, and sepia

photographs of turn-of-the-century chorines. The shop did a brisk trade in retro-chic clothing inspired by the British Arts and Crafts movement, and the sinewy black ink illustrations of nineteenth-century effete aesthete Aubrey Beardsley, newly back in vogue thanks to a sensational 1966 retrospective exhibition of his work at the V & A. Inspiration also came from the 1960s-drug culture. "We loved purple; it was highly hallucinogenic," said John Pearse nearly fifty years later. "It became our colour of choice." [25]

A nineteen-year-old Savile Row dropout, Pearse was invited by his friends Waymouth and Cohen to join them in the business. He recut their vintage clothing and stretched the limits of tailoring by incorporating fabrics not intended to be worn. The florid voluptuousness of his work made Granny Takes a Trip the Xanadu of the fashion world.

"We used to cut up blouses and dresses and turn them into shirts or tops for men," remembered Johnny Moke, the late British men's shoe designer who worked at the boutique as a sales assistant. "What was great about Granny's was that there were no boundaries. Anything went and they kept on changing. The effect of Granny's clothes was foppish, flamboyant and decadent—a 1960's reinvention on fin-de-siècle dandyism." [26]

Its reputation spread far and wide.

"I went to Granny Takes a Trip in 1967, direct from Florence," said the Italian expressionist painter Marco Sassone who later immortalized that first Swinging London visit in a vibrant oil-on-canvas entitled *Journey* (2016). "I remember thinking, 'I am Italian, but these English can teach me a thing or two about fashion.' In Italy, we had nothing like this, nothing as esoteric and experimental in clothes. I bought a pair of patchwork snakeskin boots with a stacked heel. I have those boots still. They symbolize 1960s London to me, as interpreted by Granny's. A very exciting time." [27]

For a moment, Granny's was the epicenter of pop, the place where the psychedelic 1960s eclipsed the streamlined forms of the 1950s, a proclaiming a new sense-enhancing era. The frills, flowers, and fringes took menswear to the far edges of acceptability. Such Ouida-like extravagance was transgressive. With its windows painted black and the air thick with incense, the shop beckoned and intimidated like a forbidden den. A thick air of mystery clung to the clothes, abetted by the shopkeepers who blatantly ignored the clientele if they didn't look plugged enough to matter. Their intimidating attitude made Granny's seem like an exclusive club, not for the faint of heart.

The Beatles, of course, had no problem walking in unannounced and making their presence known. "One morning we were sitting around cross-legged on the floor, passing a joint around, and these two blokes came in," Waymouth recalled. "They looked around and said, 'This is a nice place isn't it?' We looked up, and of course it was John and Paul."[28]

The other Beatles followed. They all loved the place and would often come just to hang out and soak up the patchouli-scented atmosphere. Pearse recalls seeing John perched on a clothing table and hawking copies of the London counterculture newspaper *International Times* to astonished customers. As their association with the boutique became more widely known, the Beatles tended to stay away, avoiding the fans and wannabes loitering on the sidewalk. They sent their wives or assistants to pick up clothes that they hadn't even tried on. The bill would eventually find its way to Brian Epstein via Terry ("the man from the motor trade") Doran for payment.[29]

Salmon Rushdie, then a young aspiring novelist, occupied the flat upstairs from Granny's and remembered the scene well: "Granny Takes a Trip was at World's End, at the wrong end of King's Road in Chelsea, but to the assorted heads and freaks who hung out there, it was the Mecca, the Olympus, the Kathmandu of hippie chic. Mick Jagger was rumored to wear the dresses. Every so often, John Lennon's white limo would stop outside, and a chauffeur would go into the shop, scoop up an armload of gear 'for Cynthia' and disappear with it."[30]

The Beatles knew what they wanted: various iterations of the shop's signature floral velvet jackets, made from John Lewis furnishing fabric, as well as the paisley patterned shirts with exaggerated collars that Pearse designed as unique to Granny Takes a Trip. They wore some of these beagle collar shirts on the back cover of *Revolver*, making them instantly desirable. "They were a strong influence," said Pearse. "In terms of Granny Takes a Trip, we never repeated our designs. We'd do something and we'd move on. Then *Revolver* comes out and it's suddenly, 'Oh can we have that shirt?' 'Sorry love, but no.' That was the kind of influence they had."[31]

That influence was spreading. *Life's* May 13, 1966, issue, devoted to the latest in men's fashion, featured a color cover photograph of four young men configured as a pop group against the Chicago skyline. Beatle fringes covering their eyebrows, the high schoolers sported the current "gaudy and very gear" British style, including a light blue double-breasted jacket, a

chalk stripe suit, narrow cut trousers in a checkered print, long collared shirts, including one in polka dots, floral ties, a dark ribbed turtleneck, and a leather cap of the kind John Lennon had made popular on the Beatles' first 1964 tour of America.

For many in the fashion industry, the Beatles were exactly the impetus clothing manufacturers had been waiting for. Rapid changes in men's dress had been a long time coming, but with the Beatles changes were happening not just seasonally but every time they cut a record and appeared on the sleeve sporting a new look. Their ability to move reams of product—clothes along with discs—made them the messiahs of the rag trade. "I am encouraged by youth's awakening to style and color . . . his excitement about his wardrobe . . . his adventure with coat, vest, trousers, shirts and ties," said Ben D. Coopersmith, president of the International Association of Clothing Designers, at the organization's Toronto conference in the spring of 1966.[32]

In London that same year, the growing appetite for male fashion led Mark Palmer, a godson of the Queen, to launch the English Boy male modeling agency, one of the first dedicated to the male image. Recruits included the Anglo-Irish peer Nicholas Gormanston, later the premier Viscount of Ireland, and Jane's brother, Julian Ormsby-Gore, aristos so clothes-obsessed that they had abandoned the banking and political positions typically filled by members of their class. The Beatles had something to do with that. Patrick Anson, the 5th Earl of Lichfield, took up fashion photography in the mid-1960s, crediting the band for giving him license, as a heterosexual male, to indulge in a love of clothes. "They brought in fresh winds," the Sandhurst graduate said. "They not only caused a revolution in the lower classes, as most people think. If that revolution had not occurred, I could not possibly now lead the life I lead, dress the way I dress."[33]

Fellow blueblood Tara Browne, heir to the Guinness fortune, was another budding fashion entrepreneur with a Beatles connection. His Dandie Fashions menswear boutique opened on King's Road in October 1966. The Beatles would all go there for clothes and more after Browne befriended Paul and treated him to his first acid trip. For Paul, it all went hand-in-hand: "I suppose the fashion thing was a kind of an eruption. We were erupting anyway as the Beatles; and it is very difficult to separate the Beatles' eruption from the fashion or the cultural or the mind eruption. It was all happening at once, as a whirlpool."[34]

The Beatles' appetite for the new and experimental cost them, however. Their ever-evolving looks and opinions alienated the less progressive elements of their audience. Thugs in the Philippines along with militants in Japan and Klu Klux Klan zealots in the United States burn their records at mass bonfires and threatened them with bodily violence during their final world tour. The Beatles forged ahead, relishing their role as iconoclasts. Current events, from the nuclear threat to the bloody race riots in US cities to the war in Vietnam, where countless young men the same age as themselves were dying, compelled the Beatles to rebel.

In the 1966 issue of *Datebook* magazine, dubbed the "Shout Out" issue, Paul gave an interview in which he defamed America, home to millions of Beatles fans, as a "lousy country" that was deeply racist. Surprisingly, that incendiary comment did not spark controversy. John's comment about the Beatles being more popular than Jesus did. His quote was reprinted in the same *Datebook* issue from an interview he had done six months earlier with Maureen Cleave of the *London Evening Standard*. "Christianity will go," John said. "It will vanish and shrink. I needn't argue about that. I'm right and I will be proved right. We're more popular than Jesus now; I don't know which will go first, rock 'n' roll or Christianity."[35]

In their original context, his words read as a perfectly reasonable observation of events of the day. But the comment would dog the Beatles on the North American leg of their 1966 tour, leaving seats unsold at major venues, a situation unheard of just the year before. Fans, especially in the Bible Belt, interpreted John's words as arrogance, if not heresy. Some members of the media ventured that the bubble had finally burst and the Beatles were on their way out.

The band refused to back down. "The thing is, we're just trying to move it in a forward direction. And this is the point you know, this is why we're getting in all these messes," Paul told journalists at the August 11 press conference in Chicago. "Because, you know, we're just trying to move forwards. And people seem to be trying to just sort of hold us back and not want us to say anything that's vaguely sort of, you know, inflammatory."[36]

Robert Whitaker, a lover of surrealism known for his avant-garde approach to still photography, tapped into that rebellious spirit when he asked the Beatles to pose for him dressed alike in white butcher smocks with slabs of raw meat draped like stoles around their shoulders. In their arms, they cradled the various body parts belonging to mutilated and

decapitated plastic baby dolls. The idea, he said, was to demythologize the Beatles, to show them "not gods to be worshipped but creatures of flesh and blood."[37]

Whitaker had not shared with the Beatles the idea behind his Hans Bellmer-inspired carnage, leaving them all guessing what they had agreed to. Paul thought they were making a comment on Vietnam. Ringo believed they were denouncing the butchery of their music on their American albums. George, then in the throes of discovering Hinduism and a vegetarian lifestyle, found the whole thing disgusting. John came closest to understanding that the intent was to kill their public persona as inoffensive pop stars. He fought hardest to get one of the photographs from the bloody session on the cover of *Yesterday and Today,* a compilation album which Capitol in the United States "sliced and diced" from the group's original British albums. It was released in June 1966. "I especially pushed for it to be an album cover," John said, "just to break the image."[38]

John eventually got his way, temporarily. The butcher cover went to press, only to be recalled after a universally negative response. It was replaced by a more conventional cover showing the Beatles positioned around a steamer trunk, an image more congenial to record sales.[40]

Operation Retrieve would cost the label $200,000. Not all of the originals were returned, however. Those that escaped are today rare and prized collectors' items. The Beatles would later kick themselves for not squirrelling away some away for themselves.[39]

The Beatles did have transparencies of the contraband covers which they subversively held up to cameras while making promotional films for "Paperback Writer" and "Rain." Director Michael Lindsay-Hogg, who would later film the Beatles for the full-length feature *Let It Be*, shot three black-and-white promos on videotape. The next day, he shot two more on 35-millimeter color film outdoors at Chiswick House, west of London. Made for the American market, the color sequences debuted on "The Ed Sullivan Show" on June 5. The black-and-whites aired in Britain on "Ready Steady Go!" on June 3, and on "Thank Your Lucky Stars" on June 25.

While the Beatles took the film shoot seriously, they did not order costumes for the occasion, nor did they dress the same this time. Ringo had on a worsted chalk-and-pencil-stripe wool suit and black Chelsea boots; George and John both wore green velvet trousers with different cut and colored jackets. John's, purchased at Hung On You stood out with its two-tone

The Beatles are now routinely mixing stage clothes and items from their personal wardrobes, as well as colors, textures. and patterns. (Alamy Stock Photo)

wide lapel. Paul sported a dark four-button single-breasted suit with a beige polo neck sweater and black leather loafers worn with matching socks. It was a polished look set off by a chipped tooth. He had crashed his moped in the Wirral, near Liverpool, a few months earlier. No effort had been made to cover it up. The Beatles presented themselves to the cameras as they were, flaws and all.

The earthy palette, combining shades of moss green, sand, charcoal, and bark, visually grounded the Beatles, connecting them to the trees, leaves, and shrubbery in the shoot's surrounding landscape. Heightening this connection to nature was the pink flower pinned to Paul's lapel. A sign of things to come.[40]

As their clothes were transforming, so, too, was their overabundant hair. Soon after the Beatles stopped touring, they started to grow moustaches. George, as in Hamburg days, led the way. He grew a moustache at the recommendation of Ravi Shankar in the weeks following the band's final Candlestick Park performance at the end of August. George's new musical guru thought facial hair would help to disguise the fresh-faced Beatle that September when he, accompanied by Pattie traveled to Bombay to begin his lessons in classical Indian music. As usual, once one Beatle adopted a new look, the others followed. By December, all four Beatles were sporting moustaches in addition to long sideburns. George had even progressed to a beard; Ringo would eventually grow one as well.

Adding to their new look were the round steel-rimmed glasses that John had started to wear in public since September when he'd made Richard Lester's latest movie, *How I Won the War*. The National Service specs had been part of the costume he had worn as Private Gripweed, a low-on-the-totem pole soldier who would have depended on the government's free eyeglass service. Blind-as-a-bat John had qualified for the eyewear as a teenager in Liverpool but had refused them, thinking the glasses ugly and beneath him. But after making the film, his first outside the Beatles, he began to see things differently. From now on the glasses would be his signature accessory.

ITN cameramen caught up with the new shaggier Beatles on the steps of EMI's Abbey Road studios in the days leading up to Christmas. After pursuing different projects in the months following their final US tour (including for Paul a new film, *The Family Way*, and for Ringo a new home renovation business called "Bricky Builders"), the group was reassembling

to put the finishing touches on "When I'm Sixty-Four," a cut destined for the Beatles' as-yet-untitled next album. One of the reporters rushed forward, wanting to know if the Beatles, now that they had stopped touring, would break up and go their separate ways.

The Beatles all answered no. But they did allow that they had changed direction. "Live performance for us, it's gone downhill," Paul said. "We can't develop if no one can hear us, know what I mean? If we can't hear ourselves, we can't improve. We can't get better. Now our performance is the record."[41]

This was the group's new artistic reality. The Beatles would enter the new year with a new outlook and a new image. Never again would they dress alike in matching suits and ties. George, in fact, wanted to get rid of ties altogether. On New Year's Eve, he was refused entry to London's posh Annabel's nightclub because he refused to wear one. His preference, and the group's, was for "far out" clothes made for parading and making a spectacle. The whole world had become the Beatles' stage and in 1967 they would dress the part, flitting across the pop landscape like electric butterflies.

1967
RAGING RETRO

"We wore colourful clothes, and because we did it allowed a lot of other people to do the same."
—RINGO STARR

After locking themselves for months in the recording studio, the Beatles reappeared artistically transformed at the *Sgt. Pepper* launch party. (Alamy Stock Photo)

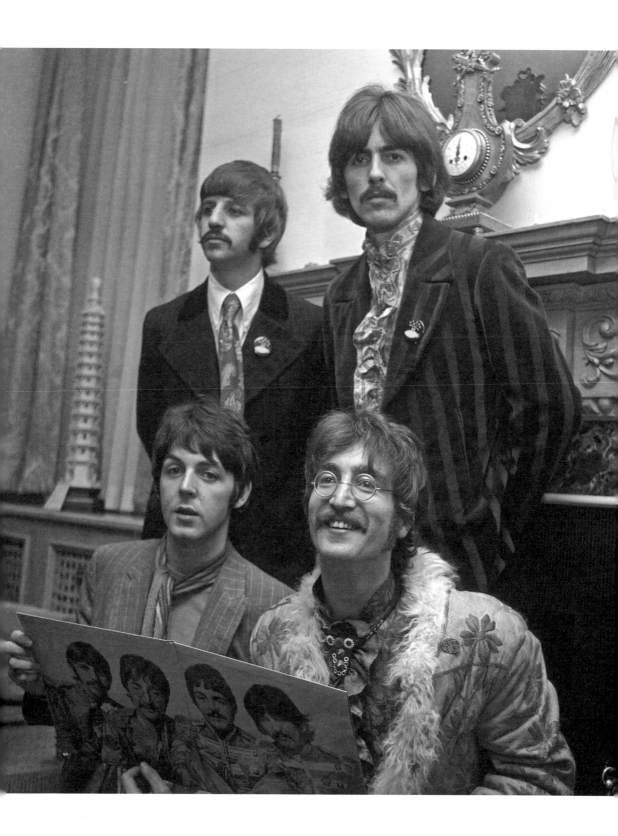

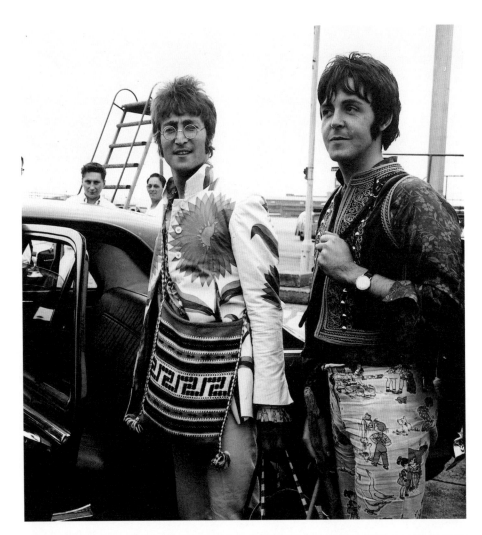

Their clothing choices were hippie inspired and included love beads, clashing patterns and idiosyncratic garments sourced from local vintage stalls and foreign hash-trade markets such as India, Afghanistan and Morocco. (Alamy Stock Photo)

Soon after they stopped touring, the Beatles retreated for six months into the security of the recording studio to begin a new phase of experimentation. *Sgt. Pepper's Lonely Heart's Club Band*, presenting the Beatles as the vibrantly dressed members of a fictitious brass band, was the stunning result. Released on May 26 in the UK and on June 2 in the US, the epoch-defining album was an instant sensation. It ushered in the Summer of Love, giving birth to a collective dream world animated by colorful visions of cellophane flowers, tangerine trees, and marmalade skies.

Widely regarded as the greatest pop record ever, *Pepper* sold 250,000 copies in its first week, 2.5 million more in its first three months, and another 32-million copies globally by the time of its fiftieth anniversary in 2017. Jack Kroll, writing in *Newsweek* upon the album's release, called it "a rollicking, probing language-and-sound vaudeville, which grafts skin from all three brows—high, middle, and low—into a pulsating collage about mid-century manners and madness." Literary critic Richard Poirier, writing in the *Partisan Review,* went further, hailing it as revolutionary. "*Sgt. Pepper* isn't in the line of continuous development, rather it is an eruption," Poirier said. "It is an astounding accomplishment for which no one could have been wholly prepared, and it therefore substantially enlarges and modifies all the work that preceded it."[1]

To the Beatles, *Pepper* was an opportunity for artistic and personal innovation. To more deliberately separate themselves from their past, they cast themselves as the ringleaders of a vaudeville-type stage show and played a variety of musical styles, from traditional brass bands to electrified rock with reverb vocals. Populist art forms like the circus and the music hall also figure in the album.

The over-arching theatrical concept owed much to then-current nostalgia for the days of Empire, the halcyon days of Albion when England, the sceptered isle, ruled supreme. It was a reaction against the shiny surfaces and minimalistic forms of Mod. *Pepper* tapped into the retro vibe but did so ironically, presenting the Beatles in ersatz Victorian uniforms made from Day-Glo-colored fabric. The eye-popping hues simulated the visuals of an acid-trip, making *Pepper,* for all its surface innocence, an emboldened affirmation of drug culture. Which essentially it was.

Certainly, the album's heterogeneous character, and its kaleidoscopic array of studio sounds, came off as mind-bending. Anecdotes abound of people falling into trance-like states when hearing *Pepper* for the first

time. It *was* a psychedelic creation, an aural happening, as musicologist Ian Macdonald has written.[2] In *Pepper,* the Beatles played with new and old, blending seemingly incompatible artistic elements like calliopes with chopped-up and randomly re-assembled pieces of audio tape and rooster-crow sound effects. The record was an artful pastiche whose idiosyncrasies, superimposed upon each other, pushed the boundaries of pop. The Beatles hadn't just produced an album. They had created a work of art whose impact was as much visual as it was musical. It was packaged and sold as a multi-media extravaganza.

To bring listeners into the *Pepper* act, the Beatles printed all the lyrics on the back cover, a pop music first, so they could play and sing along. The record also came with a cardboard insert imprinted with fake paper mustaches and *Pepper*esque ribbons and military badges that fans could cut out and wear, presumably while listening to the album. Even though the Beatles had shut themselves in the recording studio for months on end, these creative marketing ideas, again largely attributed to Paul, were an ingenious way to engage with their audience, post-touring.

Aware of *Pepper*'s pending monumentality, the Beatles crafted an image that would do their new project proud. Roughly two months before its highly anticipated release, they commissioned British pop artist Peter Blake and his then-wife, the American-born textiles artist Jann Haworth, to design a cover exploding with color and symbolic import.

The agreed-upon idea would be a photographic group portrait of 62 famous people assembled behind the Beatles, the band name spelled out in a blaze of red hyacinths. Each Beatle had a say as to who would be part of the life-size cardboard crowd. John wanted his literary heroes Lewis Carroll, Dylan Thomas, Oscar Wilde, and Edgar Allan Poe. Paul chose people reflecting his new interest in the avant-garde, like the German composer Karlheinz Stockhausen and American Beat writer William Burroughs. George picked Indian guru Sri Lahiri Mahasaya and a statue of the Hindu goddess Lakshmi. Ringo basically went along with everyone else's choices, agreeing to the inclusion of such Hollywood stalwarts as W. C. Fields, Fred Astaire, Johnny Weissmuller (the original Tarzan), and Shirley Temple, among others.[3] The illustrious gathering also included some of the Beatles' style influences: Tony Curtis (whose slicked back hair style they had all copied, pre-1960), Marlon Brando (origin of John's love of leather caps, jackets, and jeans), and Stu Sutcliffe.

Madame Tussauds' wax figure likenesses of the four Beatlemania-era Mop Tops attired in single-breasted Dougie Millings suits were included, too. The old clean-cut Beatles stood just to one side of the new handle-bar mustached versions, like shadows of their later selves. They would not actually be Beatles on this album, said Paul, who had come up with the idea, but a North of England brass band modeled on the ones they had all seen in their youth in Liverpool, playing free public concerts in the parks.

The photo shoot took place in Chelsea, at ex-*Vogue* photographer Michael Cooper's studio, on March 30. The Beatles wore the elaborate marching band uniforms custom-made for them by noted London theatrical costumier M. Berman Ltd.[4] The look riffed on what was then in fashion. I Was Lord Kitchener's Valet, a London shop that sold second-hand Victoriana to the youth market, had made dressing up in old military uniforms chic. I Was Lord Kitchener's Valet sold pure nostalgia and gained in popularity after Robert Orbach, John Stephen's former employee on Carnaby Street, co-founded the business as a used-clothing stall on Portobello Road, in Notting Hill, in 1965. John and Cynthia, accompanied by Mick Jagger and his then-girlfriend Chrissie Shrimpton (younger sister of British model Jean), were photographed shopping there for second-hand clothes on May 21, 1966.[5] The ensuing publicity generated by photographic evidence of John's patronage boosted sales and enabled Orbach to launch a chain of boutiques at which the Beatles and other pop celebrities became important customers. Coveted items included military jackets, capes, and, curiously, old-time swimming gear. "I am sitting there—weekdays were quiet—and when I looked up there is Mick Jagger and John Lennon, with their girls, just standing there," Orbach said. "They came in and they headed straight for the Grenadier Guards tunics. John Lennon bought a Victorian bathing suit. I thought I was hallucinating."[6]

Blessed by the reigning kings of pop, I Was Lord Kitchener's Valet rose to the zenith of cool in 1967, prompting a London television reporter, in a two-minute black-and-white news reel, to call the boutique "one of the most in and new move shops in London."[7] British tunesmith Peter Fenton wrote a song about the boutique with the New Vaudeville Band (a group better known for having recorded the retro-inspired hit "Winchester Cathedral"). Post-*Pepper*, the military trend infiltrated America where *Look* magazine declared "the collecting of old uniforms . . . the autumn madness of the young."[8]

As always when they picked up ideas from the street, the Beatles made them distinctly their own. They didn't follow the old-uniform trend: they put their own parodic spin on it. "At the back of our minds," said Paul, "I think the plan was to have garish uniforms which would actually go against the idea of uniform. At the time everyone was into that 'I Was Lord Kitchener's Valet' thing. Kids in bands wearing soldier' outfits and putting flowers in the barrels of rifles. We went for bright psychedelic colours, a bit like the fluorescent socks you used to get in the Fifties."[9]

Made of satin and trimmed with gold and silver frogging among other flashy materials, the now iconic *Pepper* uniforms were almost as much a production as the album itself. The band members took turns picking suit shades. Paul chose robin's egg blue, John acid green, Ringo hot pink, and George an orange shade of red approximating coral. Falling to just above the knee and worn with slightly flared trousers, the jackets sported high band collars with a tapered front edge, seamless flared skirts, epauletes, chevrons on the sleeves, and lace at the cuffs. The fronts came decorated with authentic London Fire Brigade buttons, horizontal stripes at the chest, vertical fringe, and lanyards falling down the shoulder and across the chest.[10]

To personalize their suits, the Beatles each added their own decorative flourishes. Paul and George wore their MBEs and John six war medals borrowed from Pete Best's mother, Mona. Ringo pinned on his jacket medals having to do with stars: Burma Star, Italy Star, Africa Star—a witty touch. The OPP arm badge on Paul's left sleeve can be traced back to 1964, when during a visit to Toronto to play two shows at Maple Leaf Gardens, the Beatles received four Ontario Provincial Police badges as a gift while waiting to board their chartered plane bound for Montreal.[11]

There were hats: on George, a plumed tricorn; on Ringo, a pink satin flat top captain decorated with a crown and laurel wreath design. The custom-made two-tone patent leather Oxford-style shoes, also by Berman, were just as whimsically colorful: yellow and blue for Ringo; lime green with orange fabric spats for John; yellow and red for both Paul and George. They must have been comfortable. Paul would wear his *Pepper* shoes long after making the album, during the recording of *The Beatles* in 1968, for instance, and the filming of *Get Back* in 1969. He made them a part of his everyday wardrobe.

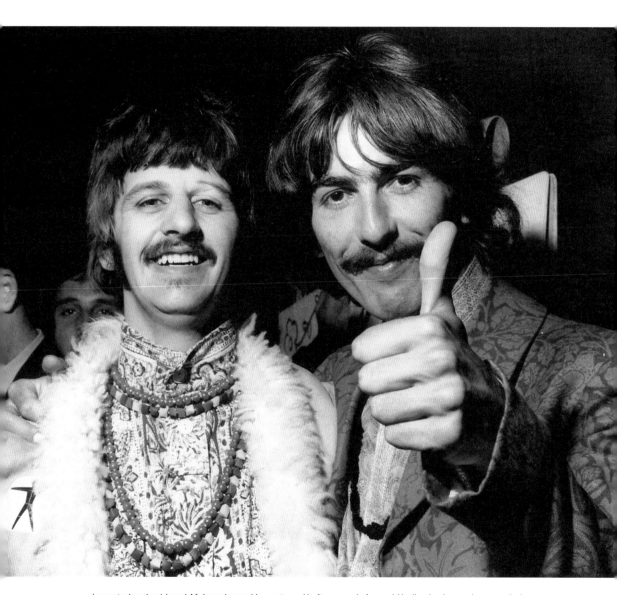

Imported embroidered Afghan sheepskin coats and kaftans made from old Indian bedspreads were ethnic garments and styles the Beatles popularized in the West during their haute hippie period. (Alamy Stock Photo)

Indeed, the line between what they wore as costumes, or performance clothes, and what they wore in real life was becoming blurred.

Throughout this pivotal year, the Beatles dressed outlandishly in public. Stripes, paisley, cartoon-patterned fabrics, satin, velveteen, and feathers all featured in their new everyday wardrobes. Loud colors and extravagant accessories like beaded necklaces, flowing neck scarves, and various styles of hats including fedoras, Trilbys, and military caps put the Beatles on parade even when they were not performing for an audience.

Eccentricity now ruled. The neo-bohemian Beatles mingled east and west, north and south, in a culture-swirling display of sartorial prodigality, comporting themselves in opera capes, batik print kaftans, and high-quality, lavishly embroidered sheepskin coats imported from Afghanistan by Craig Sams for Granny Takes A Trip.

British deejay Kenny Everett, of pirate radio station Radio London, closely observed the bizarrely dressed Beatles at a housewarming party that Epstein threw for himself in May at his new country estate in Sussex. Writing on the event for *Teen Datebook*, Everett marveled at the anarchic ensembles the Beatles were now wearing: "Every time I see John," he said, "his dress is more way out than the time before. This time it was a tablecloth he was wearing! A huge red one with orange tassels!" Ringo, he added, wore an eye-popping tablecloth, too. George chose other bright hues from the rainbow for his outfit that day—"white trousers, a yellow leather jacket with white weaving all over it and a large red dot painted neatly on his forehead."[12]

Maybe tablecloths weren't destined to be the look *du jour*. But the bold new colors seen in the Beatles' clothing that year lit up the boutiques and the pages of the world's fashion press. With everyone watching their every move, anything the Beatles wore could and would become a trend.

The mix-and-match esthetic, combining thrift store and bespoke, often in the same outfit, showed the Beatles morphing with the times even as they exerted a major influence. The matching suits were gone but they remained stylistically in synch. Each dressed in an idiosyncratic manner reflecting the group's progressing artistry, and their evolving identity as men. Their clothing choices mirrored the experimentation and self-expression of their music.

Around this time, a young London designer named Paul Reeves began making kaftans from old Indian bedspreads he found remaindered in a

"funny old department store" on Kensington High Street. Their design was inspired by "the Indian raga sound" he heard on *Revolver* and on *Pepper:* "My designing of the kaftan was influenced by them," he said, "their interest in Indian culture is where my kaftan idea would have come from." Reeves initially made six kaftans and they were full length, with a half-belt at the back. They looked like men's dresses. He put them on display at a vintage clothing stall he leased at the Chelsea Antiques Market on King's Road and was sold out within the hour after George Harrison and Mick Jagger bought one each. Reeves later cut the kaftans to knee length, netting Ringo as yet another pop star customer. "When the hippy thing took over fashion became more ethnic and diverse, but it still was very much British thing, a Beatles thing to be exact," said Reeves, who went on "to produce hundreds, if not thousands" of the kaftans which were later sold through the boutiques to the likes of Jimmy Page and Eric Clapton.[13]

Not everyone could dig it. British classical musician David Mason played a piccolo trumpet solo on "Penny Lane," the group's first single of 1967, released as a double A side with "Strawberry Fields."[14] When he laid eyes on the Beatles during the recording session, he assumed they were dressed for a masquerade. "They all had funny clothes on, candy-striped trousers, floppy yellow bow ties etc.," recalled Mason. "I asked Paul if they'd been filming because it really looked like they had just come off a film set. John Lennon interjected: 'Oh no mate, we always dress like this.'"[15]

Distaste for the look wasn't confined to the older generation. Some of their younger fans were put off by the wild and woolly Beatles as seen in the *"Penny Lane/Strawberry Fields Forever"* promotional films. "Well, really, I was ashamed of the Beatles on *Top of the Pops,"* an irate teen told the *Record Mirror* following the film's first broadcast on British television. "They looked absolutely disgusting with their moustaches." American teens, too, voiced displeasure after viewing the films on Dick Clark's *American Bandstand* on March 11. "They've changed how they used to look," lamented one. "They look like grandfathers or something."[16]

The Beatles didn't care about fan disapproval. They dressed for their fancies and none other, appearing in everything from Mexican serapes to North Indian raw silk bandi vests. They combined multiethnic garments with jeans, athletic shoes, and tailored shirts to create a series of unique signature looks that put them ahead of the fads. *Life* magazine published photographs of the transformed band in a June 1967 issue. Journalist

Thomas Thompson's accompanying article emphasized that the Beatles' creative genius had advanced to the point that they were now "stepping far ahead of their audience." They were at risk of losing public support but it did "not bother them in the least."[17] John made exactly this point, insisting that the Beatles, as true artists, had to remain true to themselves: "I don't think we have any responsibility to the fans," he said. "You give them the choice of liking what you're doing, or not liking it."[18]

The handle-bar moustaches and colorful threads were as genuine as they were outlandish, a sincere manifestation of their quest to expand their minds and enlarge their world view. As the writer Hanif Kureishi has observed, the Beatles now wore clothes "designed to be read by people who were stoned."[19] You had to be turned on to get the drug-inspired color patterns, the Zapata-style moustaches, and the even longer hair.

Because the Beatles were the Beatles, an unprecedented cultural happening to which the eyes of the world were riveted, their new psychedelic image became a thing of wonder, inspiring inquiry and ultimately a degree of acceptance. The select group of journalists invited to the *Pepper* pre-launch party at Epstein's Belgravia home on May 19 were among the first members of the press to see the Beatles in the flesh following their months of isolation in the recording studio. Ostensibly, they were there to report on the new record. But the write-ups were more fascinated by the Beatles' radically altered appearance and head space. Norrie Drummond, covering the event for *New Musical Express*, barely touched on the music at all, highlighting instead the group's "flamboyant" new image which startled even some deejays with reputations for sartorial excess. Drummond described in detail George's "dark trousers" and "maroon velvet jacket" pinned with an anti-Vietnam war protest badge depicting a yellow submarine sprouting daffodils. He also focused on John's "green frilly shirt, "maroon trousers," and "sporran" worn about the waist as a catch-all for the Beatle's house keys and cigarettes. At his neck was a distinctive piece of jewelry, consisting of three daisy-like flowers flanked by four azure rings on a grommeted strap of brown leather. John called it his mandala. It came from Tibet and was "given to John by a certain Lama visiting London," a former associate said. "He always wore that necklace when I knew him."[20]

Reserving judgment, Drummond respectfully queried John about his changed appearance, hoping to tease out the meaning behind it. Like his clothing choices, John's answers were anything but straightforward:

"Under this frilly shirt," he said, "is a hundred-year-old man who's seen and done so much, but at the same time knowing so little."[21] The response suggested he still had some changing to do.

After all that work and promotional effort in releasing *Pepper* on the world, the Beatles would have been justified in taking a rest. But a few weeks later, their work ethic getting the better of them, they were back in the studio recording their next single, "All You Need is Love." The Beatles performed the song live for "Our World," the first-ever global satellite broadcast, seen by more than 350-million people across five continents. John purposefully made the lyrics simple and easy to follow for even non-English speakers. The repeated chorus of "All You Need is Love" needed no translation. It was a group philosophy.

The Beatles performed the anthemic song in EMI Studio Two at Abbey Road on June 25, surrounded by an audience of fellow London clubbers and assorted pop star friends. In the spirit of fraternal love, the Beatles turned the "Our World" broadcast into a communal celebration. They decorated the studio with balloons, flowers, and colored streamers, and wore a new set of clothes made for them by an Anglo-Dutch art and fashion collective known as the Fool, a name taken from the Tarot, where the Fool card symbolizes success in creative and cultural endeavors.

The Fool's members, Marijke Koger, Simon Posthuma, and Josje (also known as Yosha) Leeger, were all from Amsterdam. Barry Finch, then working for a London public relations agency whose clients included Epstein's Saville Theatre, was a transplanted Canadian who fell in with the Fool after commissioning them to design a poster for an upcoming Epstein-produced show. Then twenty-four, Finch soon after became Leeger's husband and the group's informal manager. This Amsterdam foursome was creative almost to a fault, designing freely with no sense of cost and, some might argue, taste. But the custom-made clothes they made for the Beatles for the "Our World" broadcast dazzled.

John, now clean-shaven, shimmered in an iridescent frock jacket made of a shaded cornflower blue damask material with pink lapels, bell sleeves, and a high-collar shirt in a pastel-hued Art Nouveau fabric sourced from Liberty of London.[22] George shone in a floral embroidered chocolate brown velvet jacket and a Nehru-collar paisley tunic in sunset hues of orange, red, pink, and purple worn with scarlet satin trousers and his red and yellow patent leather *Pepper* shoes. With a crimson flower in his hair, Paul

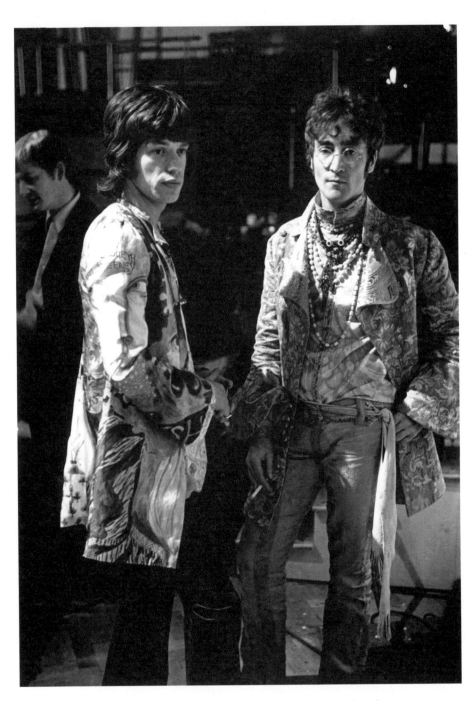

Even rival groups like the Rolling Stones took their fashion cues from the Beatles. John, dressed in a Liberty print shirt by the Fool, with a similarly attired Mick Jagger at the *All You Need Is Love* broadcast. (Shutterstock)

twinkled in a silver pave crystal scarf necklace, a hand-painted short sleeve shirt festooned with stars and fanning explosions of primary colors that he had layered over another shirt with high collar, long sleeves, and all-over blue-red-green-yellow floral paisley pattern. Alone among the Beatles in sporting a monochromatic look, Ringo sparkled in an amethyst purple satin tunic decorated with a multitude of fringe-like bugle beads for whose beauty he suffered. "It was so bloody heavy," he later complained, "I had all this beading on and it weighed a ton."[23]

The Fool first attracted the Beatles' attention while working with Cream to psychedelicize their image in the early months of 1967. A former commercial artist, Koger had painted the fretboard of Eric Clapton's guitar in the colors of the rainbow (American musician Todd Rundgren now owns it) and designed the covers of the Incredible String Band's *The 5000 Spirits or the Layers of the Onion* and the Hollies' *Evolution* LPs. Additionally, with Leeger, a trained dress designer, Koger created the stage costumes for Cream's March 1967 US. debut tour and the performance clothes for Procul Harum and the Move, psychedelic bands then making the London scene. Word-of-mouth was that The Fool was it. Always quick to a new trend, the Beatles were soon in hot pursuit.

Their wives arrived first, taking turns shopping at The Fool's intimate Karma boutique on London's Gosfield Street. "Maid Marion" dresses, cut from brightly hued filmy material, vied for space in the shop with psychedelic posters and paintings, joss sticks, finger bells, and home accessories imported from Morocco, India, Turkey, and China.[24] Pattie, Cynthia, Maureen, and Pattie's younger sister, Jennie Boyd, later posed for a September 1967 *Sunday Times* photo shoot directed by Ronald Traeger (the fashion photographer best known for his era-defining images of Twiggy). They wore The Fool's creations. Cynthia posed in a pink and purple chiffon dress with a lurex tunic, while Pattie and Maureen both appeared in voluminous pantaloons and bishop sleeve blouses made of blue and red satin. One fashion writer said they all looked like "gypsies in extra glorious Technicolor."[25] Traeger's image subsequently appeared in the premiere November issue of *Rolling Stone* and in British *Vogue* in the new year, helping to boost recognition of The Fool's handiwork world-wide.

The look was very much of the hashish-intoxicated moment. It caught everyone's attention, ushering in what British-style reporter Felicity Green would come to call hippie chic. In an article for the *Daily Mail*, published

in August, she wrote about The Fool after seeing Pattie in its mystical clothes. "Hippie hautes couturieres," she labelled them. "Compared with its baubles, bangles, beads, and bells, the Quant-type mini-skirts pale into Establishment respectability. The Hippie cult, love it or loathe it, is here." [26]

It wasn't long before the Beatles, too, were shopping at Karma. The Fool's exotic forms and textures worked harmoniously with the plasticine porters and rocking horse people in their music. As soon as they met, the Beatles came up with far-out ways to draw The Fool deeper into their own world. In 1967, George commissioned The Fool to design and paint a mural around the fireplace at Kinfauns, his bungalow-style home in Esher, a town in Surrey. The mural depicted a sitting yogi surrounded by leaping flames, cosmic spheres, and liquid vistas. John followed suit, hiring The Fool to paint his home piano in swirling psychedelic colors. Ringo, meanwhile, rented the collective his Montagu Square property. There, its members designed a travel wardrobe of psychedelic garments that George had ordered for him and Pattie to wear on a late summer excursion to California.

The Harrisons traveled first class on a Lear jet, hiring a limo to drive them around once they arrived at their destination. They took in the Monterey Pop Music Festival and made a quick trip to San Francisco to visit Pattie's sister, Jennie. They popped in on Haight-Asbury, the hippie capital of the world. George did the rounds on August 7, fetchingly dressed in a pair of The Fool's custom-made trousers with a large-scale red-brown-white paisley pattern and other organic forms. The autumnal hues complimented the crimsons and greens in Pattie's chiffon mini dress, which she wore with a beaded bolero, sparkly headband, and lavender-suede gladiator sandals banded to the knee, which she had designed herself. George was also sporting a jean jacket pinned with badges and heart-shaped glasses. He hoped the shades would allow him to walk about unnoticed. But not in those clothes. Crowds gathered and the scene grew intense. "Maybe he was hoping not to be recognized and that he would pull it off," said Gene Jacobs, then an eighteen-year-old photographer living close to Hippie Hill. "But, fuck, one of The Beatles, man? Everybody knew what he looked like. He was in purple sunglasses, he had buttons on that said, 'I'm the head of my household,' and a Bob Dylan button and it was pretty obvious who the hell they all were. Everybody knew that these guys were not the normal Haight Street crowd. *Sgt. Pepper* had just come out—they were like gods in the people's minds." [27]

George had no interest in being anyone's messiah. He rejected the dope offered him by bandana-wearing strangers and made a beeline back to the idling limo, desperate to be whisked away. For him, the visit had gone terribly wrong. Here's why. In the United States, the anti- authoritarian hippie movement was powered by resistance to the Vietnam war. It was strongly anarchic in its rejection of mainstream culture, including capitalism, consumerism, materialism, and other prevailing social norms. In the UK, the movement was less overtly political and more aesthetically allied with the avant-garde. George thought that when he meant real hippies on their home turf, he'd be encountering free-thinking creatives like himself. It was a rude awakening.

Repulsed by what he saw at Haight-Ashbury, George would claim that the experience made him want to give up hallucinogens. "I went there expecting it to be a brilliant place, with groovy gypsy people making works of art and paintings and carvings in little workshops," he said. "But it was full of horrible spotty kids on drugs, and it turned me off the whole scene."[28] By "groovy gypsy people" George likely meant The Fool. To him, they weren't freaks. They were artists. *Them* he could relate to.

On his return to England, George ordered even more clothes from The Fool, including an embossed purple velvet jacket with a high-collar, bell sleeves, flare waist, and overall cabbage rose pattern that he wore on "The Frost Programme" in September, where he publicly renounced LSD.[29] George wore yet another eye-catching piece of Fool-designed clothing, a tapestry print bell-sleeve tunic [30] to a Beatles official fan club Christmas party he attended with John in London on December 17. The Fool had no shortage of Beatles commissions in 1967. But one major job fell through.

Earlier that year, Paul had commissioned The Fool to create artwork for the inside gatefold sleeve of *Pepper*, which Koger and Posthuma, who were married at the time, executed, creating a dreamy landscape in which tiny figures of the Beatles peeped over a swirl of flora and fauna. The Beatles loved it. But Paul's gallery friend, Robert Fraser, a pop art connoisseur, strenuously objected, arguing that the trippy landscape with a peacock, an owl, and a mushroom cloud floating behind a golden mountain in the distance was bad art and would quickly date itself. Paul, then having an affair with Koger, could not see it right away. Eventually, he came around to Fraser's point of view and ceded to his suggestion to use Blake and Haworth instead.

Perhaps to make it up to them, Paul next called on The Fool to design costumes for select scenes in *Magical Mystery Tour*, the film the Beatles set out to make in September. The Fool readily complied, creating a series of high-collared, Moroccan-inspired kaftans and Indian kurta jackets for three of the Beatles to wear for the "I Am the Walrus" segment, in many ways the best part of the experimental film. Paul's high-collared garment, made of a shimmering orientalist fabric shot through with silver thread, had large round pearl buttons running down the front and images of golden lions and flowers racing down the sleeve. Koger made the "one-of-a-kind outfits" from rich materials purchased from Liberty of London and other fabric shops, including those on Portobello Road. "I made John's multi-colored coat out of raw silk," Koger said, "Paul's tunic also out of silk from Liberty's and George's coat from a brocade embellished with decorative silk braid. Ringo bought his ethnic top himself from I don't know where."[31] Ringo layered that "top," a black and orange V-neck cotton Nigerian Dashiki tunic, over the red-hibiscus-with-pink-background sateen shirt he had worn on stage during the Beatles' 1966 world tour. The outfit was completed with apricot trousers and pistachio green half boots that might have come from a candy store.

For the surrealistic shoot, the Beatles also donned animal costumes rented for the occasion from Eric Gledhill's Theatre-Zoo shop in London. Paul appeared as a Hippo, George as a March Hare, Ringo as a Parrot, and John as the titular Walrus, a character he'd encountered in the works of Lewis Carroll. The Beatles mimed the song, appearing in some shots playing their instruments in the open air and in others sitting high atop a wall at the West Malling Air Station in rural Kent, swinging their legs while dressed up as furries. Images of the Beatles were interspliced with those of hand-holding policemen and a conga-line of lunatic eggheads, imagery pulled directly from John's lyrics.

Magical Mystery Tour drew inspiration from such counterculture filmmakers as Kenneth Anger and Stanley Kubrick (unused aerial footage from the making of *Dr. Strangelove* features in the Beatles' film). Creative editing abetted the illusion of a topsy-turvy world. Cinematic devices like superimposition, colored filters, and jump cuts created a discombobulating viewing experience meant to bypass reason and appeal directly to the subconscious. As an artistic project, it advanced what *Pepper* had started at the beginning of the year—the Beatles' avant-garde phase.

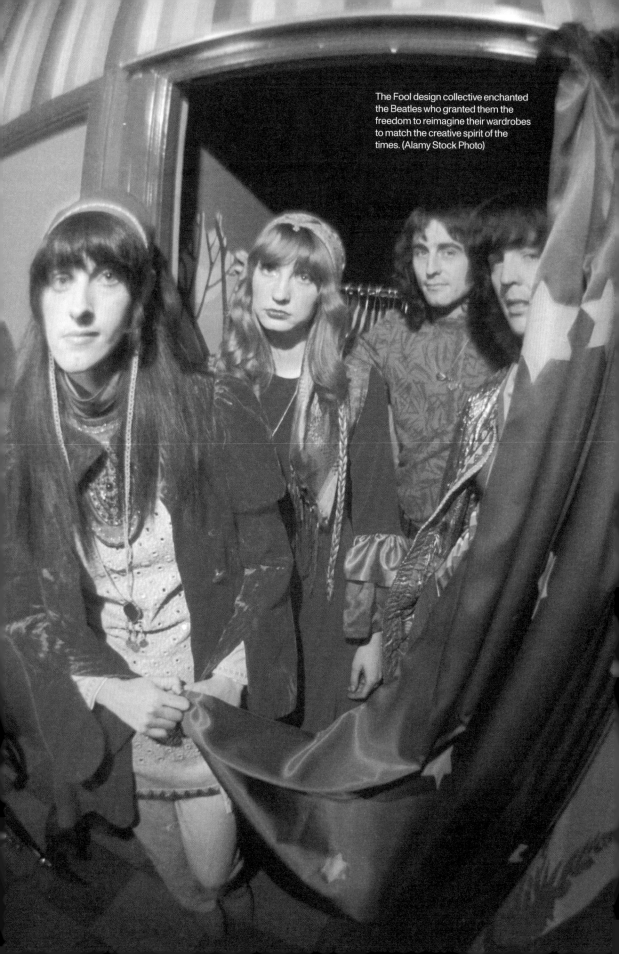

The Fool design collective enchanted the Beatles who granted them the freedom to reimagine their wardrobes to match the creative spirit of the times. (Alamy Stock Photo)

Paul's handcrafted macrame granny square vests and Fair Isle sweaters pushed knitwear for men to the forefront of fashion in the 1960s and early 1970s. (Alamy Stock Photo)

Like *Pepper*, their self-made film was a psychedelic art project rooted in the past, "a look back with a new feeling," as Paul called it.[32] Mystery Tours were an actual thing. The Beatles all remembered them from their childhood, coach tours with no fixed itinerary. "It was basically a charabanc trip," George said, "which people used to go on from Liverpool to see the Blackpool Lights."[33] That nostalgic spirit informed some of the outfits seen in the film. John's dapper brown pinstripe suit, comprising high-waisted pants worn with suspenders and a long broad-shoulder jacket with wide lapels, harkened to the 1930s, as did the fedora, decorated with bird feathers, and his two-tone shoes. The Depression-era look, the stock-in-trade of London boutique Biba, would become even more fashionable by the following year. Paul's handmade Fair Isle pullover, worn in the bus scenes and further immortalized in the twenty-four-page color booklet that accompanied the *Magical Mystery Tour* LP, would also prove to be highly influential, helping to turn knitwear for men into a major fashion trend through the remainder of the 1960s and the early 1970s. Another retro fashion hit from the film was the belted greatcoat worn by Paul in the "Fool on the Hill" sequence shot in the south of France. It, too, became a menswear staple by the end of the decade.[34]

Perhaps the biggest trend sparked by the film took years to materialize. The various scenes animating Beatles' songs created new ways of visualizing music. *Magical Mystery Tour* foreshadowed the emergence of the music video, a now ubiquitous genre where non-linear narratives, free-flowing images, and elaborate pop star fashions have become the norm. The Beatles did it first, pioneering an approach to record promotion now mandatory for anyone wanting to succeed in the music business. In some ways, they profited from this innovation. The *Magical Mystery Tour* LP, featuring six tracks which built on the studio experimentation heard on *Pepper*, became one of the fastest-selling records in Capitol's history, grossing $8 million in ten days.[35] But in another significant way they did not.

When *Magical Mystery Tour* made its televised debut on Boxing Day, the critics savaged it and the public balked. The Beatles had flopped. The film's newness backfired on them. "Rubbish . . . Piffle . . . Nonsense!" said the *Daily Mirror*. "Appalling!" echoed the *Daily Mail*. "There was precious little magic," elaborated the *Evening News*, "and the only mystery was how the BBC came to buy it."[36]

The Beatles can't be entirely faulted for the failure. The film was made in color but the BBC showed it in black-and-white, a misguided presentation stripping *Magical Mystery Tour* of its psychedelic heft. Being purposefully plotless hadn't helped matters. Paul had directed it from a pie chart he had drawn on a sheet of paper, using the circle to represent what would become a fifty-minute television special based on the loosest of ideas. He had conceived it as "an art film rather than a proper film" and as "a very stoned show."[37] The idea was that they would make it up as they went along.

The other Beatles heartily endorsed the ad-libbed concept, seeing it as a way to be liberated from the scripted images of themselves in *A Hard Day's Night* and *Help!* Those films had been Epstein's idea. But with his untimely death by an accidental overdose on August 27, the Beatles felt free to reinvent themselves without a manager's approval.

On the other hand, with their manager gone, there suddenly was no one to control the mayhem. The Beatles learned that the hard way. Their unstructured film project was beset with problems that a bit of forethought might have prevented. All the film studios were booked, forcing the Beatles to set up shop in an empty military hangar. Accommodations weren't preplanned, leaving some of the extras to sleep outdoors in tents. The bus got stuck on a narrow bridge, halting traffic for miles. One of the midgets went unpaid. Editing that was to take two weeks took eleven. When it was discovered that cameramen were ununionized, a major labor dispute ensued. Heaps of money were required to resolve it, throwing the project grossly over budget. And so on.

The Beatles weren't filmmakers, that much was clear. But they were artistically fearless. Despite the critical flogging, their movie did achieve a major goal. By illogical means, it cleansed the Beatles of their earlier identity. *Magical Mystery Tour* marked the peak of their psychedelic period where a combination of randomness and artistic chaos yielded fresh perceptions of the world and themselves in it and eased their transition into the next stage of their development.

Many critics claimed that the only good thing about the *Magical Mystery Tour* movie were the splendiferous outfits made by the Fool for the outdoor "I Am the Walrus" scene. (Alamy Stock Photo)

1968
WHO'S MINDING THE SHOP?

"Well let's sell groovy clothes."
–JOHN LENNON

The Beatles arrived at the 1968 "Mad Day Out" photo session clad in neo-Edwardian jackets, graphic Ts, striped hipsters, ruffle shirts, leather, fur and lace. As the day wore on, they gleefully swapped clothes with each other, and with some of the photographers, creating a thrilling improvised series of one-off looks that captured the essence of the Beatles as playful, imaginative, open to ideas, and to each other as mutual sources of creative inspiration. (Tom Murray/Camera Press)

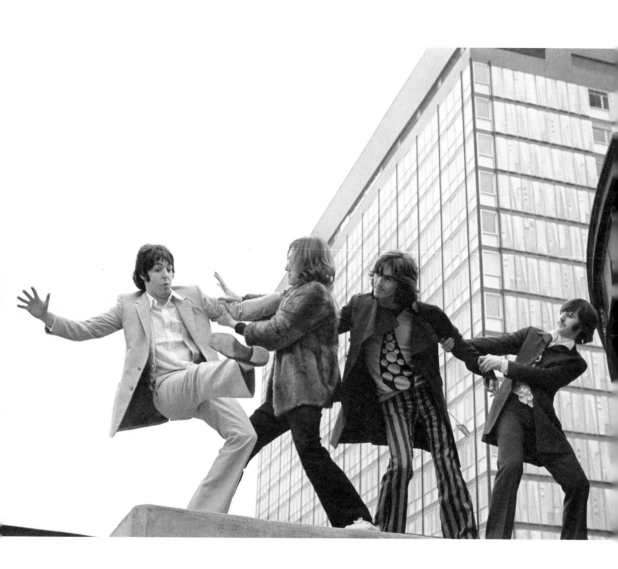

With the opening of the Apple Boutique on London's Baker Street, the Beatles established what was to become an industry-altering trend -- the rock star as fashion brand and retailer. (Alamy Stock Photo)

The opening of the Apple Boutique, the Beatles' first fashion retail venture, had originally been scheduled for early 1968, making it a New Year project that would have followed on the heels of *Magical Mystery Tour* if all had gone according to plan. But the Tarot-reading Fool collective, whom the Beatles had entrusted to things up, insisted that the 94 Baker Street store should open instead in early December when the moon was in the first quarter, a propitious time for pushing ahead on new projects. "The shop was in the Divine Plan," The Fool told *Women's Wear Daily*. "It had to happen."[1] John would remember it less cosmically.

As high-income British citizens, the Beatles were subject to the 95 per cent supertax introduced by Harold Wilson's Labour government in 1966. Launching a business, their accountant Harry Pinsker convinced them, would help to protect their earnings. After much deliberation, they settled on the formation of a multimedia company as a legal tax shelter. It was a new idea for the time, its freshness captured by the logo, a bright green apple inspired by the René Magritte painting *Le Jeu de mourre* ("The Guessing Game"), the centerpiece of Paul's growing modern art collection.

The fashion boutique was Apple's first manifestation, before the records, the films, the electronics, and the other artists eventually signed to the label. The story was suggested to them by Clive Epstein who in the wake of his older brother's untimely death had stepped in to guide the Beatles' affairs as best he could. Like his brother, he knew retail. The Beatles warmed to the idea but insisted that they have complete control. It made sense that after taking control of the recording studio, and their movie, they would look to seize command of their association with fashion.

"If we're going to open a shop, let's open something that we'd want, that we'd like to buy," John said. "We were thinking, 'Let's be the Woolworth of something,' or how great it was to go into Marks & Spencer and get a decent sweater when you were about eighteen. Cheap, but good quality. We wanted Apple to be that."[2]

Beyond just protecting their earnings, the Beatles wanted the Apple Boutique to form a strong connection with their fans. For years already, their followers had been wearing clothing like their idols' out of a desire to identify with them and proclaim their allegiance. It was an act of celebrity worship that the Beatles took pains to acknowledge. With the Apple Boutique they would directly share the spoils of superstardom, making what they wore accessible to the world. "It was silly," Ringo would say, "but we *had* wanted to open a shop and dress everyone like us."[3]

Before the Beatles, no other rock group had entered so aggressively, and with such fanfare, the rapidly evolving world of fashion retail. The Apple Boutique was the prototype for the cross-branding of music and fashion that the likes of Beyoncé, Diddy, Rhianna, Kanye West, Drake, Justin Bieber, Jennifer Lopez, and Victoria Beckham, to name but a handful of contemporary pop stars with their own global fashion brands, have made a standard business model today.

The boutique occupied a four-story Georgian townhouse at the corner of Baker and Paddington Streets, which the Beatles' accountants had earlier purchased for them as an investment property. Running parallel to nearby Oxford Street, a famous shopping destination, Baker Street was better known for being the stomping grounds of fictional English detective Sherlock Holmes than it was for fashion. It was off the beaten boutique path. But the Beatles were confident that if they opened shop, people would come. About that they were right.

A packed launch party attracted a hipster crowd, drawing in British celebrities like Twiggy, Brian Jones, Cilla Black, Kenneth Tynan, Richard Lester, Eric Clapton, and other arts, fashion, and pop luminaries. Some arrived in furs, others with their faces painted with glitter—painted faces being the latest fad. The Fool flitted about like court minstrels, playing on a variety of instruments, flute, tambourine, and finger cymbals. British entertainer Pierre the Clown handed out apples, encouraging everyone present to take a bite.

Paul, on vacation with Jane Asher in Scotland, missed the harlequinesque festivities as did Ringo, who was in Italy filming *Candy* with co-stars Richard Burton and Marlon Brando. But George and John were very much present, captured by the roving cameras of British Pathé as they trod the wall-to-wall Apple green carpeting and slid on and off polyethylene chairs while drinking apple juice with their celebrity guests.

"John and George," chirped the excited newsreel announcer, "describe their new boutique as a kind of psychedelic Garden of Eden for lovers of hippy gear with all of the trappings of beautiful living."[4] *Vogue*, reporting on the event a couple of weeks later, painted a verbal picture of what beautiful living looked like, describing the clothes as "a magician's impression of texture and colour—a touch of velvet, glimpse of satin, a smash of red, clash of blue, whispering voiles and brocades helter skelter everywhere, boleros, headdresses, trousers and capes."[5]

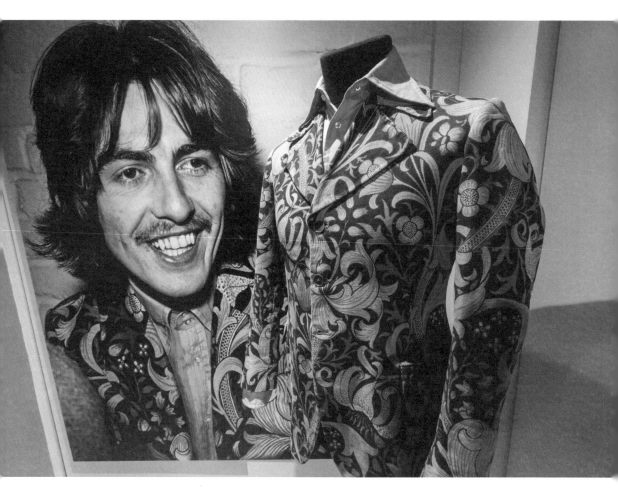

The efflorescent jacket from Granny Takes a Trip that George wore to the Apple Tailoring opening became a fashion classic, immortalized in museum shows and British design retrospectives. (Alamy Stock Photo)

The Fool designed the trippy clothes for the Apple Boutique, having them mass-produced elsewhere, in workshops around London. This was common practice. Granny Takes A Trip, Hung on You and Dandie Fashions all outsourced their designs to be cut and stitched by skilled hands, often in the East End. The handiwork usually matched the high quality of the cloth. But in the case of the Fool, the workmanship and cut was noticeably poor, suggesting that the collective hadn't organized themselves to hire competent workshop labor in time or monitor the work for quality. Perhaps they had been too busy purchasing materials and trinkets on extended buying trips to Marrakech with the £100,000 they extracted from the Beatles to get the boutique up and running. There had been plans to start a mail order catalog as Barbara Hulanicki had done at Biba "so the kids in the provinces who can't afford to come to London can get their garments and goods,"[6] a newspaper said. It didn't happen.

The Fool concentrated their energies on being "creative," at the Beatles' expense.[7] They filled the racks with what one critic called Hobbit clothes, so fanciful they could not practically be worn in the workplace or most anywhere else in society without ridicule. But the Beatles liked their audacity and encouraged The Fool to do as they pleased, even if it meant bending retail rules.

When The Fool applied to the City of Westminster for permission to dress up the Baker Street building itself with a gigantic psychedelic mural designed to draw attention to the shop, they were refused on the grounds that such a painting could be construed as an advertisement. They did it anyway, with Beatles encouragement. "Trying to influence people and doing things like painting the Apple shop was all just part of the Teddy Boy in us, the Teddy Boy theme of 'We'll show them,'" George said. "We thought, 'We'll paint the building one night, and the next morning people will come up the street and the whole bloody building's going to be psychedelic.' That was what it was all about."[8]

Marijke Koger created the rainbow-hued mural image of a wild-eyed genie juggling the moon and the planets for the boutique's Paddington Street façade, executing it with help from a group of local art students over a single weekend.[9] George called it "amazing."[10] Paul deemed it "gorgeous."[11] Others liked it as well. *Eye* magazine reported on how the "wild wizardry in the sludge of Baker Street" inspired other neighborhood shopkeepers to "gaze, gulp, think again about their own windows."[12]

But the mural, predictably, would be short lived. Within a few months of its execution, it was whitewashed into oblivion. The municipality and the landlord, Portman Estates, threatened to sue the Beatles for defacing the property.

There were other problems. The Beatles' idealistic approach to running a business led them to staff their shop with friends and family members with no qualifications other than that they were part of the Beatles' inner circle. Pete Shotton, John's friend from his Quarryman days, managed the boutique while Jenny Boyd, Pattie's younger sister, worked the floor. The lack of retail experience might account for why the Apple boutique quickly hemorrhaged money. Yes, fans wanted to wear the same clothes as their beloved Beatles. But few could afford the luxury. Some turned to stealing the clothes instead.

Abetting the rampant shoplifting was ambient lighting so subdued as to cloak fingers whisking garments into bags. When the staff realized that the boutique had become a free-for-all, the Beatles, practicing what Paul termed a Western kind of communism, told them it was uncool to call the stealing out. A similar laissez-faire attitude prevailed when Shotton complained to John that the silk labels The Fool was sewing into their designs cost more than the clothes themselves.

Shotton had already confronted The Fool's Simon Posthuma about the extravagance. He had been answered with a tantrum. He thought John, coming from the same streetwise Liverpool background, would be impatient with prima donna behavior. But no. Shotton remembers John saying: "Oh, just do it the way he wants. Remember, Pete, we're not business freaks, we're artists. That's what Apple's all about—artists . . . so fucking what, anyway. If we don't make any money, what does it fucking matter?"[13]

The plug never was in the drain. The Apple Boutique would lose nearly £200,000 within seven months.[14] Members of The Fool were alleged to have been in on the thievery, helping themselves to the best garments before being ordered to stop when a new manager, John Lynden, a former Portobello Road clothing stall manager with a theatrical background, stepped in and documented the skimming.[15]

The Beatles had the right to take legal action but refused, allowing The Fool to make a discreet exit to New York around the time their mural was painted over by city officials.[16] The Beatles would come to regret having involved themselves in their cleverly orchestrated folly. "The idea of it was

much better than the reality," George mused. "It was easy to sit around thinking of groovy ideas, but to put them into reality was something else. We couldn't, because we weren't businessmen. All we knew was hanging around studios, making up tunes."[17]

They were not finished with fashion retail, however. The Beatles had redoubled their involvement in London's vibrant boutique scene when soon after opening the Apple Boutique they formalized a business relationship with John Crittle, a wild Aussie who was proprietor of Dandie Fashions, a smart menswear boutique on King's Road. In February 1968, Neil Aspinall invested in Dandie Fashions on behalf of the group, purchasing a 50 per cent share, which made Crittle equal partners with the Beatles.

Members of the group had been buying clothes from Dandie Fashions ever since Guinness heir and Beatles friend Tara Browne founded it in 1966 as a retail outlet for his Foster & Tara tailoring firm. The shop was successful, but Browne didn't get to see it. Less than a week before the opening, Browne died when his borrowed Lotus Elan roadster crashed into a wall in South Kensington, killing him instantly but sparing his passenger, English fashion model Suki Potier. Browne's the man who "blew his mind out in a car" immortalized in "A Day in the Life." After his passing, Crittle, a Dandie Fashions employee, bought Browne's share of the business.

Browne had been Paul's friend. Crittle was more John's. They liked each other and made each other laugh. John met Crittle, recently arrived in London from his birthplace of Mullumbimby, New South Wales, when he worked for Michael Rainey at Hung On You as a cabinet maker and fabric locator. The more well-bred Rainey tired of Crittle's boorish, beer-drinking ways and urged him to find work elsewhere. Crittle decamped for Dandie Fashions, just a few blocks down the road, in 1966, taking with him a few of Rainey's ideas as well as his client list. John Lennon's name was on the list.

John didn't need much persuading to follow Crittle to his new place of employment. They had already been socializing at each other's homes and in the clubs. They also partied at Dandie Fashions, which stayed open late, making it an exclusive after-hours destination where banned substances flowed as freely as booze. John insisted that Crittle come to the Apple Boutique opening as his personal guest. Crittle sauntered in late in an attention-getting wide-brim hat, white Mongolian fur coat, and single-breasted pin-stripe jacket with satin cuffs and lapels similar to the double-breasted one George wore that evening, also from Dandie Fashions.

"We sold made-to-measure suits in a Regency style in fabric sourced by John Crittle from Berwick Street market and other places," says Alan Holston, a club kid hired to manage the store. "As the business grew, we had more off-the-peg stuff and began to buy in shirts and accessories. We had our own tailoring workrooms, Fosters, which kept our look exclusive. It went down well with the rock fraternity and the Chelsea clubbers."[18]

The boutique's secret was that its clothes were designed not by Crittle but by his fashion-savvy wife, Andrea (née Williams), perhaps better known as the mother of British prima ballerina Darcey Bussell, her child with Crittle. Before they joined forces, she had been designing suits for Hung On You, among other London boutiques. A native of London who had grown up in an eccentric family of means, surrounded by aunts who bought designer clothes, the self-taught designer liked a slim silhouette and came up with a method to create a man's suit that lay close to the body.

"When clothes for men first came out, I thought they were dreadful. The armpits were all too big. Men never looked chic," Andrea said. "I like a fine-looking man as opposed to a body-builder type man and we were all so terribly thin in those days. Eating wasn't fashionable. We were all ema-ciated, really. And so I cut the jackets in panels to shape the men more, a bit like a woman's shape, you know, with the way you cut a jacket with two panels down the front, and I raised the armpit. Men are so easy to dress, actually. Easier than women, anyway."[19]

With his wife quietly at the drawing board and Crittle gregariously front-ing the shop, Dandie lived up to its name, producing trend-setting couture coveted not just by the Beatles but Jimi Hendrix, Brian Jones, and the Who's Roger Daltry. It gained a reputation for sartorial elegance. "We used the most expensive fabrics—lovely silk velvets with silk collars. That is actually why Dandie's never made any money," Andrea explained. "I used to spend days cutting to make suits as slim as possible. We thought it was an art form."[20]

With the Beatles' entry into the business, Dandie Fashions was rebranded as Apple Tailoring (Civil and Theatrical) and promoted as an upmarket extension of the Baker Street store. The new name was written on a plain white placard in cursive script. The placard covered the pris-matic Binder, Edwards & Vaughan wall painting that had adorned the shop's façade since the Tara Browne days. The new minimalist design dovetailed nicely (if accidentally) with the whitewashing of the Apple Boutique, providing the Beatles with a consistent brand presence that

would culminate later in 1968 with the release of *The Beatles*, a double record whose bleached-out cover, designed by British contemporary artist Richard Hamilton, was conceived, in part, as the antithesis of the high artifice of *Sgt. Pepper*. White represented a blank slate, a fresh canvas.

"The Beatles' dress sense is quieting down now, like everyone else's," said Crittle to the press. "They all went mad last year, but now they're all coming back to a normal way of life. . . . We're pushing velvet jackets and the Regency look. . . . We're catering mainly for pop groups, personalities, and turned-on swingers. The teenagers seem too frightened to come in, even though they know this is The Beatles' place. Maybe it's because the place is too elegant and too expensive."[21]

Asserting their control over Apple Tailoring, the Beatles invited Leslie Cavendish, then cutting the hair of Paul, George, and John (but only when John sat still), to open his own salon in the lower level of the King's Road premises. The May 22 launch party took place at the store, followed by a lunch at Club dell'Aretusa. Again, only two Beatles showed up, John and George. John wore a fur coat over a modish white rollneck, making it hard to tell if he was wearing his new store's clothes or not. George made no attempt to hide that he wasn't. He came to the opening wearing a green-and-black floral jacket made from a bolt of William Morris upholstery fabric and a muted orange ruffle-front silk shirt, both from Granny Takes a Trip. By wearing the work of the competition to the boutique he and the other Beatles were publicly supporting, George made clear that he was not going to be crass about promoting it.

The opening was noteworthy for another reason. It marked the first time that John was seen in public with a new love interest, Yoko Ono. John had met the Japanese-born multidisciplinary artist, then at the vanguard of New York's conceptual art scene, in the months before the Beatles left on their prolonged search for an altered consciousness in India that year.

When they went together to the Himalayas, the Beatles all went native, dressing in Indian clothes made for them by a tailor who sat cross-legged on the ground just outside the compound's gates, using an old, hand-operated sewing machine. A local villager, the man worked quickly, churning out the jewel-coloured silk saris worn by all the Beatles' women within days of their arrival at Rishikesh as well as the traditional clothes worn by the Beatles themselves while in India, like kurta pyjamas made of unbleached homespun cotton. "We all had Indian clothes made," Ringo said, "because

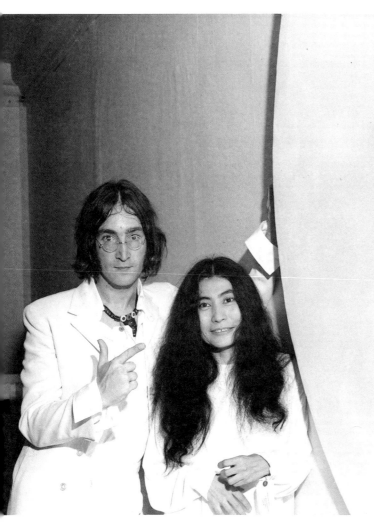

After John met and fell in love with conceptual artist Yoko Ono he renounced
color and wore all white as she did. (Alamy Stock Photo)

they could do it right there: huge silly pants with very tight legs and a big body that you'd tie up tight, Nehru collars. We got right into it."

Yoko didn't go to the ashram with the Beatles, but John had considered asking her. Being out of sight didn't mean she was out of mind. While John was in Rishikesh, from February through April, Yoko sent him a steady stream of haiku-like postcards. "I'm a cloud," she wrote on one of them. "Watch me in the sky."[22] John now saw her everywhere, including by his side.

Yoko wasn't like other women John had known. She was no painted dolly bird. She was an artist, a Juliette Gréco type about whom John had long fantasized. Her clothes confirmed that: black sweater, black trousers, and shoes, "with her long black hair hanging over her shoulders like a bell tent: very Greenwich Village bohemian," said one observer.[23] John found her fascinating. He strongly identified with her. "She's me in drag," he said.[24]

To manifest their connection, John began wearing his hair like Yoko, long, lank, and parted in the middle. He also started to dress like her, abandoning color and busy prints to wear only black or white as Yoko frequently did. John's monochromatic makeover was in evidence when he and Yoko both dressed head-to-toe in white at their first joint art exhibition, "You Are Here, at London's Robert Fraser Gallery on July 1. John's white four-button single breasted suit, an Apple Tailoring design, marked a departure. Yoko's influence on him was glaringly visible. Gone was the extravagance of his haute hippie period. The look now was honest, virginal, a pure declaration of all-consuming love. For John, a new beginning had begun, and he wanted everyone to know about it.

"'We're going all white now,' John Lennon said, and so I was dispatched," said Andrea. "I went all over London looking for white clothes for them to wear—white trousers, white jeans, white jackets. I had to go into all the boutiques to find them. Eventually they had the clothes custom made, which made things easier."[25] On other occasions, John abandoned clothes altogether, posing with Yoko in the nude for a series of full-length photographs taken with a time-delay camera at Ringo's flat at 34 Montagu Square. The adulterous couple (both were still married at the time, as the tut-tutting press kept reminding people) had gone into hiding there, high on heroin and each other, while waiting for John's divorce from Cynthia.

John would use one of the self-made photographs for the cover of *Two Virgins*, the first avant-garde record made by the couple from tape loops compiled during an all-night session that ended with lovemaking at dawn.

Nakedness notwithstanding, clothes played a role in their collaboration. Yoko had arrived for the evening in a purple dress. She told the journalist, Ray Connolly: "John said later that it was a good sign because purple is a very positive color."[26]

Released on November 11, in advance of the *White Album*, *Two Virgins* exposed to the world John's latest quest for renewal. He was beyond giving a damn about his Beatles image.

His nakedness wasn't the only thing noticed in the photograph. He had shaved off the woolly mutton chop sideburns he had been sporting since the "Lady Madonna" promo video at the beginning of the year. That he was suddenly bare-faced again sent the trend spotters into a tizzy. "Since the Beatles had helped set the long-hair trend, as well as trends in music, fashion and lifestyle, this was shocking news," wrote one journalist. "In Hashbury, the East Village, in the Sunset Strip, whispers—not whiskers—were heard, 'Is hair out? Must we shave?'"[27]

Initially, the other Beatles did not share in John's stripped-down aesthetic. For the *Yellow Submarine* premiere at the London Pavilion on Piccadilly Circus on July 17, George, consistent with the burst of sunshine in the film's title sequence, donned a made-to-measure canary-colored suit with matching hat, both Apple Tailoring/Dandie Fashions. Ringo wore a lemony ruffle shirt from the Mr. Fish boutique and Paul a gold satin neck scarf with dark jacket, shirt, and trousers.

The feature-length animated film was another Technicolor vision, rendered in eye-popping psychedelia. The Beatles characters are utopian ideals dressed in surreal, drug-hazed clothes. They successfully subdue the music-hating Blue Meanies, symbols of the establishment. In "All Together Now," featured on the *Yellow Submarine* soundtrack album, the Beatles sing about cosmic entanglement, the interconnectedness of all things. It was starting to sound a bit off. In real life, the Beatles had begun to act more as four individuals as opposed to a tight unit. John's new love interest signified the growing divide.

John now brought Yoko with him everywhere: to the men's room and, more alarmingly, to the Beatles' recording sessions where she sat on Paul's amp, ate George's biscuits, and dispensed unwanted advice to George Martin through a studio microphone. Her presence put everyone on edge. John was either oblivious or uncaring about the effect his new lover was having on the band. His preoccupation with Yoko brought underlying

tensions in the Beatles to the surface and threatened their continued existence.

Yoko wasn't entirely to blame. While making the *White Album,* Paul browbeat Ringo over how he was playing his toms on one of Paul's tracks. Humiliated, Ringo walked out of the August 22 session. "I knew we were all in a messed-up stage," Ringo would later say. "It wasn't just me. The whole thing was going down."[28] But to the public, unaware of the group's internal dynamics, Yoko had cast a spell on John, making him behave in ways unbecoming a Fab. For those who had come to regard the band as a cultural institution, as British as the BBC, this was an outrage. People openly called her witch, weirdo, homewrecker, and worse. They attacked her with racist slurs. Hating this strange, oriental woman became something of a national sport.

In October, John and Yoko's flat was raided by police. The couple was arrested and charged with possession and obstructing the execution of a search warrant. Newspapers had been tipped off by police in advance of the takedown, which involved a large number of plainclothes investigators as well as constables in uniform. One officer had disguised himself as a postman to trick John and Yoko into opening the door at the first knock. But John knew they were coming. A journalist friend had warned him three weeks prior. He had scoured the premises clean of illegal drugs. But he had forgotten about a chunk of hash hidden in a binocular case a year earlier.

John pleaded guilty to possession, sparing Yoko who, as a non-British citizen, faced deportation if convicted. John arrived at Paddington Green police station cheekily dressed in a tailored military-style jacket. Things got nasty when someone in the crowd violently pulled Yoko's hair. The arrest and the viciousness of the fans confirmed the Beatles' transformation. "I guess they didn't like how the image was looking," John later reflected. "No reason to protect us for being soft and cuddly any more—so bust us!"[29]

Solo shots of the Beatles on the inner sleeve of the *White Album* demonstrated how much the image had changed. For the most part, they turned their back on the finery selling in their shops. Only Ringo, in a ruffled shirt and tailored jacket, made an effort to dress up. Paul appeared deliberately unshaven. John, in a faded Levi's jacket, hadn't bothered to comb his hair. George left the top button of his Henley T-shirt undone. The shift from chic to shabby troubled clothing manufacturers and retailers on both sides of the Atlantic, who had come to rely on the Beatles for fashion trends. "Now that they've got the riches the Beatles have gone back to rags," complained

one fashion observer. "Paul McCartney shows up in a floppy T-shirt. Ringo Starr and George Harrison appear in embroidered fur jackets looking like Tibetan yak-herders. And John Lennon has attained the ultimate in informal dress—his latest album cover shows him stark naked."[30]

The band's direct involvement in fashion retail became another target for attack. A newspaper column criticized the Beatles for having turned into shopkeepers, the implication being that they were not prophets of a new era of creativity but mere profiteers. This so infuriated John and Paul that they ordered the Apple store closed. The Beatles held a massive giveaway, an anti-consumerist gesture said to have been Yoko's idea, reinforcing their original concept of giving back.

The event, publicized in London newspapers, caused a massive snaking line to form outside the Baker Street premises first thing in the morning. Everyone wanted some Beatles merch. It was the closest many people would ever get to owning a piece of the band and, by all accounts, it was a frightening sight to behold: "People got in line two and three times, snatching at articles like sharks at a frenzied feeding," said Apple executive Peter Brown. "When all the merchandise was gone, the bolts of raw silks and velvets were torn apart by the crowds. They took the hangars and the store fixtures, too, and no one stopped them until one woman tried to pry the carpeting off the floor. By noon it was all over."[31]

George regarded the mania from a safe distance, unfazed. For him, the boutique had lost its sparkle as soon as the mural disappeared: "Once we were told we had to get rid of the painting, the whole thing started to lose its appeal." The Beatles would quietly withdrew their support from Apple Tailoring, too, but invited Crittle and Cavendish to continue their respective businesses at 161 King's Road, which both did, for another two years.

Closing the fashion business was a blessing in disguise. Even as the store was opening, the Apple Boutique's brocaded bodices and trailing head scarves were almost risibly behind the times. Flower Power had started to wilt with violent political eruptions and burgeoning social movements sowing chaos across the globe. The 1960s had been one of the most tumultuous fashion decades ever and some of the scene's players were exhausted, no longer able to keep up with the pace of change. Michael Rainey and Jane Ormsby-Gore abandoned fashion and London altogether, purchasing a Gypsy caravan that they took on the road to Glastonbury in search of the Holy Grail. "The Flower Power scene had collapsed," said The Who's Pete

Promoting the trippy 1968 film *Wonderwall* at Cannes, George stole the spotlight with an Apple Tailoring pink-striped suit and purple ruffle-front shirt. He would wear the same dandified ensemble when making the *Get Back* project the following year. (Bridgeman)

Townshend, "and Rainey's stuff was no longer the image. He and the rest of psychedelia were soon out of business."[32]

Depression-era clothes, consisting of calf-skimming skirts cut on the bias and chalk pinstripe suits worn with trilby hats, had become the new chic in 1968 thanks, in part, to the release of the Faye Dunaway/Warren Beatty gangster film, *Bonnie and Clyde*, the summer before.[33]

The Apple Boutique's failure to stay on top of the trends was attracting scorn from the London style and counterculture communities. "Those people," scoffed Granny Takes a Trip's John Pearse, "poured a lot of money into the project but had nothing to back it up."[34]

Andrea Bussell agrees: "I had dealings with the Fool, and I thought them dreadful. You'd never seen such tat, and so badly sewn and made.... There were so many talented designers around in those days—Ossie Clark, Jean Muir, Foale and Tuffin. But the Beatles chose them?"[35]

Andrea meanwhile was leaving her husband, who turned out to be another of the group's questionable business partners. When Crittle managed Apple Tailoring, he built a secret chamber equipped with a two-way mirror in the basement of the shop so he could spy on unsuspecting female customers in an adjacent changing room. He boasted of the dirty ruse to Cavendish, showing him how he accessed the lair through a trap door on the ground floor. The Beatles' hairdresser was appalled. Cavendish believed the creepy behavior sullied not only Apple Tailoring's reputation for bespoke sophistication but the Beatles by association. "I was overcome by the first sense of real disappointment in the whole Beatles project," he said. "I'd noticed the lack of financial control at Apple, the rampant alcohol and drug abuse on the premises, and the way a lot of people seemed willing to take advantage of the Beatles' generosity and naivety. But here was my first face-to-face encounter with a close friend and collaborator who clearly wasn't to be trusted."[36]

The Beatles' severance from Apple Tailoring and the Apple Boutique had nothing to do with morality and everything to do with saving face. "We came into shops by the tradesman entrance but we're leaving by the front door . . . they just weren't our thingy . . . Apple is mainly concerned with fun not frocks," declared Paul in a published statement.

"We had to refocus," he added. "We had to zoom in on what we really enjoy, and we enjoy being alive, and we enjoy being Beatles."[37] Which meant getting back to basics.

1969
UNRAVELLING THE THREADS
"Well, we change all the time, really, our style."
— GEORGE HARRISON

The Beatles in their twilight year exude an effortless style. They unselfconsciously mix high and low fashion elements to suit their individual whims and yet they still manage to look harmonized, as if they pulled their outfits from the same chest of drawers. (Alamy Stock Photo)

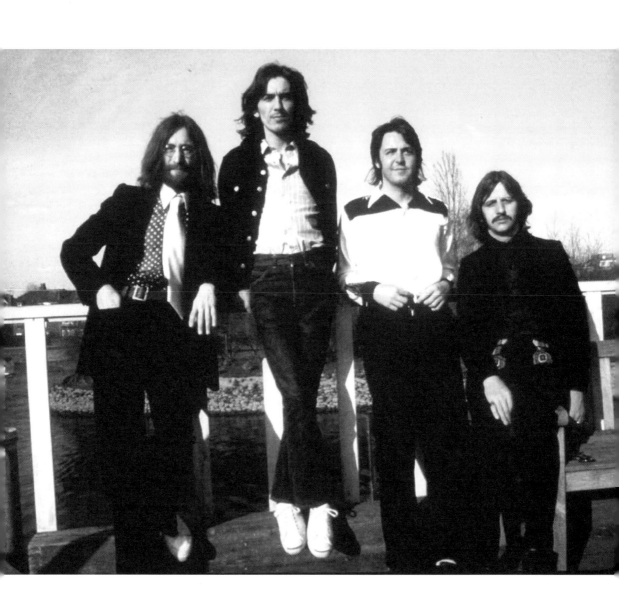

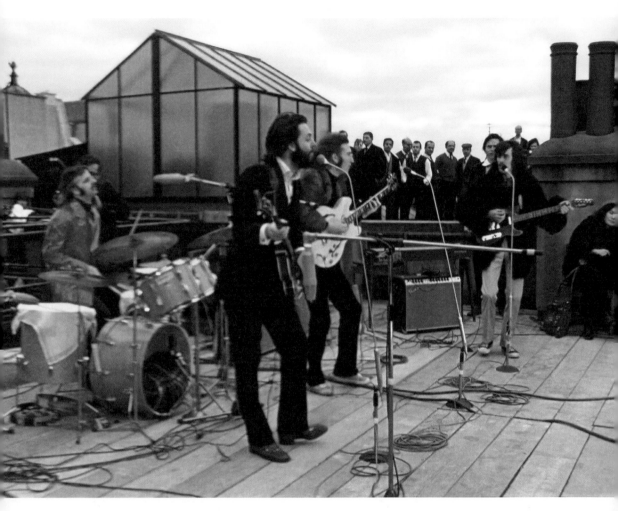

The Beatles' final live concert on the roof of Apple headquarters was a fashion extravaganza teeming with furs, colored togs, and Paul's new bushy beard. (Alamy Stock Photo)

Days into the new year, the Beatles were set on putting 1968 behind them. They met at Twickenham Film Studios to work on an entirely new project, a combination record/film/live performance that would prepare the way for their concert comeback. *Get Back,* as the venture would be called, aimed to return the Beatles to their rock-and-roll roots, to the time before they were stage-managed and overdubbed to a polished sheen.

The Beatles, said producer George Martin, did not want to repeat themselves so they replaced him at the control board with recording engineer Glyn Johns. "They wanted something authentic," Martin explained, something that more reflected the people they were becoming, and something that would demystify the brand. The *Get Back* project would be about showing how the sausage was made. The focus was on process, the often tedious, frustrating, unglamorous side of creating a hit record. The resulting film, the last of three they were contracted to make for United Artists, would present the Beatles stripped of artifice and this push toward late-career unpretentiousness would be evident in their clothes.

John led the way. The year before, he had already assumed a new proto-grunge wardrobe comprising scuffed tennis shoes and Henley undershirts under a black waistcoat, likely part of an old Dougie Millings three-piece hanging in his closet. This might have been John's version of heroin chic. The clothes weren't just down market, they were down and dirty. But it was a *look*. His don't-give-a-shit style made its screen debut with the "Hey Jude" promotional video, shot at Twickenham not six months earlier. Staged as a live performance with an audience squeezing in close on the Beatles as they sang of taking a sad song and making it better, "Hey Jude," one of the band's greatest accomplishments, would provide the inspiration for the *Get Back* project. The video was a first step toward the live concert they expected to play at the end of nearly a month of filmed rehearsals. Michael Lindsay-Hogg, who directed "Hey Jude" in addition to other Beatles' musical shorts, would again be behind the camera. Clothes, too, would carry over. John's "Hey Jude" outfit would appear in *Get Back,* as would Ringo's lime green pinstripe suit and silky high-neck ruffle cream shirt, both Apple Tailoring/Dandie Fashions. George would revisit some of his Dandie-era stripes and frills for *Get Back.* Paul's open-neck shirt, a relaxed style point seen in both "Hey Jude" and *Get Back*, would serve as another link in the chain.

But there was more to *Get Back* than an elaboration on "Hey Jude." Through twenty-one days of studio time, the Beatles wore more than twice the number of outfits. Almost their entire history together as style makers is evident at one point or another: the black rollnecks, the drainpipe trousers, the neo-Regency jackets, the paisleys, pinks, purples, and polka dots. Released the following year as *Let it Be,* the film can be viewed as a showcase of some of the Beatles' greatest sartorial hits.

Peter Jackson's 2021 recut of Lindsay-Hogg's footage, a documentary about the making of a documentary, goes further in establishing *Get Back* as a kind of Forever Fabs runway show. At more than four times the length of the 1969 original, *The Beatles: Get Back* is a three-part operatic spectacle that fully showcases the Beatles' chameleon-like style. Almost every day there's a new look, or two, or three.

The overall impression is boho-eclectic. They've dressed not to be in fashion but to be true to themselves, mixing in high-quality fabrics with proletarian denim and Converse high-tops. Old stage clothes make appearances, including Ringo's 1966 cherry sateen Hung On You shirt, along with such recent purchases as Paul's oatmeal coat with burgundy windowpane check, its padded shoulders forecasting a 1970s menswear trend. George mesmerizes in a pair of embroidered shearling Tibetan boots and a succession of roll necks in such flash hues as rose pink and saffron yellow.

The controversial long hair is now longer than ever. Three of four Beatles have sprouted facial hair. It's one of their shaggiest appearances ever and it confirms their ongoing status as trend setters. The mostly young men in the clean-shaven film crew that shares their sound stage regard the magnificently hirsute Beatles with undisguised awe. Some have collar-length hair, jeans, open-neck shirts, and suede jackets, emulating the Beatles of the *Rubber Soul* period. Glyn Johns, looking very much like a rock star himself, is resplendently attired on set. His double-breasted King's Road jacket with velvet collar, lapels, cuffs, floral shirt, and long bangs and sideburns are emblematic of the group's 1967 peacock period. His clothes are well pulled together, as if from a catalog of former Beatles fashion. But this is 1969 and the band has moved on.

While toned down relative to, say, *Sgt. Pepper*, the Beatles still pop, even in the dimly lit corners of the film studio. Ringo, at one point, dazzles in a sapphire blue jacket and a ruby red satin shirt, and even some

of John's T-shirts are jewel-toned. The palette remains bright even when the mood at Twickenham grows dark and threatens to split the band apart.

The clothes aren't just eye candy, however. They're a barometer of the Beatles at this time in their turbulent history. There are changes afoot and even Paul, the Beatle most invested in matters of self-presentation, can't escape them. When he arrives at Twickenham in early January, he's sporting a new bushy face-covering beard that effectively obliterates his former cuteness. It is one of Paul's best looks in years and in a moment of genuine brotherly love, captured by the ever-present cameras, George tells him so. "I think your beard suits you, man."[1] Paul smiles modestly at the compliment. Even at this late point in the game, they are each other's biggest fans.

George temporarily quits the Beatles after his own songs, now vastly improved, are snubbed by the two Beatles-in-chief, John and Paul. When he returns to the studio, the sessions grow civil again. John's rainbow-stripe Oxford shirt with a pointed collar in lieu of one of his ever-present Henleys signals the shift in the atmosphere. Paul, relentless in his belief that hard work and shared commitment will make all the Beatles' problems go away, wears comforting, old-fashioned, hand-knit vests that reinforce the "daddy" role he has assumed within the group in wake of Brian Epstein's death some eighteen-months earlier.

The Beatles advance that feeling of camaraderie mid-way through production when they relocate from Twickenham, a complex so vast and alienating it reminded George of Liverpool's Lime Street train station, to the comfort of their own building at 3 Savile Row. The Beatles had moved their Apple Corp headquarters to London's fabled tailoring enclave after abandoning their Baker Street boutique the summer before. Apple was the first non-clothing business to take up residence on the row since the opening of the first men's clothing establishment there in 1846. It occupied a stately four-story Georgian townhouse said to be where the bowler hat originated in the nineteenth century.[2] But this wouldn't be another fashion shop (though later in life the building would become one).[3] The plan was to build a recording studio into the lower level of the house, making 3 Savile Row a fully functioning workspace for the band. That fell through when Beatles' friend "Magic Alex" Mardas, who claimed familiarity with electronics, bungled the job. When the Beatles opened the basement door, they

found nothing in working order. George Martin, watching quietly from the sidelines, came to the rescue. A mobile recording unit was brought in from EMI, enabling the Beatles to finish their film.

The rehearsal went much better after that. Billy Preston, a band friend since the Hamburg days, popped by to say hello and ended up joining the sessions. His intuitive playing of both electric piano and Hammond organ, as well as his easygoing manner and ready smile, warmed the vibe in the room. The Beatles invited him back, thrilled by his contributions. John quipped that Preston was now a member of the group, an official fifth Beatle. He is heard on a number of *Get Back* tracks and was the first musician outside the band to share credit on a Beatles record.

Preston not only remained for the duration of the recording but was there on January 30 when the Beatles climbed out of the cozy confines of their basement studio to perform on the roof. The long-awaited concert was to serve as the dramatic climax to their film. It did not come off as planned, largely because there was no plan. The Beatles had been musing about one venue or another since November—London's Roundhouse performing arts venue, a Tunisian amphitheater, a luxury ocean liner, the Cavern in Liverpool, an insane asylum. They couldn't decide on where to play, or if they should play at all. They drove their cigar-chomping director almost to distraction. Ringo might have been the one to suggest the rooftop in the end; he liked the city views it afforded. Lindsay-Hogg scrambled up there, saw for himself an expanded horizon for the Beatles to perform in, and the venue was finally set.

Cameras were hooked up on adjacent buildings and on the street below to achieve a full spectrum presentation of what would become one of the most celebrated concerts in pop history. There was no audience *per se*, just startled pedestrians—groups of mini-skirted secretaries and shirt-and-tie clerks who spilled out of offices to watch the Beatles rip through loudly amplified versions of "Get Back," "Don't Let Me Down," "Two of Us," and other songs they had been tooling all that month.

Paul was the most reluctant Beatle to climb the stairs that day. Until the last minute, he was holding out for a much bigger platform. The Beatles were superhuman. They deserved the Greek amphitheater. He didn't want back-to-basics to mean a diminution of the band. John basically told him to shut it, they were going to the rooftop and playing. Paul fell into line and followed the leader out into the cold.

The temperature that day measured 45 degrees Fahrenheit. It was relatively mild for the dead of winter. But an impending fog, a result of high humidity levels, made the air feel icy. Two of the Beatles had arrived at Apple wearing fur coats. George's was the same black Mongolian lamb piece, designed by Mary Quant, that he had worn on his wedding day in 1966. John's tawny mink, a woman's hip-length coat, was a recent purchase, a vintage find that likely came from a King's Road antiques market where Pattie and her sister Jenny Boyd had a stall.

John had been photographed in the mink at the Apple Tailoring on two occasions in 1968. It was not a stylish coat. It was something his Aunt Mimi might have worn to church. John wore it almost ironically, parodying what once had passed as elegant middle-class dressing. Yoko had given John license to be quirky and he had begun to wear garments with no resemblance to Beatles clothes. He wore the second-hand fur so often in her presence that it gave rise to rumours that it belonged to her, not him. This does not appear to have been the case. When they were arrested for cannabis possession the year before, a scantily-clad Yoko had grabbed John's mink to cover herself, and as seen in photographs from that day, it was far too big on her.[4] When John wore it, the sleeves fell short on his arms, but otherwise sat comfortably on his shoulders. It claimed him.

John wore his ladies' coat nearly every day of the *Get back* sessions, including on the roof. More devotedly masculine men—from Canada's Prime Minister Pierre Trudeau to New York Jets quarterback Joe Namath to auto racing champion Jackie Stewart—were quick to follow his lead, establishing yet another trend in men's fashion.[5]

Although Ringo didn't wear fur that day, he, too, wore a woman's coat: his wife Maureen's bright red slicker, another Mary Quant design. "I tried not to get wet," he said by way of explanation.[6]

Paul seemed intent on ignoring the chill that day. He performed in a slim-fit three-piece black wool suit, brown leather loafers, and a white and gray pin-stripe shirt unbuttoned at the throat. Jumping up and down on the makeshift wooden floor laid down only the night before, Paul seemed oblivious to the piercing cold. He screamed and flailed and raised the heat on a throbbing bass line that caused windows to shake in their casements.

The Beatles' performance seemed to melt the reserve of staid Savile Row. Passersby on the street craned their necks, most of them instantly recognizing the Beatles' sound. Roving cameramen canvassed their

often joyous reactions. The Beatles were back where they belonged, playing rock-and-roll as nature intended, although the choice of a rooftop did perplex them.

Inevitably, there were critics who deemed the concert an assault on the neighborhood. Police were called. A pair of young bobbies assigned to restore the peace at 3 Savile Row couldn't quite figure out how to turn the noise off once they arrived on the premises. A hidden camera in the foyer captured their consternation over the stalling tactics of a wily Apple receptionist and a polite but purposefully unhelpful Mal Evans. Only when threatened with arrest did Mal lead the law enforcers to the roof where he was ordered to unplug an amp. Annoyed, George plugged it right back in again and continued, defiantly, to play his guitar. He even hiked up the volume. Paul whipped his head around to catch sight of what he sensed was the perfect dramatic ending to their film about the Beatles being Beatles. His bushy beard couldn't hide his glee at that moment. The Beatles had done it. Still pissing off the establishment, after all these years.

"Savile Row didn't really welcome the Beatles," said Apple's PR man Derek Taylor. "Many of the shopkeepers there, silly, snobbish, growly, obsequious people, believed that since they had been selling marvellous suits to marvellous people, they had a right to be the *only* ones there which is about as daft as you can get…. When the Beatles gave their wonderful concert and, however briefly, gave West London a shining hour of absolutely unique excitement, in 1969, it was the stiff-necked shits of Savile Row who called in the law and had the music stopped."[7]

The Beatles would have their revenge. Within weeks of their rooftop concert, the Beatles ushered in another disruptive element to venerable Savile Row. His name was Tommy Nutter. In 1969 he launched the first bespoke tailoring shop on the street in more than a century. Nutters of Savile Row took premises at number 35a, on the same side of the street as Apple. The proximity was no accident. Nutter was backed by friend Cilla Black, a Liverpudlian singer managed by his boyfriend at the time, Apple's Peter Brown. His 540-foot showroom launched on Valentine's Day with a splashy party attended by Paul, Twiggy, her paramour-manager Justin de Villeneuve, and other members of London's 'In' crowd.

The shop received a precious load of Beatles-endorsed publicity. Brown had dressed the Apple Corps doorman in a Nutter frock coat, giving everyone who came to No. 3 on Beatles' business a sneak peek of his

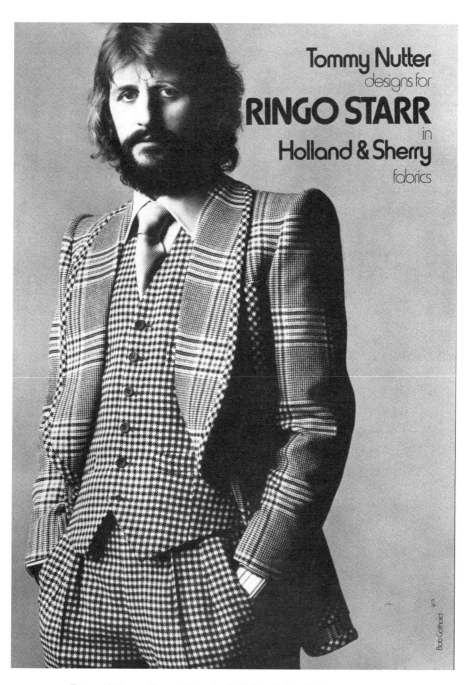

Tommy Nutter was the new kid on the Savile Row fashion block. Ringo modeled one of his signature clashing pattern suits in an advertisement for Holland & Sherry fabrics that ran in *Vogue* magazine. (Alamy Stock Photo)

new-Edwardian style. The Beatles were all customers, their clothes custom-made by Nutter's master cutter, Edward Sexton. "So, the Beatles, because of Tommy's social life, started to come to us," said Sexton. "They wanted quality. And they wanted something different, something new, something fresh. They gave the fashion industry something new to write about. We got massive ink on our show room and on our business because of them. That all contributed to our success."[8]

It wasn't just Nutter's connection to rock's elite that made him stand out from the staid Savile Row crowd. According to Hardy Amies, couturier to the Queen, Nutter knew his way around a bespoke suit. "Tommy Nutter is the most exciting tailor on Savile Row in several decades," he declared. "Marvelous tailor, Tommy Nutter. Absolutely marvelous."[9]

The emphasis was on menswear, but women shopped their too, among them the young and beautiful Bianca Pérez-Mora Macias who started wearing bespoke Nutters suits following her 1971 wedding to Mick Jagger, and Yoko Ono who arrived early on with John. Whether for a woman or a man, the look, according to Nutter's biographer, Lance Richardson, was elegant and eye-catching:

> Edward was an expert at building hacking jackets: long, full-bodied coats originally made for horseback riding, with wide skirts that could spread out across a saddle. The Nutters silhouette took this template and exaggerated it, adding 'masses of shape and flare' to the skirt, as Tommy once explained, and a tight waist and chest that would emphasize the wearer's body. To this close-fitting creation ('long and leafy,' said Edward) they then went totally overboard on the width of the lapels, adding double-breasted lapels to a single-breasted coat that were so enormous they grazed the sleeve heads. The coat pockets were straight and flapped, with the outside pocket cut 'deep, deep.' The waistcoat also supported seriously capacious pockets. The trousers, by contrast, were such a snug fit that pockets were impossible, though these were suits for people who liked to move, so there was flexibility there too. The full effect, when you stepped back and took it in as a whole, was pleasing to the eye; it displayed a 'gallant Nutter character' that *Punch* would once memorably pin down as an 'eccentric mix of Lord Emsworth, the Great Gatsby, and Bozo the Clown.'"[10]

Nutter, who died in 1992, was not a tailor. He never had the training, although he had apprenticed for seven years as a Savile Row salesman, which gave him a deep understanding of the rules and traditions of classic British menswear. A great looker and dresser with an impeccable eye and a knack for public relations, Nutter could design a man's suit using only his imagination. Sexton brought Nutter's ideas to fruition, no matter how outlandish, lavishing on them the attention to detail which was a hallmark of his craft. "The thing about our clothing," said Sexton, "is that although our cut was very different, it was made in the true tradition: hand tailored in Savile Row, all the handwork, everything was in there as it was a hundred years ago. But the style was completely fresh; it was really out there. It was modern, it was edgy, it was elegant. It was just amazing." Which is why the Beatles liked it.

Ringo wore one of the house's signature clashing-patterns suits in an advertisement for Holland & Sherry fabrics in *Vogue*. Paul went further, incorporating Nutters into the very fabric of his personal life. On March 12, now clean-shaven, he married American rock photographer Linda Eastman in a black single-breasted Nutters suit. When Stella McCartney, one of the children of that union, later declared her desire to become a fashion designer, Paul insisted she apprentice to Sexton, her mentor for many years in the tailor's art of cutting, tacking, and hand-stitched finishes. "Paul," said Sexton, "really appreciated the craft of what Nutters provided. He really respected that, so much so that when his children were growing up, he used to sit and talk to them about the experience of having clothes made for him. He instilled it in them."[11]

Paul had wanted his wedding to be a low-key affair. He had not invited any of the other Beatles to the ceremony, hoping to avoid a scene. As it happened, Ringo was away filming *The Magic Christian* with Peter Sellers and wouldn't have been able to make it. The press still came out in force, guaranteeing that Paul's wedding was a scene. Scores of weeping and fainting fans clogged the street out front of the Marylebone Registry Office, making best man Mike McGear,[12] Paul's younger brother, late for the ceremony. More had prostrated themselves in front of Paul's Cavendish Avenue home, devastated that the last bachelor Beatle would no longer be available to them as their fantasy boyfriend/lover/husband-to-be. The event itself was otherwise low key and totally lacking in glamor.

Linda was nearly four-months pregnant, precipitating Paul's rush to marry. To hide her expanding belly, she wore a belted V-neck daffodil-yellow wool coat over a plain beige dress worn with black opaque stockings, a look more practical than fashionable. Besides a black Nutters suit, Paul wore a tie the same sunny shade as his new wife's coat, signaling his commitment. Linda's young daughter, Heather, wore dark tights like her mother. Paul would soon formally adopt Heather. He was at heart a family man.

George and Pattie were expected to attend the lunch reception post-ceremony at the Ritz but were waylaid by Detective Sergeant Norman "Nobby" Pilcher, the same bent cop from the Metropolitan Police of London drug squad who had busted John the year before. Pilcher chose Paul's wedding day to orchestrate a raid on George's home. The search turned up a chunk of hash, which George and Pattie both swear Pilcher planted (he would eventually serve jail time for concocting evidence) but which nevertheless saw them whisked away for fingerprinting and sentencing. George complained that the papers covered their arrest "like a fashion show: George was wearing a yellow suit and his wife Pattie had on." On the other hand, a clotheshorse like him should have been accustomed by now to public fascination with his appearance.[13]

John learned of the frenzy from the TV news and vowed to do things differently when he married Yoko eight months later. He wanted no fans throwing fits, and no fashion show, either. He wanted to wed offshore, far from the madding crowds. After various ideas for a safe location fell through, Gibraltar, a British Overseas Territory, ended up as the default site of John and Yoko's nuptials. It was the only place they could wed hassle-free with a modicum of bureaucracy.

After all the research that went into finding a locale, the wedding itself was rushed. On the morning of March 20, John grabbed Yoko by the hand to board a private plane and fly three hours for what ended up being a ten-minute ceremony at the British Consulate. They had been in Paris and hadn't the time, or the inclination, to buy themselves new wedding clothes. Yoko wore what she had traveled in, a multi-tiered woolen mini skirt with knee socks, running shoes, signature big black sunglasses, and a floppy hat. John, now fully bearded, wore a miscellany of mismatched suit pieces including a double-breasted corduroy jacket with flap pockets and a patch pocket cut on the diagonal, from one of Pierre Cardin's ready-to-wear

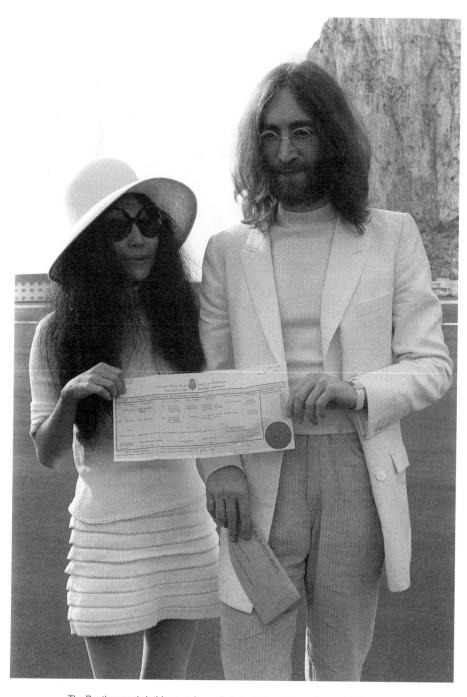

The Beatles used clothing to telegraph their choice of new primary relationships. John dressed in white like Yoko for their wedding in Gibraltar. (Alamy Stock Photo)

Paul married Linda Eastman in Chelsea wearing a tie in the same marigold hue as his bride's coat dress. (Alamy Stock Photo)

collections.[14] "I couldn't find a white suit," said John. "I had off-white corduroy trousers and a white jacket. Yoko had all white on. . . . It was very romantic."[15]

Where their wedding had been private, involving only themselves, a registrar, and Peter Brown together with Tommy Nutter's brother David serving as witnesses, their honeymoon would be a public spectacle, viewed by millions around the world. John and Yoko had decided to use their celebrity status to advocate for the end of conflicts in Vietnam, the Soviet Union, China, and Northern Ireland. They invited the world's press to watch them lie in bed as a soft protest. Yoko had conceived the bed-ins as an extension of her own interactive conceptual art, in which dreamscapes and themes of peace had dominated for years.[16]

Few knew what to expect when the first of the week-long bed-ins commenced at the Amsterdam Hilton on March 25. Anyone who had arrived at the hotel thinking to see John and Yoko naked, as they had been on the cover of *Two Virgins*, came away disappointed. "They fought their way in, and their faces dropped," John would gleefully recall. "There were we like two angels in bed, with flowers all around us, and peace and love on our heads. We were fully clothed; the bed was an accessory. We were wearing pajamas, but they didn't look much different from day clothes—nothing showing."[17]

Their modest clothing belied their growing notoriety as exhibitionists. John and Yoko's pyjamas projected prim and proper: a white cotton high-neck Victorian nightgown with delicate floral embroidery and lace at the sleeves on her; a white-on-white striped cotton set with blue piping round the lapel on him. Later that year, the couple would screen an experimental art film showing John's semi-erect penis in slow motion. He would also face obscenity charges for a series of erotic lithographs he made with Yoko. The London gallery in which they were displayed was raided.

John was studiously crafting a new identity outside the Beatles. It was part of his ongoing personal quest for authenticity but his identity was in flux. People were uncertain what to make of it. Ringo, interviewed on the set of *The Magic Christian*, was asked what he thought was going on. "I know a lot of people there are saying that [John] has gone a bit crazy. But all he is doing is not keeping up with the image they have created and they think he has gone off his head," he told *New Musical Express*. "People have

really tried to typecast us. They think we are still little moptops, and we are not."[18]

The proof lay in Ringo's own appearance. "Except for a pink and gray scarf tied John Wayne-style around his neck," it was reported, "Ringo is dressed entirely in black—black silk shirt, black pants, black socks. His fingers are festooned with two rings, a white gold wedding band on his left hand and an opal on his right pinky."[19]

All the Beatles were in the throes of personal transformation. They were men approaching their thirties with wives and children and other responsibilities, as well as interests outside the band. Paul and George were not far behind. The youngest, George, went along to EMI studios on Abbey road on his twenty-sixth birthday, February 25, to tape a few songs without his bandmates, including "Old Brown Shoe" and an early version of "All Things Must Pass." Paul was also there that day, recording the young Welsh-born singer Mary Hopkin and a new group called Badfinger (discovered by Mal Evans) for whom he had written the chart-topping single "Come and Get It."

Although following individual paths, John, Paul, George, and Ringo remained a unit. They continued to create together and play together. They still craved each other's company, even as John and Paul had differing ideas about the Beatles' business affairs. While making *Get Back*, John, with Yoko, met up with Allen Klein, a gruff and not altogether trustworthy New York businessman who had secured for the Rolling Stones a better record deal than the Beatles had with Capitol. After a January 29 dinner during which Klein flattered John and Yoko with scrupulously researched flattery about their respective geniuses, John impulsively signed Klein as his manager. He wanted Klein to manage all of the Beatles and proposed it to the group. George and Ringo went along with the idea. Paul was vehemently opposed. He wanted his new in-laws, the powerful New York entertainment lawyer Lee Eastman and his son, John, to work for the Beatles. This difference of opinion would eventually split the Beatles irrevocably. Until then, the bonds of friendship held.

On April 14, John and Paul teamed up to record "The Ballad of John and Yoko," a jaunty a-side about John's picaresque wedding adventure on which they played all the instruments and shared vocals. Linda McCartney shot the cover photo, depicting all four Beatles with a masculinely attired Yoko, a few days later. George is head-to-toe in denim. Paul and Ringo both have on rollnecks. John, like Yoko, wears a tie. John and Yoko are also alike in

both wearing white socks and tennis shoes with their tailored ensembles. Other photos from the session published decades later reveal that Paul's socks are bright yellow, a nod to Teddy Boy style, and a sign of his frequent flashes of brilliance within the band.

Paul would soften his rock-and-roll edges on May 4 when he and John met up with Ringo at *The Magic Christian* wrap party in London's Les Ambassadeurs nightclub. All three Beatles dressed in suits from Nutters, John in crumpled white linen and lace chemise, Paul in an indigo wool jacket with pinstripe trousers, and Ringo in a neo-Edwardian style jacket with a textured beagle collar shirt and flowing silk neck scarf. While drawing from the same sartorial well, they were selecting different things as evidenced by the disparate cuts and fabrics. The results varied. Ringo by far was the sexiest Beatles that night, John the most androgynous, despite his caveman beard, and Paul, in a generic striped tie, the least eccentric. Paul's suit had classic lines and his shirt, with its large cuffs protruding from the jacket's sleeve, had a gleam that suggested a luxurious cloth, the very portrait of understated elegance.

Paul again wore a tailored suit when he and the Beatles reassembled at EMI headquarters for a photo shoot for the not yet finalized *Get Back* album on May 13. It had been John's idea to recreate the *Please Please Me* cover image shot by Angus McBean at EMI House in 1963, a furthering of the back-to-roots concept. "So we made the last album cover an exact replica of the first album cover," said Paul. "We were very conscious of having come full circle."[21]

The Beatles appear to have enjoyed the photograph. They are all smiling broadly as if relishing their own self-parody. But they had all taken an aversion to the album for which it was intended. They couldn't be bothered to mix the hours of tape from the month-long *Get Back* sessions and so abandoned the project until it was resurrected a year later with a new name and a new producer, the notorious Phil Spector.

Soon after *The Magic Christian* party, Ringo and John made plans to travel together on the new super deluxe Queen Elizabeth 2 ocean liner to New York. John was prohibited from boarding the ship when he arrived with Yoko at the English port city of Southampton. His cannabis bust the year before disqualified him from getting a visitor's visa to the US. Ringo made the voyage without him, accompanied by Derek Taylor, who handled public relations for Apple, and their respective wives.

John had been looking forward to the trip, a pleasurable break before the business of bringing his "advertisement for peace," as he called it, to North America. He and Yoko had decided to take the bed-in on the road. New York was to follow Amsterdam but when John was denied entry, he rerouted the enterprise, first to Freeport in the Bahamas, where the heat and humidity made the prospect of a week in bed unappealing, and then to Montréal, Canada, close enough to the US to attract its media. On May 26, John and Yoko checked into Montreal's upscale Queen Elizabeth Hotel for what would be an eight-day stay. They brought with them "twenty-six pieces of baggage, and various white suits," plus a film crew to record the event for posterity.[22]

According to Jerry Levitan, a besotted fourteen-year-old Beatles fan who tracked John down in a Toronto hotel room after hearing on the radio that his idol was overnighting there en route to Montreal, there was a large trunk among the baggage. "It was the kind of thing you might see on the Titanic," recalled Levitan, who later wrote a book about the encounter. "I helped him push it up onto a hotel bed, and we were nose-to-nose, and I still remember what he smelled like—a kind of antiseptic scent, whether British soap or spearmint gum, mixed with the smell of Gitanes, which was everywhere."

Once the trunk was in position, John opened it up, allowing Levitan a glimpse of the contents: "I don't remember everything in it, other than that there was a lot of colour, and everything was very organized."[23]

It's not clear if John wore much of the gear brought on the trip. Every day, from nine in the morning until nine at night, he lay with Yoko in bed dressed only in his pyjamas, entertaining as many as 1,500 journalists on the subject of peace. Some of the interviews were done in person, others by speaker phone or, in the days before satellite, remote hook-up. The Lennons occupied rooms 1738, 1740, 1742, and 174 but didn't have much privacy. John was a magnet for American celebrities. Visitors included LSD guru Timothy Leary, comedians Tommy Smothers and Dick Gregory, poet Allan Ginsberg, pop music journalist Paul Williams and cartoonist Al Capp. Fellow Brit Petula Clark showed up as well. Yoko's six-year-old daughter, Kyoko, by her former husband Tony Cox, was in the entourage. On June 1, John corralled them all into singing "Give Peace A Chance," a song he improvised on the spot, recording it on a four-track tape machine rented from a local recording studio. John would release his anti-war anthem on

the Apple label in July. The single rose to the No. 14 spot on *Billboard* and to the Number Two spot on the UK charts.

At John's insistence, Derek Taylor ventured to Montreal after disembarking from the QE2. He reported on the bed-in for *Beatles Monthly*, describing it as "a big People Theatre," brimming with creativity and chaos. Among Taylor's specific tasks was supplying John and Yoko with fresh bed clothes each day of their Montréal stay.[24]

A journalist on his way to the bed-in stopped by the flagship location of Canada's Le Château chain of hip clothing stores at Victoria Square, a short stroll from Queen Elizabeth. He ran into founder Herschel Segal and invited him to come to see John and Yoko. Born in 1931, Segal was a huge Beatles fan, playing the group's music in his stores. His appreciation of them had grown after he sold them armloads of Le Château clothing when they played the Montréal Forum in 1964. "We closed down the St. Catherine's Street location for them," said Segal. "They bought shirts and pants that they wore their way. They were great. They were fantastic. They were artists."[25]

Le Château had many celebrity clients, among them Rudolf Nureyev and Andy Warhol. They came for the sexy tight-fitting leather ensembles made at Segal's family-owned manufacturing facilities in Montréal. "We were the IN store of the late 1960s. All the stars came to us for the styles. We had good styling." Segal's selection included knitted imports from Italy, tailored suits from France, and the latest "youthquake" fashions from Carnaby Street, all handpicked by Segal on buying trips. He would go to all the London boutiques looking for designs he could knock off and mass produce for the Canadian market, including miniskirts and bell bottoms. Access to his own manufacturing facilities enabled Segal to customize what he found. He made a killing with hipsters, tweaking the original London design to fit women. "We were among the first to do the unisex look," said Segal, "and this made our reputation. We always sold men's and women's clothes together."[26]

One of Le Château's biggest sellers was a zip-front jumpsuit for men and women. The form-fitting garment had two square pockets at the breast and two more at the hips and slightly flared legs and sleeves. It came in a variety of colors and fabrics that changed with the seasons. "It was our biggest item," Segal said. "It was kind of a uniform. We sold them until the cows came home."

Sitting cross-legged on the floor across from John at the Queen Elizabeth Hotel, Segal offered to get John a couple of the jumpsuits, one for him and another for Yoko. John couldn't pick them up himself so hotel bellboy Tony Lashta was dispatched on his behalf.[27]

The unisex jumpsuits were made of black velour, a plush knitted fabric with stretch built into the material. They were tight-fitting but extremely comfortable. As is plainly seen in photographs taken August 22 at Tittenhurst Park, his new seventy-two-acre estate in Sunninghill, near Ascot, John wore his without underwear. He also pulled the zipper down to show some chest. He looks at ease in his own skin. While his long hair and beard give him a slightly feral look, the jumpsuit, soft and supple, tempers any hint of aggression. John wasn't playing the tough guy anymore. He was flirting with his feminine side, accessorizing the mass market jump-suit with a wide brim hat with a purple satin band, likely a Herbert Johnson design, a funky Aztec-patterned hip belt/fanny pack, and a delicate chain and pendant necklace. All that remained of John's former bad-boy persona were his sleek black leather Beatle boots.

The day's shoot would appear on the cover of *Hey Jude,* a compilation album released in the US by Capitol records the following year. It would be the last time all four Beatles were photographed together, although no one knew it at the time. "It was just a photo session," said Ringo later. "I wasn't there thinking, 'Ok, this is the last photo session.'"[28]

None came dressed for the end of the world, in other words. It was just another chance to get together and pose.[29] They hadn't conferred over how to present themselves; they dressed according to individual whims, and yet there was synchronicity.

Both John and George sport eye-catching hats. John's looks like a Spanish sombrero while George's ten-gallon hat invokes the American frontier. George, in a great fitting pair of skinny cut Levis, also wears a neo-Edwardian jacket and neck scarf, as does Ringo. Both George and Ringo's jackets are from Nutters, as is Paul's blue suit. The artful splicing of proletarian elements and Savile Row tailoring exudes confidence. The Beatles are rock stars all right, but rock stars keeping it real.

For some of the photos taken that day they stood unsmilingly amid tall windblown grasses, looking like a wild bunch of defiant outlaws. It was exactly the outsider image they had been courting since the beginning, created with ingenuity from a blend of American and British inspirations.

The Tittenhurst photos set in amber the Beatles' nonconformist vibe, English dandies with a cowboy attitude.

Largely at George's insistence, the Beatles were paying attention to The Band, the former backing group for Bob Dylan and Ronnie Hawkins, even going so far as to mimic aspects of their simplified style. George especially appreciated The Band's performance versus the studio approach to music. He incessantly played *Music From Big Pink*, the group's debut album, during the filming of *Get Back*. The Tittenhurst photo session, showing the Beatles in blue jeans, wide-brim felt hats, flared jackets, and scarves tied bandana-style around the neck, mirroring the backwoods aesthetic of The Band's record cover.

"That was a lovely compliment," said Robbie Robertson, The Band's principal guitarist and songwriter. "But it wasn't a look. It was just the way we dressed every day. And then it became so influential in the culture, in the music, in the sound and the look of everything. We weren't involved in any way in trends or in anything that was happening. All we knew was that we were not on anyone else's road."[30]

The same could be said of the Beatles. "They had their own style of dress sense, the way they wanted to look. They were all dressing individually. They did it themselves," said Edward Sexton. "They weren't trend followers, let me just say that to you. They were very self-minded and they knew what worked well for them."[31]

The Beatles' individual style sense is immortalized on *Abbey Road*, their last recorded album released in September 1969. One of the most visually quoted pieces of pop music history, the cover image depicts John, Paul, George, and Ringo striding single file across the zebra crossing near EMI Studios. They are portentously walking away from the building that had been their musical home since they cut their first single in 1962. They are united in purpose and dress. With the exception of George in denim, a look reflecting his growing interest in country rock, John, Paul, and Ringo wear suits by Nutters of Savile Row, a masterful stroke of marketing for the fashion house. It happened by accident.

The Beatles had come to Abbey Road that afternoon to record three tracks for the new album: "Oh! Darling," "I Want You (She's So Heavy)," and the aptly named "The End." It was a working day. The clock was ticking. There was a deadline, and the goal-driven Beatles were anxious to get the photograph out of the way. John, dressed in the same white suit,

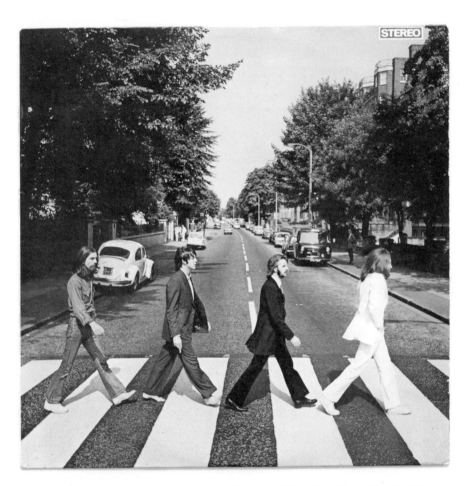

Three of the Beatles wore suits by Nutters on the cover of *Abbey Road*. (Alamy Stock Photo)

lace shirt and Spring Court tennis shoes he had worn earlier to the *Magic Christian* party, was especially antsy. He shouted at Scottish photographer Iain Macmillan to get a move on.

It had been Paul's idea to have the Beatles advance on the zebra crossing. He had sketched what the image should look like. The Beatles smoked and chatted among themselves as they waited for Macmillan to set up a step ladder in the middle of the road to accommodate Paul's vision of the band on the move. When it finally came time for the Beatles to pick themselves off EMI's front steps, a policeman was called to stop traffic. As the four fell into single line formation on the curb, Paul adjusted Ringo's collar, John tucked in the back of his shirt, and George lost his oversized tortoise shell shades. "Come on, lads, hurry up now, keep in step," called John, impatiently leading the way.[32]

The Beatles traversed the road six times before John ordered them all back into the studio. Paul, after examining the transparencies, would pick the fifth crossing as the cover image. It was the one where they were most in synch.

"Now, that *Abbey Road* shoot, let me tell you—you couldn't have orchestrated that or planned that if you tried," said Sexton. "We didn't have any PR people involved or any stylists involved. That is what they chose to wear themselves. Thank God, we get the credit for that. They were our clothes, with the exception of George's."[33]

How can he be so certain? John's suit, for instance, is sometimes attributed to another designer, the French couturier Ted Lapidus, famous for getting Twiggy out of a mini skirt into a double-breasted suit and tie. Lapidus and Lennon mused about opening a chain of ready-to-wear boutiques together, an idea that went nowhere, and John did commission at least one white bespoke suit from the designer but not the one worn on the cover of *Abbey Road*. "Oh, I know the signature of my clothing," harrumphed Sexton from the Knightsbridge showroom where he continued to work, well into his seventies. "I have always believed in strong architectural lines in my clothing. I love a strong shoulder. And a great lapel. I love a great lapel. We call it the Sexton appeal—collar, shoulders, and sleeves. All that, and the high armhole, and then the long thin body coming in at the waist and the gentle flare off over the hips. I like my jackets just a tad longer than most people's."

Scrutinizing an image of the *Abbey Road* cover sourced on the Internet, Sexton pinpointed some of the tailoring details in the Beatles' clothing:

Paul is wearing my suit; it's got my shoulders, it's got my lapel and it's got a slight flare in the trousers. It's been done in a blue Hopsack. Ringo, he's wearing a longer jacket; that's probably a black gabardine. Again, it's quite a long jacket and that's quite Edwardian, but he's still got the slight flare on the trouser, and he's wearing traditional shoes with that. And then coming forward, is John who is definitely wearing a white linen, with that same waisted flared look, a slight flare on the trouser.

Paul is barefoot in the photo. The day was sweltering hot. He kicked off his sandals just before crossing the road. John later said that this was how Paul often asserted his style, by wearing one thing that was just a bit off—yellow socks for instance, or, in this case, no socks at all.[34] For Sexton, it's further proof that the Beatles had their own style. "That's called English eccentricity," Sexton said, "where you've got great taste and you can make it look wonderful and exaggerated by just having the knack to see where it goes. It doesn't necessarily have to blend in. It just works. It's street fashion."

Paul later said that he owed his barefoot bohemia look to Sandie Shaw, the 1960s British singer who frequently performed without shoes. Unknown to the public, she had been born with misshapen feet. Going barefoot became her signature style and marked her as one of the decade's IT girls. Paul liked her aura of unconventionality. When he walked barefoot across Abbey Road, he considered it a homage to a performer he admired.

However innocent Paul believed the gesture to be, he courted trouble by removing his shoes. Not since John had appeared nude on the cover of *Two Virgins* would a Beatle's lack of clothing generate so much controversy.

Conspiracy theorists read the photo as evidence that Paul was no longer among the living. Shoelessness is a Mafia symbol of death. The man in the blue Hopsack on the *Abbey Road* album cover was a Beatle lookalike, an imposter filling in for the real Paul McCartney who had died in a motor vehicle accident in 1966. George, all in denim, was supposedly the gravedigger. Ringo, all in black, was the undertaker. John, all in white, was the spiritual figure who had guided Paul's barefoot corpse to the other side.[35]

There were other clues to Paul's demise, also embedded in clothing, said a US radio deejay whose hoax broadcast on October 12 spread the conspiracy around the world. For instance, Paul's black carnation on a white tuxedo in *Magical Mystery Tour*. And his OPP (a.k.a. Ontario Provincial

Police) badge on the left arm of his *Pepper*'s suit could be read as OPD, a false acronym for Officially Pronounced Dead, due to a fold in the blue satin material.

The Paul is Dead rumor, as Ringo put it, was part of the madness that had been swirling about the Beatles since the beginning.[36] They tried to deny it but some people wouldn't believe them. The Beatles decided to use it to their advantage. "It's just insanity," said John, "but it's a great plug for *Abbey Road.*"[37] The record would become one of the biggest-selling albums of all time.

There was only one way in which allegations of Paul's death weren't entirely far-fetched. He had started to become dead to John who replaced him with Yoko Ono as his partner in all things creative. The signs were there for everyone to read, again embedded in their clothes.

Paul was wearing suits with clean lines. John's clothes had become kinky, even disordered, as he pulled away from the group and embraced a range of artistic projects and activist causes in collaboration with his new wife. Paul had gravitated to darker hues. John was wearing bride white, symbolic of his new conjugal existence. On the cover of *Abbey Road*, he's the first Beatle seen walking away from the studio where the band was recording its last album together. John was making a break. Paul would be left behind.

When John informed his song-writing partner he wanted out, he couched it in marital terms, declaring to Paul that he wanted a divorce. Like many break-ups, the end came suddenly after a long build-up. John blurted out his intentions at an Apple business meeting on September 20, about a week after performing a live gig at the Toronto Rock 'N' Roll Revival outdoor concert. Instead of his usual bandmates, he'd played with Eric Clapton on guitar, Klaus Voormann on bass, and Alan White on drums. This ad hoc Plastic Ono Band had been assembled last minute and rehearsed only on the international flight over. Yoko was central to the enterprise. She wailed and writhed in a bag as John, again in white, performed "Cold Turkey," his latest solo composition about coming off heroin. Documentarian D. A. Pennebaker caught it all on film. Yoko performed some of her avant-garde works, including the freak-out number, "Don't Worry Kyoko (Mummy's Only Looking For Her Hand In the Snow)," which the crowd loudly booed.

John was just as free form, at one point getting his players to lean their guitars against the amps while they stepped back for a smoke and allowed

the feedback to take the spotlight. Even though he had vomited in the wings from nerves, John was invigorated by the experience. "The buzz was incredible," he said. "I never felt so good in my life."[38] On the flight home, he resolved to leave the Beatles. Paul had been right all along. What they needed to get their mojo back was a return to raw rock and roll. Paul just hadn't meant for John to do it alone.

After John clumsily broke his news, Paul packed up his newborn daughter, Mary, his newlywed wife, Linda, and new stepdaughter, Heather, and high-tailed it to his remote property in the Scottish countryside. There he drank whiskey for breakfast, lunch, and dinner. Most days, he could barely get out of bed. He had fallen into a deep depression, lost to himself and the world.

Paul's self-imposed exile made rumours of his death, smoldering as hearsay, catch fire. In the weeks following the September 26 release of *Abbey Road,* news outlets inundated Apple with calls asking if Paul were alive or dead. When no one provided a definitive answer, *Life* sent a reporter and photographer into the lowlands to quell or confirm the rumours. After trudging by foot through the Scottish heather, the duo managed to locate Paul at his Campbeltown property, alive and kicking as it were, and furious that anyone would dare intrude on his privacy. He screamed and threw a bucket of garbage. He chased his would-be interrogators away and then, recalling that he had always been the diplomatic Beatle, jumped into his Land-Rover, tracked the intruders down, and invited them back home. An exclusive interview was exchanged for the film of him losing his cool.

Life published a cover story in November with fresh photographs of Paul McCartney in the flesh. Unshaven, his eyes puffy and sad looking, he perched on the bumper of his car with Linda and his children by his side. Looking more like a farmer than a rock star, Paul wore rubber boots, dungarees, a crinkled Oxford shirt, and no coat despite a heavy sky. Wind tussled his hair as he raised his hand to give a feeble wave. Paul was ending the year as he had started it, braving the cold. "The Beatle thing is over," he said.[39] The death rumours rang true.

1970 AND BEYOND

SLOUCHING TOWARDS IMMORTALITY

"We were fresh. We were new. We had a certain style of dress and attitude on our songs, and we had an image."
—RINGO STARR

The dream might be over, the Beatles gone their separate ways, but the legacy of the foremost style makers of their era lives on. (Alamy Stock Photo)

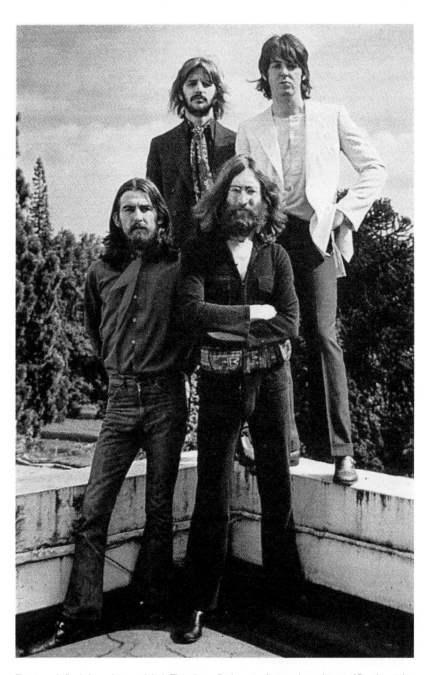

The group's final photoshoot at John's Tittenhurst Park estate featured a melange of Beatles style hits — made-to-measure jackets, skinny blue jeans, distinctive hats, flowing neck scarves, and Beatle boots as fresh as ever. (Alamy Stock Photo)

The Beatles dressed soberly in 1970. Old sweaters, overalls, and rain-repellent oil skins, their drab apparel symbolizing the end of an era, which it was. At the beginning of the new decade, the pop culture dress code was rustic as opposed to refined. Stripped of artifice, the anti-look represented a continuation of what the Beatles had jumpstarted the year before: a return to basics. Sturdy indigo-dyed denim now ruled. The feminizing brocade and shiny satin worn by the Beatles in the mid-1960s looked out of touch against the humble modes of dress now prevailing. Rule Britannia, the name of the fashion game in the Beatles era, gave way to Americana and ubiquitous blue jeans. "The kids these days are specializing in the earthy, ecological look," reported *Parade* magazine. "It seems like a reaction to Edwardian refinery."[1]

Originating in the 1800s as no-nonsense workwear, proletarian blue jeans were the staple of the counter-culture wardrobe. The Beatles had been wearing them as early as the 1950s. They were among the first Britons to get their hands on denim imported to England from America. They wore jeans growing up in Liverpool, on the stages of dance halls and clubs while honing their rock-and-roll identity, and off stage during the Beatlemania years. They were back in jeans on album covers and other publicity materials in 1968, and by 1970 were using denim to emphasize their break from the trappings of fame and all that was Fab. Collectively, even while drifting apart, Beatles wore jeans nearly all the time now, runaways from their beautiful people's past.

John had on a faded Wrangler jean jacket in February on *Top of the Pops* where he promoted his new single, "Instant Karma." Paul, as seen in photographs taken by Linda on the farm in Scotland, wore jeans while wrestling rams and making *McCartney,* his first solo record released in April. Ringo wore jeans in Nashville to make *Beaucoups of Blues*, his country-and-western album which came out in September. George wore jeans on the cover of *All Things Must Pass,* his major opus released in November. Putting away their velvet trousers, the Beatles now seemed to want to blend in, or at least get on with their post-Beatles existence. John so wanted a new start that he shaved his head and gained close to thirty pounds. "I was a slob," he said later. "Well, I am an artist, not a model, so fuck it."[2]

In earlier times, any alteration of the Beatles' look would have triggered avid media interest. John's radical new haircut was hardly noticed, a sign of a new era. A looming recession on both sides of the Atlantic, the

expansion of the Vietnam war into Cambodia, and police shootings of protesting students at US university campuses, among other atrocities, made the new decade feel decidedly less joyous and youthfully optimistic than the one the Beatles had just led.

The music scene changed as well. In 1970, British hard rock band Led Zeppelin was named the top world group in *Melody Maker*, a title the Beatles had held for eight consecutive years. No one was interested in the Beatles beyond speculation about whether or not they would play together again. "That was the big question," said Paul, who stayed in the Lowlands to avoid having to answer. "It's like asking a divorced couple when are you going to get back together. You just can't stand the thought of going back to your divorcee."[3]

The other Beatles weren't as down on themselves, at least not in public. Mindful of the band's image, John, George, and Ringo worked to preserve the mighty Beatles brand even as their group identity was imploding. "There's nothing wrong with the Beatles," Ringo told the press in March, just weeks following the release in the US of the *Hey Jude* compilation album. "When we've got something to do, we'll do it. We're all in touch."[4] Added George in a New York radio interview: "The least we could do is to sacrifice three months of the year, at least, you know, just to do another album or two. I think it's very selfish if the Beatles don't record together again."[5] John, who had initiated the divorce the year before, told the media he wasn't looking to destroy the group. "It might be death or a rebirth," he said on BBC radio, "but it's probably a rebirth."[6]

Those notes of optimism kept fans believing, as did a flurry of activity in the group's twilight year. The Beatles put out two chart-topping albums in 1970, a brace of best-selling singles, and released (finally) the *Let It Be* movie. They opened a new Apple office in New York and spoke publicly about future group projects, including a proposed follow-up to the *Abbey Road* album and a new documentary film that would tell the Beatles story the way they wanted it told, without the usual mythologizing, or so they said.

The Long and Winding Road, a title borrowed from one of Paul's songs on the *Let It Be* album released in May, was planned as a ninety-minute film made of home movies and other memorabilia from their personal archives. Neil Aspinall, the official keeper of the Beatles flame, had been overseeing the project since its origins in 1968. He had been storing canisters of

film behind locked doors at Savile Row. Before long, he had so much visual material that he rented premises off-site, at Bishop's Place, to house it all. By spring 1970, he had a rough cut in hand, the plan being to screen the biographical film in British cinemas at Christmastime. That plan was scuttled when Paul launched lawsuits against his fellow bandmates to formally dissolve the band. The first was served on November 15, the second on New Year's Eve, just as Ringo was about to host a party to which all the Beatles and their wives had been invited. Eventually, the project came into existence as *The Anthology*, a TV series and illustrated book project released in 2000.[7]

There had been talk of a Beatles reunion, including by John who didn't rule out the possibility in some of the interviews he gave to the media in the early 1970s. But it never happened. Two and sometimes three Beatles would occasionally get together to play with each other on stage and on each others' solo records (John's *Imagine,* Ringo's *Photogravure,* and George's *Concert for Bangladesh* at Madison Square Gardens, for example), but they never regrouped as a four-man band. Each would go on to make music that could still top the charts. Paul's "Uncle Albert/Admiral Halsey," George's "My Sweet Lord," John's "Whatever Gets You Through the Night," and Ringo's "Photograph," all claimed the Number One spot upon their respective releases in the early half of the new decade. But as solo artists they never came close to meaning to the world what they did in their Beatles' years. They became revered more for their past accomplishments than for anything they did in the present, even when their solo efforts were impactful.

George's triple LP *All Things Must Pass* has sold millions of copies around the world as has Paul's *Band on the Run,* the hit album he put out in 1973 with his new band Wings. Paul also went on to score a James Bond film and was the first of his bandmates to be knighted. He has written a score for ballet and an oratorio, opened an arts academy in his native Liverpool, and released experimental records under the Fireman pseudonym. As prolific as ever, Paul continues to put out records and perform live in packed arenas around the globe into his eighties. Ditto Ringo whose All Starr Band supergroup of past hitmakers like BTO's Randy Bachman, Toto's Steven Lukather, and Edgar Winter is still going strong since its launch in 1989, fueled in part by regular releases of new material penned and performed by the drummer himself—with a little help from his friends. John was tragically

murdered in December 1980 and George died of cancer in November 2001, both denied the longevity of Paul and Ringo's solo careers. But even during their lifetimes they had retreated from the spotlight, George preferring to garden and John to bake bread to the grind of touring and churning out new records. They weren't driven to be on top as much as before and yet post-Beatles, they continued to indulge in fashion as self-expression.

John was obsessed with it, according to May Pang, the woman he lived with during an eighteen-month split from Yoko in the early 1970s. In *Loving John*, her memoir about their intimate relationship, Pang writes that the only thing that would get John out of bed was a shopping spree on E60th Street in New York.[8] He would buy skinny black jeans in multiples and be so attached to his clothes that they went with him when he returned to Yoko and the Dakota Apartments. One of their suites in the building contained a room for John's clothes, including all of his Beatles clothes, which he wanted to preserve. He continued to change his look as frequently as he had in the 1960s. Many of the changes were variations on a Beatles fashion theme: hats, roll-neck sweaters, bomber jackets, and flowing neck scarves. He was wearing dark cords on the night he was shot dead.[9]

Paul eventually came out of hiding to rekindle his love affair with fashion, dressing in graphic T-shirts, wide-leg checked trousers, platform shoes, ribbed sweaters, and a mullet haircut to front his new band, Wings. As in days gone by, Paul shopped at the latest London boutiques. At one point, he approached Tommy Roberts at Mr. Freedom to create his stage clothes, but the commission fell through.

George, too, continued to use fashion to feed an independent spirit. Photos of him on stage during his 1974 North American tour with Ravi Shankar show him in glossy patterned shirts, faded denim overalls, beaded choker necklaces, and long-sleeved Ts imprinted with Buddhist and Hindu imagery.

By the 1980s, both Paul and George had started to look dowdy, dressing in baggy pants and white undershirts under checked shirts. They looked like what they had become: middle-aged dads living in the suburbs. Before departing from the material world, George was even spotted wearing baseball caps. Paul eventually came back into the fashion fold by way of his designer daughter, Stella, who has been dressing him in the svelte tailored suits (also Beatles-inspired) she launched in 2016 as part of her first menswear collection.

Ringo, for his part, has always rocked steady. In the 1970s, he embraced bow ties and bell bottoms, maxi-length fur coats, open-neck floral shirts, belted sweaters, big shoulder suits, and an impeccably groomed beard. In the 1980s, he dressed glam, a jet-set playboy in cravats and tuxedos. His love of fashion has never abated. These days, as the All Starrs' front man, at every show, he bounds on stage in a signature head-to-toe black ensemble comprising slim-cut jeans, waist-length jacket, white sole sneakers, a T-shirt with a large sequined star covering the chest, and a silver peace sign dangling from a black silk string tied round around his neck. Even his ubiquitous shades are dark. With his salt and pepper hair cropped short like his beard, Ringo still has it. "If you look at the Beatles, Ringo has the best taste," said Andrew Loog Oldham. "In terms of who's the long-distance clothes runner of the group, it's him."[10]

But then, none of the Beatles ever dressed to please others. Through all the transitions— jeans, leather, Mod, neo-Regency, hippy, Western cowboy, Indian ashram, and back to jeans—they were mostly concerned to please themselves. It just so happened that their constantly changing sounds, hair, and looks *were* fashion. "They never ordered anyone to follow their fashions," said Joel Glazier, a prominent Beatles fan, collector, and archivist, "but we were happy to do it."[11] As a result, they disrupted and reinvented British sartorial traditions, shaking up the monotony of male dress. They normalized male pageantry, unisex dressing, and then anti-fashion. They inspired a new type of urban man, freely reinvented through a rich array of clothes asserting individuality, sexuality, and a self-made place in society.

John's prediction of rebirth may never have come true, but in a very real sense the Beatles never died. Instead of a second coming of the band, the world was given an undying influence. Throughout the half a century since they disbanded, the Beatles have retained their power to awe and inspire.

This was evident soon after their breakup. Crosby, Stills, Nash & Young was a Los Angeles-based supergroup comprised of former members of the Hollies, the Byrds, and Buffalo Springfield. It exploded on the scene at Woodstock in 1969 and a year later had a bestselling folk-rock album and hit songs like "Marrakesh Express" and "Judy Blue Eyes" topping the charts. Paul went to see them when in London at the Royal Albert Hall and was extremely flattered when the quartet, celebrated for their vocal harmonies, played his song "Blackbird" as part of their set, openly

acknowledging the influence of the Beatles on their music and very existence. "I'd never seen anything like them before, or since," said guitarist David Crosby. "They changed my life."[12]

Other acts could claim the same. Bob Dylan, Black Sabbath, the Bee Gees, Billy Joel, the Beach Boys, Cheap Trick, David Bowie, Electric Light Orchestra, the Guess Who, King Crimson, the Pretenders, the Ramones, the Rolling Stones, Santana, Terence Trent D'Arby, and Oasis, to name just a few, have all publicly acknowledged the Beatles influence whether on the instruments they played to the clothes they wore. Some like the Eagles, one of the top-selling country rock bands of all time, dressed like the Beatles from the *Get Back/Let It Be* period, in jeans, scuffed running shoes and scraggly collar-length hair. But even then, the band's guitarist, Joe Walsh (later to be Ringo's brother-in-law), remembered with great fondness the days of the Mod suits when the Beatles had first altered his consciousness. "I took one look on *The Ed Sullivan Show*," Walsh told *Rolling Stone* in 1975, "and it was, 'Fuck school. This *makes* it!' I memorized every Beatles song and went to Shea Stadium and screamed right along with all those chicks." Not uncoincidentally Walsh's first band, the Nomads, was a Beatles' clone. "My parents still have a picture of me all slicked up, with a collarless Beatles jacket and Beatles' boots playing at the prom."[13]

Kiss, a 1970s band known for its striking visual appearance, also credits the Beatles for its start. "There is no way I'd be doing what I do now if it wasn't for the Beatles," said Kiss bassist Gene Simmons. His band took the Beatles' long hair and tight leathers to theatrical extremes with dramatic make-up and lashing tongues. The look wasn't precisely or even recognizably Beatlesesque. It was more a distillation of the Beatles' sensibility. Kiss members made personal statements within a well-defined group identity through an artful manipulation of fashion. The Beatles' style wasn't just about the clothes, said Simmons. It was an expression of their personalities as musicians and artists in control of their creative destiny. "They were a cultural force that made it OK to be different."[14]

Female musicians also modeled themselves on the Beatles. Heart, the first world-famous women-led hard rock band, owes its existence to the Fab Four, said lead singer Nancy Wilson. When she and her sister first saw the Beatles in 1964 on US television "it was a huge event, like a lunar landing: that was the moment Ann and I heard the call to become rock musicians." Together they went to see the Beatles live in concert in 1966 at the Seattle

Coliseum. They didn't scream but intently studied the Beatles, intent on absorbing everything that made them mesmerizing and exciting. "We didn't want to marry them. We wanted to be like them," said Wilson. She and Ann were soon staging performances in the family room, playing air guitar while dressed in matching Beatles uniforms made by their seamstress mother. The allure was as much visual as it was musical. "They were really pushing hard against the morality of the times," said Wilson. "That might seem funny to say now, since it was in their early days and they were still wearing suits, but their sexuality was bursting out of the seams. They seemed to us like punks seemed to the next generation—way out of the box for the time."[15]

Long after the Beatles left the scene, those boundary-breaking suits continued to exert an influence. In 1979, an LA band called The Knack broke into the charts with "My Sharona" while dressed like the Beatles in dark tight-fitting trousers with cropped jackets, white shirts, and skinny ties. The homage extended to the cover of the Knack's first album which resurrected Capitol's Beatles' era logo. The back and front covers showed the group in early Beatles' poses.[16]

Copying the world's most successful band might not have been the most original of ideas, but it worked. While the Knack had talent—its somewhat cynical lyrics were simple to remember and its melodies catchy—dressing like the Beatles lifted the group to the next level. The Knack got a lot of press and sold a heap of records, not because they were especially innovative, but because they knew whom to imitate when creating an image.

Beatles suits were lucky charms in the world of popular music. Grunge band Nirvana dressed like the Beatles circa 1962 when it performed Kurt Cobain's and Dave Grohl's "Pennyroyal Tea" live on French television in 1994. The seven-member South Korean boy band BTS appeared on *The Late Show with Stephen Colbert* in 2019 wearing a classic Beatles look: matching bum freezer jackets, slim-cut trousers, white shirts, and thin ties made for them by British designer Thom Browne. It was a direct homage, complete with tapered-toe Beatle boots. The boys also brushed their hair over their foreheads and sang the na-na-na chorus from "Hey Jude" in case anyone missed the connection.

None other than the BBC has called BTS "the 21st century Beatles."[17] Of course, the Korean-born rappers are nothing like them. They sing and dance and don't play any instruments. But they, too, have their screaming

The Knack was just one in a series of bands to adopt the Beatles' style after the breakup. (Alamy Stock Photo)

Dressing like the early Beatles was part of the formula that made K-pop boy band sensation BTS mega stars. (Alamy Stock Photo)

fans and a pile of top-selling albums, and they understand the power of clothes and image-making. Everyone, including Paul McCartney, has noticed and praised their dynamic stage presence.[18] "I think it's fair to say that lot of musicians are all under the influence of Beatles," said the group's leader Kim Nam-Joon, or RM as he's known professionally. "We're very grateful to be called [the 21st century Beatles]. That makes us feel that we are doing good."[19] Not coincidentally, BTS and the Beatles were the two top-selling bands in the world in 2020, each posting a million record sales.[20]

Apple Corps, still managed by Paul, Ringo, and the widows of John and George, has made a concerted effort to keep the band's work and image relevant to new generations of fans. In addition to internal projects like *Anthology,* Apple has one of the production companies on Ron Howard's 2016 documentary of the Beatles' touring years, *Eight Days A Week,* and Peter Jackson's 2021 *Get Back* documentary series, winner of five Emmy awards.

Apple's first legacy-building collaboration, instigated by George, was Cirque du Soleil's Las Vegas show *Love,* which ingeniously re-examines the Beatles' music as well as their fashion. For the original 2006 theatrical production, producer Gilles Martin remixed hundreds of songs, delivering them as whole compositions and fragmented memories of the Beatles-led British Invasion. French costume designer Philippe Guillotel dressed Cirque's acrobats, clowns, and aerial artists in an astonishing array of looks combining bespoke British tailoring traditions with Victoriana and original designs evoking the full range of clothing worn by the Beatles in their time. An interpretation rather than a reproduction of the group's appearance, the costumes underscored the aesthetic, political, and spiritual messages embedded in the Beatles' fashion choices, recognizing them as integral to the group's artistic progression.

Stylized replications of the Beatles' fashion iconography are also found in *The Beatles: Rock Band* music video game, launched in 2009. Another Apple Corps collaboration, the interactive game was developed by Harmonix, a US firm whose designers plumbed the full Beatles' archive to present the band as animated figures. The Beatles appear in Cavern Club leathers, velvet-collar Dougie Millings suits, their Hung On You bottle-green stage clothes, and late-period fashion mash-ups. Hairstyles are also faithfully reproduced. "They used their hair really consciously," the

game's lead designer Dare Matheson told *The New York Times*, adding that individual Beatles could be identified by hair alone, without facial features.[21] Paul, continuously preoccupied with managing the Beatles' image, had hoped that technology would render their gaming faces life-like, with hyper-realistic detail, but Harmonix opted for a cartoon-like design. Dhani Harrison, George's son by his second wife Olivia Arias, helped with the animation. Ringo reunited onstage with Paul to promote it.[22]

Other recreations of Beatles' fashion have escaped the band's artistic control. The blockbuster Austin Powers trilogy of comedy spy films—1997's *International Man of Mystery*, 1999's *The Spy Who Shagged Me*, and 2002's *Goldmember*—owes its distinctive clothing styles to the Beatles' Swinging London period. Working independently of Apple Corps, costume designer Deena Appel poured over published images of the Beatles when creating the late-sixties clothing worn by Mike Myers in the titular role: Beatle boots, patterned neck scarves, striped trousers, and beautifully tailored velvet suits in eye-catching shades of cerise and peacock blue. George was the Beatle who particularly caught her eye. She considers him the biggest dandy of them all and cited his floral jackets, his love of rich color, deluxe fabrics, and body-conscious silhouettes as direct inspirations for her work. One suit she made for Myers had a curved hem, an idea she took from George. The noticed the unusual line of the jacket in a photograph and it intrigued her "because there was something feminine about it."[23] She also took design ideas from George's India-inspired wardrobe, including the Nehru collar jackets and clothes made of natural materials.[24]

These iterations of Beatles clothing are the fashion equivalent of cover songs, a new performance of a tried-and-true hit. The inspiration is readily available in photography, film footage, men's magazines, fashion magazines, newspapers, fanzines, and other widely disseminated materials, sources that amount to a living museum of the Beatles' style legacy. That helps explain why the Beatles have never gone out of fashion in the fashion world.

The list of designers influenced by the Beatles is nearly as long as that of musical acts. Where to begin? With Tom Ford, the former Gucci designer with a line of rounded Lennon sunglasses sold under his brand? Hedi Slimane, whose ready-to-wear shows for CELINE, Dior Homme, and Saint Laurent Paris have showcased skinny suits and ties, sculpted black

The entire aesthetic of the *Austin Powers* film series is indebted to the Swinging London fashion sensibility of 1960s Beatles. (Alamy Stock Photo)

Contemporary designers continue to mine the Beatles for inspiration, among them Hedi Slimane for his Beatles-inspired menswear collections for CELINE, Dior Homme and Saint Laurent Paris. (Alamy Stock Photo)

Designer Peter Dundas for Italian fashion house Roberto Cavalli channeled the Beatles' psychedelic period for the 2017 runway collection he presented in Milan. (Robert Cavalli)

leather, and camel-colored Nehru collar Shea Stadium jackets, and who routinely references the Beatles as the height of masculine chic? Or John Varvatos who hired Ringo as the model for his 2014 black leather-and-jeans collection of rock-and-roll-inspired men's clothing?[25] Or Peter Dundas, whose inaugural 2016 opulent paisley-print menswear collection for the prominent Roberto Cavalli Italian fashion brand was directly inspired by the English Dandy clothes of George Harrison—"il mio preferito dei Beatles," as Dundas said to the Milanese press?[26] There's also Rei Kawakubo, the iconoclastic designer behind the Paris-based Comme des Garçons, who in 2009 teamed up with Apple to produce a range of Beatles-inspired travel bags, shirts, and T-shirts.[27] Patterned with green apples and the designer's signature polka dots, the genderless clothes and large bags made of embossed PVC materials and grommets were "deliberately undesigned," Kawakubo said, "as this can best express the spirit of the Beatles."[28]

Fashion is fickle, cyclical, and tied to change. And yet, year after year, the Beatles keep showing up as a new trend. In 1992, Domenico Dolce and Stefano Gabbana put Beatles-inspired pop art floral bell bottoms and love beads in a runway presentation that also featured the band's music played at high volume.[29] In 2003, Tommy Hilfiger played the Beatles during his New York catwalk show with its Beatles-inspired menswear, including double-vented trim suits with drain-pipe trousers, skinny ties, and black lamb peacoats.[30] In 2009, Balmain showed a regimental *Sgt. Pepper*'s-influenced jacket in Paris that was so popular it sparked an international mania both as a luxury item and fast-fashion knock off.[31] In 2017, Gucci's Alessandro Michele put Beatles-era floral suits and kipper ties back on the runway, paying homage to 1960s dandyism in general[32] and George Harrison, Michele's style icon, in particular.[33]

Paul's daughter, Stella, a sustainable fashion advocate, has tapped the Beatles' legacy for her own highly regarded collections. In 2019, she released a colorful line of Beatles' inspired clothing called "Altogether Now," after one of dad's songs. Made of organic cotton, repurposed cashmere, and environmentally friendly viscose, the collection debuted at England's Glastonbury Festival where singer Billie Eilish wore a custom two-piece stamped with an image of the Blue Meanies.[34] Contemporary recording artists Joy Crookes, KEYAH/BLU, Femi Koleoso, and Oscar Jerome appeared in the designer's promotional video wearing sparkling

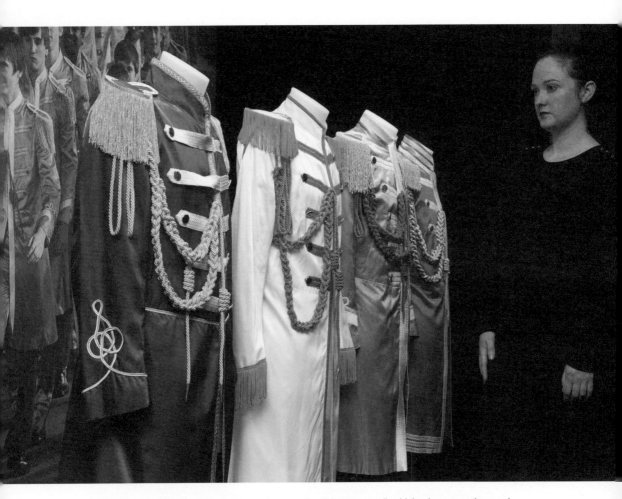

Original Beatles clothing has become like a fine art collectible, commanding high prices at auctions and appearing in museum exhibitions and permanent collections around the globe. (Alamy Stock Photo)

The Beatles' bohemian style pervades New York designer Anna Sui's fall
2021 womenswear collection. (Richie Lee Davis)

"Lucy in the Sky" dresses and unisex shirts emblazoned with lyrics like "all you need is love." An advertising campaign included cartoon images of the Beatles pulled from their 1968 animated movie. "The new collection," wrote Stella on Instagram, "brings the fun, fantasy and psychedelia of The Beatles iconic film 'Yellow Submarine' back to life and shares its message of peace, love and togetherness with a new generation."[35]

When the fashion shows came back after a nearly two-year pandemic hiatus, the Beatles still had currency. Anna Sui claimed them as an influence for her Fall/Winter 2021 fashion show staged in a subterranean New York nightclub where she replicated the sets designed by The Fool for *Wonderwall,* the 1968 film for which George Harrison had written the score. "I love the idea of men dressing almost like nineteenth-century poets with ruffle shirts and jabots and frock coats and I think the Beatles really carried it to an extreme with all the Indian influence in the embroideries and of course the whole psychedelic aspect, my favourite style period of theirs," Sui said. "If you look at the *Get Back* series, where we got that fly on the wall experience and you saw the outfits everyday when they came to the studio, George was just the epitome. Like that pink and purple outfit he had on, with those Tibetan boots? I must have replayed and replayed and replayed that section just to study it. You don't get that kind of jolt anymore from performers today. I mean, the fashion was incredible. The Beatles rocked our world."[36]

Sui's mention of Peter Jackson's *Get Back* confirms a prediction made by British fashion writer Lisa Armstrong at the beginning of 2022: that the Beatles, as a result of that documentary, would emerge as the year's biggest style icons: "There's so much that's still relevant for men and women," she wrote in *The Telegraph,* "from George Harrison's gender fluid ruffled blouses (eat your heart out Harry Styles) to Paul's Savile Row meets Margaret Howell meets country squire groove (a look much referenced later by Mumford & Sons and Guy Ritchie). And there's Ringo—cute, lovable, wearing jackets heavily influenced by the Beatles' 1967 Sergeant Pepper marching band suits designed by costume designer Noel Howard. He doesn't quite seem on this planet. But none of them does. . . . It will be a miracle if we don't see the band's influence in collections over the coming year."[37]

The prediction held up. In 2022, Japanese designer Takahiro Miyashita, a self-described Beatles' freak, referenced the band in the Spring/Summer collection he released at Tokyo Fashion Week under The Soloist label.[38]

Paul's daughter, star designer Stella McCartney, keeps the Beatles' fashion legacy alive for the next generation with tributes like her 2019 *All Together Now* collection. (Alamy Stock Photo)

A few months later, streetwear brand Market released its own Beatles-themed collection in New York.[39] In 2023, the Beatles were again on the runway, at the Kenzo *White Album*-inspired menswear show staged at a concert hall during the annual winter edition of Paris Fashion Week.[40]

Meanwhile, the Beatles' original clothes have become like fine art collectibles, commanding huge prices and international media attention whenever they appear at auction. George's black leather jacket, said to date to the Beatles' first visit to Hamburg in 1960, fetched $180,000 when sold on the secondary market in 2012. Two blue capes worn by the Beatles in *Help!* reaped $142,000, when the film's director Richard Lester put them on the block in 2014. A pair of John's round sunnies sparked a bidding war when they appeared at auction in 2019, ultimately selling for $169,000. Even small clothing items have sparked a buying frenzy. John's black knit skinny tie, worn at a 1962 Cavern session, sold for $5,600, more than double its $2,000 estimate, when auctioned off in 2013. Likewise, Ringo's custom red polka dot ruffle collar shirt, dating to 1968, also went for more than double its original asking price when it sold for $8,500 at Sotheby's in 2019.

Noticeably absent from the auction madness are any items of clothing belonging to Paul. He doesn't like to give his Beatles clothes away and has become litigious whenever an item of his, likely stolen, has shown up at auction without his express permission. A cape he had worn in *Help!* along with one of his Dougie Millings Beatles suits was withdrawn last minute when Paul contested their sale at a 2014 Liverpool auction. The cape and the suit had been valued at between £10,000 and £15,000 each.

That the four lads from Liverpool became rock stars was an intentional act. That they also became four of the greatest fashion influences of all time no one saw coming, the least of all them. There was never a plan to be trendsetters or to bring the worlds of music and fashion into some new union. The Beatles liked to look good. They liked to make statements. Their clothes were a visual manifestation of their iconoclastic personalities. They had a shared appreciation for one another's style even before they'd played a note together. They knew that clothing would help them fashion a band identity. Brian Epstein impressed upon them that the right stage attire would open the door to mass acceptance, and that the right image could propel them up the charts. They understood the power of clothes and were keen to find a look that was way beyond compare.

And it just happened.

There was never anything calculated or cynical about the Beatles' appearance. They followed their own style promptings, their own whims and wants. They were delighted by everything new and cool and eager to stay ahead of the curve, but they were never precious or slaves to fashion. Their image, like their music, was original, genuine, an expression of their maverick creativity, curiosity, and drive to be the best little rock-and-roll band on the planet.

It was because their style was personal and authentic that they were never stuck in a particular look, as happens to so many performers, or afraid to try something new. It is why so many people couldn't take their eyes off them in the sixties and new generations of musicians, designers, and fans find them captivating and worth emulating today.

The clothes tell the story.

Acknowledgments

I could not have written this book if not for the unwavering support of my husband, Victor Barac. He encouraged and believed in me every step of the way. He was always there when I needed him, to suggest a better word or phrase, to call out cliches, and to share his advice for how to make the writing better. He cleared a path for me to do this while I was working full-time and steering our children, Vladimir and Isadora, through school, the pandemic and the lockdowns. He gave me my weekends and summer holidays to do the book, taking over in the kitchen to cook the meals and wash the dishes and all the other stuff in life that happens when you're busy making other plans. He sparked the idea to write on the Beatles in the first place, telling me one day, while we were in the kitchen talking over coffee, that it was what I was meant to do. "You're Beatles obsessed," he said. Which is true. But only after I thought to write on their potency as style makers did I take up the challenge. I wanted to say something original about my favourite band and he helped me to do that, with constant blasts of reassurance. I can't thank him enough. My gratitude is equal to my love for him and that love is boundless.

But just because I thought writing about the Beatles and their fashion a good idea doesn't mean it was one. I sought validation and then quickly received it from the world's foremost Beatles' historian Mark Lewisohn, who graciously endorsed my proposal, giving me all the incentive I needed. When I worried the task would be daunting, Susan Willemsen, my friend since middle school, gave reinforcement. "Remember that Beatles trivia contest we listened to on the radio when we were thirteen? Well, I do, and you knew all the answers! You were born to do this!" She cheered me on, start to finish.

Others, once they heard me speak of my Beatles and their fashion idea, were also unstinting with their enthusiasm. Thanks to Daniel Fiorio,

Jonas Prince, Louise Dennys, Jake Gold, Natalie Bibeau, Lesley and Rob Wagner, Pierre Marchand and David U.K. (who took me by speedboat to meet Ronnie Hawkins at his home on a lake) for their early expressions of support and encouragement.

An even bigger push came from my agent Hilary McMahon at Westwood Creative Artists who worked long and hard to make the book become a reality. I am genuinely amazed at the amount of time she spent on the proposal alone, polishing every word and vetting every image for maximum impact. She understood that the way the Beatles looked was way beyond compare and she motivated me to reach high and dig deep to bring their image alive on the page.

It required that I embark on a long and winding road of research on a topic about which little has previously been written. Consequently, I spent countless hours at Toronto Metro Reference Library where I started the process by reading every issue of *Life* magazine published in the 1960s to immerse myself in the Beatles' time. Metro Reference is where I also located and read other hard-to-find books on the Beatles: Nik Cohn's epoch-defining *Today There Are No Gentlemen,* for instance. I am grateful that such a publicly accessible repository of ideas and information exists in my own backyard.

The Beatles in Canada author Piers Hemmingsen often met with me at the library's main floor espresso bar, sharing with me other sources of relevant information. He's the one who told me about Butterick's Beatles clothes patterns and the northern Ontario cowboy boots George Harrison wore when the Beatles were first in Hamburg. Also lending a helping hand was Roger Gingerich, the Canadian International Fashion Film Festival CEO, who never ceased to champion the book, introducing me to former rock impresario Johnny Brower (the man who brought John Lennon to Toronto in 1969) and members of the Commonwealth Fashion Council in the UK where he is a board member. I am grateful to have him in my court.

England is where the Beatles first made their mark and an early research trip to London yielded many fresh discoveries. I initially made the journey to meet with Beatles' hairdresser Leslie Cavendish, whose Fabs-inspired memoir, *The Cutting Edge,* was a great source of information. We met in a Bloomsbury hotel coffee shop where, during a six-hour interview, he proceeded to blow my mind, astonishing me with not just vividly recalled style stories from the day but also an extraordinary list of

other interview subjects he thought might be useful for me. Thanks to him, I next corresponded with Robert Orbach of I Was Lord Kitchener's Valet fame, Terry Bloxham, former secretary and co-editor of the British Beatles Fan Club, and Peter Feely, a collector and connoisseur of men's psychedelic fashion, among others. Those contacts opened new vistas for me, enriching my knowledge of the Beatles and their fashion considerably. To Leslie I owe a huge debt of gratitude.

On the same London trip, I met up with David Jays, editor of *Dance Gazette*, who, after hearing about my Beatles' book project, promptly put me in touch with Veronica Horwell, a 1960s and 1970s fashion expert with a byline in *The Guardian* in addition to other publications. I thank her profusely for teaching me all I needed to know about kaftans, British-made corduroy, Nehru collars and ancient bowl-cuts. An early reader, Veronica generously shared with me her insights of the period and added considerably to the endnotes, especially with regard to Soho's fashion history. We exchanged information long distance via email, becoming friends along the way. l am glad this book brought us together.

Sharon Kane of the indispensable *Sweet Jane* fashion blog also generously shared her expertise and I can't thank her enough. She also was an early reader and her thoughtful suggestions helped to make the book stronger. Alex Schultz, Devin McKinney, and Jonathan Walford read the manuscript while it was in development, offering much encouragement. To each I am obliged. My recently departed mother Sylvia E. Kelly was a constant supporter of this project and would have been proud to see it come to fruition. My brother Kevin J. Kelly tolerated me lining the walls of our shared bedroom with Beatles' posters; he's had my back from the beginning.

When it came time to putting the book together, Irina Liner stepped forward to provide much needed support. I am deeply grateful for her patronage and many years of devoted friendship. Irina helped turn a dream into a reality. My gratitude extends also to Canadian ballet star Chan Hon Goh and my uncle David John Dawson who also provided greatly appreciated material assistance.

These efforts and more would have been wasted if not for Ken Whyte, publisher and editor of Sutherland House Books. He discerned the book's potential, and moved swiftly to get it made. He was the editor I kept wishing for when I was writing the manuscript and I am here to say that wishes

do come true. I thank him for his diligence, editorial experience, and good taste.

A big thank you to photo researchers David Lee and Nicole DiMella who helped to track down images relating to the Beatles and their fashion. Thanks also to book designer Lena Yang and to Shalomi Ranasinghe, managing editor of Sutherland House, who oversaw production of the manuscript. Ultimately, this book was very much a group effort, a JohnPaulGeorge andRingo-like combination of creative ideas and combustive energies. I thank the Beatles for inspiring it.

About the author

Deirdre Kelly has written on dance and pop culture since 1985. Starting as the award-winning dance critic and pop music columnist for *The Globe and Mail* and continuing through today as dance correspondent for the *Dance Gazette* in London, England. She is the resident dance critic for the Toronto-based arts e-zine, where she also writes on fashion and The Beatles. She is the author of *Ballerina: Sex, Scandal and Suffering Behind the Symbol of Perfection* and *Paris Times Eight*.

Notes

1960: Tough Leather

1 *The Beatles Anthology* (San Francisco: Chronicle Books, 2000), p. 30.
2 Martin Scorsese, dir., *Living in the Material World*, HBO, 2011. Film.
3 "The Days and Lives of the Beatles," *Life Magazine*, September 13, 1968, p. 94.
4 Mark Lewisohn, *The Beatles: All These Years, Vol. 1: Tune In* (London: Crown Archetype, 2013), p. 108.
5 *The Beatles Anthology*, p. 12.
6 Larry Kane, *When They Were Boys* (Philadelphia: Running Press, 2013), p. 107.
7 Email exchange with the author, July 4, 2022.
8 In 1959, Helen Anderson did a drawing of John wearing the black leather ensemble she made for him while they were both students at the Liverpool College of Art; it appears on the cover of the 2019 book, *All Roads Lead to Lennon*, by Philip Kirkland.
9 *The Beatles Anthology*, p. 14.
10 *The Beatles Anthology*, p. 20.
11 Alex Bilmes, "Paul McCartney Is Esquire's August Cover Star," *Esquire*, July 2, 2015. Accessed August 16, 2020, at https://www.google.ca/amp/s/www.esquire.com/uk/culture/news/amp8511/paul-mccartney-interview/
12 Jonathan Cott, *Days That I'll Remember* (New York: Doubleday, 2013), p. 30.
13 Cynthia Lennon, *John* (London: Hodder & Stoughton, 2005), p. 18.
14 *The Beatles Anthology*, p. 37.
15 His birth name was Alan Caldwell and both Paul and George dated his sister, Iris Caldwell, as teenagers.
16 *The Beatles Anthology*, p. 48.
17 His real name is John Askew, and he was just one of several Liverpool male rockers in the late 1950s given stage names by promoter Larry Parnes. Most of the new names suggested heightened as well as hardened states of being—Billy Fury, Marty Wilde, Tommy Steele, Vince Eager. Johnny Gentle, a balladeer, was the least aggressive sounding of the lot.
18 Lewisohn, *Tune In,* p. 300.
19 Paul would again perform under the name Paul Ramon when he dropped in on a Steve Miller Band recording session in London and played on their record, "My Dark Hour" on February 3, 1969.
20 Lewisohn, *Tune In,* p. 310.
21 *The Beatles Anthology*, p. 44.

22 Bob Spitz, *The Beatles: The Biography* (New York and Boston: Little, Brown and Co., 2005), p. 123.

23 Lewisohn, *Tune In*, p. 74.

24 *The Beatles Anthology*, p. 18.

25 Spitz, *The Beatles*, p. 108.

26 *The Beatles Anthology*, p. 20.

27 Lewisohn, *Tune In*, p. 332.

28 Pete Best and Patrick Doncaster, *Beatle! The Pete Best Story* (London: Plexus, 1985), p. 63.

29 "The Beatles' image in Hamburg and a look at some previously unseen stage clothes," YouTube video, May 25, 2020, Liverpool Beatles Museum, 3:38. https://www.youtube.com/watch?v=lK5bXFygbLc&feature=share

30 Philip Norman, *Shout!* (London: Hamish Hamilton, 1981), p. 91.

31 *The Beatles Anthology*, p. 46.

32 Matthew H. Clough, ed., *Astrid Kirchherr: A Retrospective*, August 25, 2010, to January 29, 2011, Liverpool: Victoria Gallery and Museums (Liverpool: University of Liverpool Press, 2011), p. 135.

33 Spencer Leigh, *The Beatles in Hamburg: The Stories, the Scene and How It All Began* (Chicago: Chicago Review Press, 2011), p. 53.

34 Ian Inglis, *The Beatles in Hamburg* (London: Reaktion Books, 2012), p. 52.

35 Lewisohn, *Tune In,* p. 359.

36 According to the Beatles in Canada historian Piers Hemmingsen, Bill's Men's Wear belonged to Bill Zapotochny in the town of Kirkland Lake, a former gold mining hub located approximately 600 kilometres north of Toronto in the Canadian province of Ontario.

37 Piers Hemmingsen, interview with the author, June 28, 2019.

38 Aaron Krerowicz, "The Influence of Gene Vincent on the Beatles," *Flip Side Beatles*, July 7, 2014. Accessed August 18, 2020, at https://www.aaronkrerowicz.com/beatles-blog/2

39 *The Beatles Anthology*, p. 73.

40 Lewisohn, *Tune In,* p. 382.

41 Lewisohn, *Tune In,* p. 421.

42 Clough, *Astrid Kirchherr*, p. 143.

43 Jason Fine, *Harrison* (New York: Simon & Schuster), pp. 60–1.

44 "Astrid Kirchherr's Early Photographs of the Beatles Going on View in Los Angeles," ArtInfo.com, August 23, 2013. Accessed October 25, 2014, at http://blogs.artinfo.com/artintheair/2013/08/23/astrid-kirchherrs-early- photographs-of-the-beatles-going-on-view-in-los-angeles/

45 Lewisohn, *Tune In*, p. 485.

46 The location was Hôtel de Beaune, two hundred steps from the Seine, says Lewisohn. For more details see *Tune In,* p. 487.

47 *The Beatles Anthology*, p. 64.

48 Pete Best with Bill Harry, *The Best Years of the Beatles* (London: Headline, 1996), p.71.

49 Norman, *Shout!*, p. 154.

50 Stuart Maconie, "Love Me Do: The Beatles '62," TV Movie Documentary, BBC Four, September 20, 2015, 1:30.

51 *The Beatles Anthology*, p. 73.

52 Lewisohn, *Tune In*, p. 387.

53 Spencer Leigh, *The Beatles in Liverpool* (Chicago: Chicago Review Press, 2012), p. 67.

54 Lewisohn, *Tune In,* p. 392.

55 Lewisohn, *Tune In,* p. 391.

56 *The Beatles Anthology*, p. 56.

57 *The Beatles Anthology*, p. 56.

58 Gillian G. Gaer, "I Am the DJ: An Interview with the Cavern's Bob Wooler," *Goldmine*, November 8, 1996. Accessed October 21, 2020, at http://www.beatles.ncf.ca/gaar.html

1961: Cosmetic Conversion

1 Ryan White, *Good Ol' Freda* (2013), Documentary, 1h 26m.

2 Alistair Taylor with Martin Roberts, *Yesterday, The Beatles Remembered* (London: Sidgwick & Jackson Ltd., 1988), p. 10.

3 Brian Epstein, *A Cellarful of Noise* (London: Souvenir Press, 1964), p. 32 (Kindle Edition).

4 *The Beatles Anthology TV Series* (July 60 to March 63).

5 Taylor, *Yesterday*, p. 11.

6 Lewisohn, *Tune In*, p. 499.

7 *John, Paul, George, Ringo and Me* (New York: Da Capo Press, 2006), p. 6

8 Epstein, *A Cellarful of Noise*, p. 33.

9 Lewisohn, *Tune In*, p. 506.

10 Lewisohn, *Tune In*, p. 499.

11 Ian Inglis, *The Beatles in Hamburg*, p. 100.

12 *The Beatles Anthology*, p. 67.

13 *The Beatles Anthology*, p. 65.

14 Lewisohn, *Tune In*, p. 434.

15 "17 December 1961—Sunday Albert Marrion's Studio Wallasey," The Savage Young Beatles, Photographs of the Beatles 1950s to 1963, BeatleSource.com. Accessed September 6, 2019, at https://www.beatlesource.com/savage/1961/61.12.17%20albert%20marion/61.12.17marion.html

16 Alan Clayson, *John Lennon* (London: Sanctuary Publishing Ltd.), p. 87–8.

17 Lewisohn, *Tune In*, p. 553.

18 *The Beatles Anthology*, p. 73.

19 *The Beatles Anthology*, p. 67.

20 *The Beatles Anthology*, p. 73.

21 Interview with the author, May 30, 2019.

22 Harry Taylor, "Beatles – Hair, There and Everywhere," *The Beatles & Bournemouth*, May 15, 2012. Accessed January 20, 2020, at https://www.bing.com/search?q=Harry+

Taylor%2C+%E2%80%9CBeatles+- +hair%2C+there+and+everywhere%2C%E2%80%9D+The+Beatles+%26+Bournemouth%2C&PC=U316&FORM=CHR OMN

23 *When They Were Boys*, p. 326.

24 Lewisohn, *Tune In*, p. 555.

25 Lewisohn, *Tune In*, p. 555.

26 Jonathan Gould, *Can't Buy Me Love: The Beatles, Britain and America* (London: Piatkus Books, 2007), p. 32.

27 *The Beatles Anthology*, p. 73.

28 Bill Harry, "Parisian Rock by Paul McCartney," Mersey Beat. Accessed October 12, 2021, at http://triumphpc.com/mersey-beat/archives/parisian-rock.shtml

29 *The Beatles Anthology*, p. 552.

30 Kane, *When They Were Boys*, p. 326.

31 Lennon, *John*, p. 106.

32 *The Beatles Anthology*, p. 75.

33 *The Beatles Anthology*, p. 75.

34 *The Beatles Anthology*, p. 75.

35 Lewisohn, *Tune In*, p. 554.

36 *The Beatles Anthology*, p. 67.

37 Lisa Robinson, "A Conversation with John Lennon," *Hit Parader*, December 1975, in Jay Spangler, The Beatles Interviews Database, accessed February 1, 2023, at http://www.beatlesinterviews.org/db1975.1200.beatles.html]

38 Lewisohn, *Tune In*, p. 672.

39 Mark Savage, "When George Martin Met the Beatles: The Story of 'Love Me Do'," *BBC News*, March 9, 2016.

1962: Gold-Colored Cuff Links

1 Lewisohn, *Tune In*, p. 599.

2 Lewisohn, *Tune In*, p. 599.

3 Mark Lewishon, *The Complete Beatles Recording Sessions* (New York: Harmony Books, 1988), p. 164

4 *Vogue UK*, April 1962, p. 124.

5 Lewisohn, *The Complete Beatles Recording Sessions*, p. 16.

6 *The Beatles Anthology*, p. 70.

7 Lewisohn, *Tune In*, p. 645.

8 Ian Inglis, *The Beatles in Hamburg*, p. 96.

9 *The Beatles Anthology*, p. 77.

10 Tony Barrow, *John, Paul, George, Ringo and Me* (New York: Thunder Mouth's Press), p. 27.

11 Lewisohn, *Tune In*, p.730.

12 "An Original Peter Kaye Photograph Autographed By The Beatles Just As Ringo Had Joined The Band," Frank Caiazzo, Beatles Autographs. Accessed June 25, 2022, at https://www.beatlesautographs.com/PhotographsImages7.htm

13 *The Beatles Anthology*, p. 75.

14 *The Beatles Anthology*, p. 73.

15 Lennon, John, p. 128.

16 Lewisohn, *Tune In*, p. 762.

17 Paul Jobling, *Advertising Menswear: Masculinity and Fashion in Britain in the British Media Since 1945* (London: Bloomsbury, 2014), p. 81.

18 Hardy Amies, *Still Here: An Autobiography* (London: Weidenfeld and Nicolson, 1984), p. 68.

19 Rodney Bennett-England, *Dress Optional: The Revolution in Menswear* (London: Peter Owen, 1967), p. 56.

20 Paul Anderson, *Mods: The New Religion* (London, Omnibus Press, 2014), p. 28.

21 Rob Ryan, "Baby, You Can Wear My Suits," *GQ,* April 2000, pp. 85–90.

22 Soho's tailoring had two sources, both pre-dating the music business. In the west of Soho were low-rent old premises that housed small freelance tailoring workshops that took in and turned around quickly work put out to them—in busy seasons, or specialist jobs—by the posh Savile Row and other West End tailoring establishments off the other side of Regent Street. Soho's tailoring and dressmaking houses also worked on costumes for the many West End theaters located within the surrounding square mile. An ecosystem of fabric (expensive and cheap) and notion suppliers grew up around these businesses. From the eighteenth century on, those who wanted fancy dress or unusually cut clothing went to the theatrical firms in Soho to get it made.

23 Paul Gorman, *The Look* (London, Sanctuary Press, 2001), p. 55.

24 Gorman, *The Look,* p. 55.

25 Interview with the author, November 8, 2017.

26 Lewisohn, *Tune In*, p. 801.

27 *The Beatles Anthology*, p. 77.

28 Jem Aswad, "Paul McCartney Writes Touching Tribute to Little Richard," *Variety*, May 10, 2020.

29 *The Beatles Anthology*, p. 77.

30 Lewisohn, *Tune In*, p. 779.

1963: Uncollared

1 "Get Back to the Staircase," *The Genealogy of Style*, N.D. Accessed October 24, 2015, at https://thegenealogyofstyle.wordpress.com/2014/12/08/get-back-to-the-staircase/

2 Philip Norman, *Paul McCartney The Life* (New York: Little, Brown and Company, 2016), p. 178.

3 *The Beatles Anthology*, p. 110.

4 Wesley Laine, "Beatles Beatles," *Record Mirror*, February 2, 1963.

5 Anderson, *Mods: The New Religion*, p. 35.

6 The publication launched in 1963 and ran for seventy-seven editions until it ceased publication at the end of 1969.

7 Tony Barrow, *John, Paul, George, Ringo and Me*, p. 42.

8 *Aberdeen Evening Express*, October 12, 1963, p. 2.

9 Maureen Cleave, "Why the Beatles Create All That Frenzy," in *The Mammoth Book of the Beatles*, ed. Sean Egan (Philadelphia: Running Press, 2009), p. 24.

10 Honey's founder was Audrey Slaughter who through her marriage to Charles Wintour, editor-in-chief of the *Evening Standard*, later became stepmother to Anna Wintour, editor of American *Vogue*.

11 Piet Schreuders, Mark Lewisohn, and Adam Smith, *The Beatles' London* (Northampton: Interlink Books, 2008), p. 15.

12 *The Beatles Anthology*, p. 94.

13 Barry Miles, *Paul McCartney: Many Years From Now*, p. 120.

14 Scott Berns, "Gordon Millings Interview," *YouTube video*, May 13, 2006, 7:37, https://www.youtube.com/watch?v=V9Zd2ZHiIHE

15 Clough, *Astrid Kirchherr: A Retrospective*, p. 58.

16 Interview with the author, January 24, 2023.

17 Nik Cohn, *Today There Are No Gentlemen*, p. 67.

18 Gorman, *The Look*, p. 59.

19 "With The Beatles—Pop A La Mod," *Boyfriend*, February 1963, pp. 11–12.

20 "Fiona Adams, photographer of The Beatles and other rock stars, dies at 84," BBC.com, July 10, 2020. Accessed on December 4, 2021, at https://www.bbc.com/news/entertainment-arts-53365590

21 *The Beatles Anthology*, p. 102.

22 Roger Stormo, "Lybro Jeans Photo Shoot," *The Daily Beatle*, December 9, 2015. Accessed February 18, 2016, at http://wogew.blogspot.ca/2015/12/lybro-jeans-photo-shoot.html

23 Colm Keane, "The Beatles' Irish Concerts." Accessed August 18, 2020, at https://www.colmkeane.com/book/beatles-irish-concerts/

24 Colin Barratt, *The Beatles in the News, 1964, Volume One* (Lulu.com, 2015), p. 1.

25 David Johnson and Roger Dunkley, *Gear Guide* (London: Old House Books, 1967/2013).

26 Andrew Loog Oldham, *Stoned*, p. 235.

27 Barry Miles, *The Beatles Diary, Volume One: The Beatles Years* (London: Omnibus Press, 2001), p. 93.

28 A whiff of menace still clung to their image. On June 18, at Paul's twenty-first birthday party, John made the papers when in a drunken rage he beat Cavern deejay Bob Wooler so badly he came close to killing him, or so he feared. The vicious fight took place outside Paul's Auntie Gin's house after Wooler had insinuated that John, who had accompanied Epstein on an April 1963 holiday to Spain, while his first child was being born, had become intimate with his manager, whose homosexuality was not a well-kept secret. John shut him up with a metal pole and then issued an apology and paid for damages after Wooler launched a lawsuit against him.

29 Keith Badman, *Beatles Off The Record* (London: Omnibus Press, 2010), p. 61.

30 "Raves in Retrospect," *Vogue UK*, December 1963, pp. 98–9.

31 "The Beatles, Four Parody Singers, Now the Passion of the British Young," *Vogue USA*, January 1964, pp. 100–1.

32 Forrest Wickman, "'BEATLEMANIA!' Is Born," *Slate*, October 24, 2013.

33 Queen Elizabeth II, who was patron of the Royal Variety Performance, was pregnant with Prince Edward and so had stayed at home, at the palace.

34 Derek Johnson, "Beatles Keep Royal Suits Secret," *New Musical Express*, November 1, 1963, p. 6.

35 Ian Inglis, "'I Read the News Today, Oh Boy': The British Press and the Beatles," *Popular Music and Society*, Vol. 33, No. 4, October 2010, pp. 549–62; p. 554.

1964: Well Hello Mop Tops

1 A pre-Olympia concert, a warmup to the main event, took place at the Cinéma Cyrano in Versailles the day before, On January 15, making it the first Beatles performance on French soil.

2 Tom Adam, *Looking Through You: Rare and Unseen Photographs for the Beatles Book Archive* (London: Omnibus Press, 2016), p. 35.

3 "16 January 1964, Live: Olympia Theatre, Paris," *The Beatles Bible*, November 6, 2020. Accessed on November 20, 2021, at https://www.beatlesbible.com/1964/01/16/live-olympia-theatre-paris/

4 In "Les Beatles à l'Olympia," Yellow-Sub, June 9, 2021. Accessed November 19, 2021, at https://yellow- sub.net/beatles/les-beatles-sur-scene/sur-scene-en-france/31348-beatles-a-lolympia

5 The Beatles shared equal billing with the Bulgarian-born chanteuse Sylvie Vartan and American singer Trini Lopez, then riding the charts with "La Bamba" and "If I Had a Hammer." They played third to last on the program. But just as had happened months before, fan adulation grew so rowdy during the Paris run that the Beatles ended up closing out the shows that took place up to three times a day.

6 "The Beatle," *San Francisco Chronicle*, December 26, 1963, p. 12.

7 In "Yeah, Yeah, Yeah," *The Guardian*, February 1, 2014.

8 "How the Beatles Took America: Inside the Biggest Explosion in Rock & Roll History," *Rolling Stone*, January 1, 2014. Accessed on November 18, 2019, at https://www.rollingstone.com/music/music-features/how-the-beatles- took-america-inside-the-biggest-explosion-in-rock-roll-history-244557/

9 Jack Paar aired a clip of the Beatles performing "She Loves You" from the BBC The Mersey Sound documentary on his late-night NBC television show on January 4, making it their first American TV appearance. They were seen dressed in their collarless suits, a look they would never actually wear in America. The performance was taped, not live, which is why *The Ed Sullivan Show* was the more important spectacle. It marked the Beatles' first live show in the United States.

10 Chris Hutchins, "Beatles: New Suits For U.S.A.," *New Musical Express*, February 7, 1964, p. 13.

11 In A.J.S. Rayl with photographs by Curt Gunther, *Beatles '64, A Hard Day's Night in America* (New York: Doubleday, 1989), p. 60.

12 Albert Goldman, *The Lives of John Lennon* (New York: William Morrow and Company, 1988), p. 158.

13 Interview with the author, November 23, 2021.

14 It was the first of three shows the Beatles did for Ed Sullivan that winter—two in New York and one at the Deauville Hotel in Miami Beach on February 16.

15 Spitz, *The Beatles*, p. 460.

16 Interview with the author, July 16, 2020.

17 In Betty Luther Hillman, *Dressing for the Cultural Wars, Style & the Politics of Self-Presentation in the 1960s and 1970s* (University of Nebraska, 2015), p. 14.

18 Spitz, *The Beatles*, p. 460.

19 Denise Schomberg, "The Beatles' Cultural Influence," *Wink: An Online Journal*, July 24, 2004. Accessed on November 22, 2021, at https://www.westerntc.edu/sites/default/files/student-life/documents/SchombergD.pdf

20 Art Seidenbaum, "Teen Hair Problem: Long and Short of It," *Los Angeles Times*, April 24, 1966.

21 "Anthropologist Says Beatles' Fashions Show 'Poorly Developed Sense of Self,'" *Nevada State Journal*, December 27, 1964, p. 18.

22 The Beatles admired Dylan as much as he did them. Says Paul: "It was really a question of everyone admiring Dylan. And we felt, kind of honoured that he admired us. We'd go to see him as the big guru, that was it, really."

23 In Greil Marcus, "The Beatles," *The Rolling Stone Illustrated History of Rock & Roll* (New York; Random House/Rolling Stone Press, 1980), pp. 179–80.

24 "Beatle Fashions Bring Suspensions," *The Record*, February 28, 1964, p. 36.

25 Matthew Wills, "The High School Hair Wars of the 1960s," *JStor Daily*, March 10, 2018. Accessed on November 22, 2021, at https://daily.jstor.org/the-high-school-hair-wars-of-the-1960s/

26 Jann S. Wenner, *Lennon Remembers, The Rolling Stone Interviews* (New York: Verso, 2001), pp. 108–9.

27 Amy Larocca, "The House of Mod," *New York Magazine*, February 6, 2003.

28 *Times Colonist*, Victoria, B.C., February 14, 1964, p. 16.

29 Spitz, *The Beatles*, p. 460.

30 Simon Napier-Bell, *Black Vinyl, White Powder* (New York: Random House, 2013), p. 55.

31 "The British Boys: High Brows and No-Brows," *The New York Times*, February 9, 1964.

32 Mark Lewisohn, *The Beatles Day by Day, 1962-1969: A Chronology* (New York: Harmony Books, 1987, 1990), p. 40.

33 The Beatles Press Conference at JFK Airport (1964), *YouTube*, February 6, 2013.

34 Badman, *Beatles Off The Record*, p. 82.

35 Al Aronowitz, "Beatlemania in 1964: 'This has gotten entirely out of control,'" reprinted in *The Guardian* from Rock's Backpages, January 29, 2014. Accessed on November 20, 2021, at https://www.theguardian.com/music/2014/jan/29/the-beatles

36 The sneaky hair snipper has since been identified as Beverly Rubin (née Markowitz),

then an eighteen-year-old resident of Silver Springs, Maryland, who had crashed the 1964 Washington party on the arm of her deejay boyfriend.

37 *The Beatles Anthology*, p. 120.

38 Michael R. Frontani, *The Beatles: Image and the Media* (Jackson: University of Mississippi Press, 2007), p. 40.

39 Bob Neaverson, *The Beatles Movies* (London: Cassell, 1997), p. 21.

40 Besides observing the Beatles as a cultural phenomenon, Owen also observed how extraordinarily talented and ambitious they all were, watching with amazement as John and Paul whipped off six new songs custom-made for Lesters' as yet-untitled fictionalized film. "Can't Buy Me Love," released in March as the group's sixth single ("You Can't Do That," also written in Paris, comprised the B side) was composed on the piano the Beatles had installed in their hotel suite near the Champs Elysées. These as well as other songs written during that first US visit and later in London following the Beatles' return on February 22 were custom-made for the soundtrack to be released as the Beatles' third studio album—the first to feature all original material—on July 10. It would open with a *kraang!*—a distinctive Beatles' chord, played on George's 12-string Rickenbacker, that sounded the group's ongoing pursuit of originality.

41 But while a colorful turn of phrase, "a hard day's night" underscored just how hard the Beatles did work. On March 19, 1964, for instance, the Beatles filmed scenes in the morning and late afternoon for *A Hard Day's Night* at Twickenham Studios, located outside London. At lunch, they drove into the city to attend a Variety Club charity luncheon where the then Leader of the Opposition, Harold Wilson, presented them with the Show Business Entertainers of 1963 award. That night, they returned to London again to film their debut on *Top of the Pops*, Britain's most popular music show. The Beatles performed their duties hard, day and night.

42 The film's hairdresser was Betty Glasgow who trimmed the heads of the famous Mop Tops in between takes. She would later sell a lock of John's auburn brown hair, taped to the pages of *In His Own Write*, for £24,000 at a 2007 auction.

43 "Julie Harris Interview," *CostumeOnScreen*, MP3 Audio File, June 2011. Accessed June 14, 2015, at https://costumeonscreen.files.wordpress.com/2011/06/julie-harris-on-darling1.mp3

44 The young woman who gives Ringo the flick is Geraldine Sherman, now known as Dena Hammerstein, the writer, and theater producer. She appeared a year later as Rube in *Up The Junction The Wednesday Play by Nell Dunn,* directed by Ken Loach for BBC 1.

45 Walter Shenson (producer), *You Can't Do That! The Making of A Hard Day's Night*, 1996 [video documentary film], The Criterion Collection, 1h.2m.

46 Mark Lewisohn, *The Beatles A Hard Day's Night, A Private Archive*, Martha Karsh (ed.), Foreword (London: Phaidon, 2016), p. 12.

47 Andrew Sarris, "A Hard Day's Night: The Village Voice, August 27, 1964," in June Skinner-Sawyers (ed.), *Read the Beatles: Classic and New Writings on the Beatles* (London: Penguin Books, 2010), pp. 56–9.

48 Shenson, *You Can't Do That!*

49 Shenson, *You Can't Do That!*.

50 Shenson, *You Can't Do That!*

51 *The Beatles Anthology*, p. 160.

1965: Kings of Corduroy

1 Sherwood Hagerty, "Land of Scouse and Glory," *Newsweek*, December 14, 1964, pp. 33–4.

2 "Beatles Interview: MBE Reaction," *The Beatles Ultimate Experience*, June 12, 1965. Accessed September 18, 2019, at http://www.beatlesinterviews.org/db1965.0612.beatles.html

3 Marcus Collins, "'The Age of the Beatles': Parliament and Popular Music in the 1960s," *Contemporary British History*, Vol. 27, No. 1, pp. 85–107.

4 "On Rhythm Guitar John Lennon," *The Beatles Book Monthly*, No. 1, August 1963.

5 Lewisohn, *Tune In*, p. 585.

6 Farid Chenoune, *A History of Men's Fashion* (Paris: Flammiron, 1993), p. 218.

7 Dominic Sandbrook, *The Great British Dream Factory: The Strange History of Our National Imagination* (London: Penguin Books, 2016), p. 56.

8 Badman, *The Beatles Off the Record*, p. 185.

9 *The Times*, June 19, 1965, p. 9.

10 Dominic Sandbrook, *White Heat: A History of Britain in the Swinging Sixties* (London: Little Brown Book Group, 2006), p. 287.

11 Robert Greenfield, "The Rolling Stone Interview: Keith Richards," *Rolling Stone*, August 19, 1971. Accessed January 24, 2020, at https://www.rocksbackpages.com/Library/Article/the-irolling-stonei-interview-keith-richards

12 Interview with the author, May 30, 2019.

13 Nik Cohn, *Awopbopaloobop Alopbamboom, The Golden Age of Rock, Revised Edition* (New York: Grove Press, 1972). Ebook.

14 "Harry F. Waters, "Jean Shrimpton and the London Look," *Newsweek*, May 3, 1965, p. 69.

15 "Hooray for the Yé-Yé Girls," *Life*, May 29, 1964.

16 Laird Borrelli-Persson, "It Girl Pattie Boyd Talks Mary Quant," *Vogue*, April 5, 2019. Accessed on April 7, 2019, at https://www.vogue.com/article/1960s-it-girl-model-pattie-boyd-on-mary-quant

17 Lesley Jackson, *The Sixties* (London: Phaidon, 1998), p. 38.

18 Christopher Breward, *Fashion* (Oxford: Oxford University Press, 2003), p. 60.

19 Jonathon Walford, "Fashion Hall of Obscurity — Moya Bowler," July 30, 2012. Accessed January 30, 2020, at https://kickshawproductions.com/blog/?p=4088

20 Mary Quant, *Mary Quant: Autobiography* (London: Headline, 2012), p. 61.

21 Jonathan Aitkin, *The Young Meteors* (London: Secker & Warburg, 1967), pp. 34–5.

22 Marnie Fogg, *Boutique: A 60's Cultural Phenomenon* (London: Mitchell Beazley, 2003), p. 119.

23 Christopher Breward, David Gilbert, and Jenny Lister eds., *Swinging Sixties* (London: Victoria & Albert Museum, 2006), p. 112.

24 "British Ambassador Leads New Sales Drive in U.S.," *The Times*, June 9, 1965, p. 8.

25 Isadore Barmash, "Puritan Fashions Gets 'Mod' Look," *The New York Times*, June 4, 1965, p. 47.

26 Kevin Almond and Caroline Riches, "Gerald McCann: The Rediscovery of a Fashion Designer," *Costume*, Vol. 52, No. 1 (2018), pp. 97–122, p. 103.

27 Harry F. Waters, "Jean Shrimpton and the London Look," *Newsweek*, May 3, 1965, p. 68.

28 "British Ambassador Leads New Sales Drive in U.S.," *The Times*, June 9, 1965, p. 8.

29 Gloria Emerson, "Britain's Best-Dressed: The Youthful Mods," *The New York Times*, February 24, 1965, p. 43.

30 "Julie Harris Interview," *CostumeonScreen*, MP3 Audio File, https://costumeonscreen.files.wordpress.com/2011/06/julie-harris-on-darling1.mp3.

31 A.J.S. Rayal, *Beatles '64, A Hard Day's Night in America*, p. 215.

32 The Beatles met Elvis in the flesh in Los Angeles on August 27, 1965, a visit arranged by their respective managers, Brian Epstein and Colonel Parker. The meeting was initially tense, the Beatles awe struck in the presence of the King of Rock and Roll, but the mood relaxed when Elvis brought out guitars for them all to play together. Ringo tapped out a backbeat on a piece of furniture. Unfortunately, no one took any photographs. It was a momentous occasion, never to be repeated.

33 Interview with Tim Hudson, Warwick Hotel, August 1965. Harrisonstories. Accessed June 25, 2022, at https://harrisonstories.tumblr.com/post/99841019598/q-you-can-see-the-paint-paint-on-his-blue. See also "15 August 1965, 'Lord' Tim Hudson Interview (29:53), The Beatles Archives: Beatles Interviews & Spoken Words Recordings. Accessed June 25, 2022, at http://www.beatlesarchives.com/talk-beat.htm

34 "Boots to Match," *The Beatles Book Monthly*, No. 23, June 1965, p. 29.

35 Peter Bart, "Keeper of the Beatles," *The New York Times*, September 5, 1965, p. X7.

36 "Bosley Crowther, "The Other Cheek to the Beatles," *The New York Times*, September 12, 1965, p. X1.

37 *The Beatles Anthology*, p. 167.

38 Sara Schmidt, "Meet The Beatles During Help (repost)," *Meet the Beatles For Real*, January 17, 2019. Accessed January 18, 2019, at http://www.meetthebeatlesforreal.com/2019/01/meet-beatles-during-help-repost.html

39 Interview with the author, July 20, 2020.

40 David Sheff, *All We Are Saying: The Last Major Interview with John Lennon and Yoko Ono* (New York: St. Martin's Griffin, 2000), p. 196.

41 *The Beatles Anthology*, p. 197.

42 See Devin McKinney, *Magic Circles: The Beatles in Dream and History* (Cambridge: Harvard University Press, 2003), pp. 103–111.

43 "The Indomitable Style of Bob Dylan," *GQ*, October 13, 2016. Accessed January 31, 2020, at https://www.gq.com/story/bob-dylan-style

44 Badman, *Beatles Off The Record*, p. 168.

45 "Der Peatles in Austria," *Rave*, May 1965. Accessed November 29, 2021, at https://beatlesbeforepepper.tumblr.com/post/648626151958396928/the-beatles-in-help-rave-magazine-may-1965

46 "Blue Chip Beatles," *Newsweek*, October 4, 1965, p. 82.

47 Badman, *Beatles Off The Record*, p. 155.

48 Martin King, "The Beatles in Help! Re-Imagining the English Man in Mid 1960s' Britain," *Global Journal of Human-Social Science: C Sociology & Culture*, Vol. 14, No. 4 (Version 1.0), 2014. https://globaljournals.org/GJHSS_Volume14/1-The-Beatles-in-Help.pdf

1966: From Mod To Odd

1 Pattie Boyd, *Wonderful Tonight* (New York: Harmony Books, 2007), p. 90.

2 Steve Turner, *Beatles '66, The Revolutionary Year* (New York: HarperCollins, 2016), p. 81.

3 "Boutique Boom," *Rave*, September 1965. In Sweet Jane blogspot. Accessed November 23, 2020, at http://sweetjanespopboutique.blogspot.com/2013/01/the-british-boutique-boom-1965-part-one.html

4 John Crosby, "1966 and All That," *GQ*, September 1966, p. 134.

5 Turner, *Beatles '66, The Revolutionary Year*, p. 325.

6 Jane Howard, "Oracle of the Electric Age," Life, Vol. 60, No. 8, Feb. 25, 1966, pp. 91–2.

7 Turner, *Beatles '66, The Revolutionary Year*, p. 145.

8 Dave McGuinn, then the guitarist for the Byrds, had been wearing blue-colored glasses when, with Peter Fonda in tow, he visited the Beatles at their rented Laurel Canyon bungalow in 1965. As he told *Rolling Stone* in 1990, McGuinn had found the frames in Los Angeles, at a Carnaby Street-like boutique called DeVoss, located on the Sunset Strip, after first seeing John Sebastian, leader of the Lovin's Spoonful, wearing something similar in New York's Greenwich Village. But it was only after the Beatles wore the tea glasses that the look took off, emerging as a major trend for men and women in 1966 and the hippy years beyond. Tinted eyewear is just one example of how the Beatles could take a nascent trend and turn it into fashion gold, simply by claiming an existing look as their own.

9 Piri Halasz, "Great Britain: You Can Walk Across It On The Grass," *Time*, April 15, 1966, p. 30.

10 Simon Philo, *British Invasion: The Crosscurrents of Musical Influence* (Lanham: Rowman & Littlefield, 2014), pp. 101–3.

11 Cohn, *Today There Are No Gentlemen*, p. 66.

12 Ted Polhemus, "Trickle Down, Bubble Up," *The Fashion Reader*, Second Edition, Linda Welters and Abby Lillethun, editors (Oxford, New York: Berg, 2011), p. 452.

13 John Walsh, "Sixties Sloanes: The Posh Hippies of the 1960s," Tatler, June 21, 2017. Accessed September 22, 2019, at https://www.tatler.com/gallery/sixties-sloanes-and-posh-hippies-1960s

14 "London and Paris: Mod and Cardin Aftermaths," *Gentleman's Quarterly*, February 1967.

15 "Interview with Jane Ormsby-Gore," Victoria and Albert Museum, March 2006. Accessed September 14, 2017, at http://www.vam.ac.uk/content/articles/i/jane-ormsby-gore/

16 In Cally Blackman, "Clothing the Cosmic Counterculture: Fashion and Psychedelia," in Christoph Grunenberg and Jonathan Harris, eds., *Summer of Love* (Liverpool: University of Liverpool Press, 2005), p. 214.

17 John Crosby, "The Return of the Dandy," *The Observer*, May 1, 1966.

18 "The Swinging Revolution," *Life*, July 11, 1966.

19 Richard Sandomir, "Michael Rainey, Boutique Owner in Swinging London, Dies," *New York Times*, February 2, 2017. Accessed September 14, 2017, at https://www.nytimes.com/2017/02/17/world/europe/michael-rainey- dead.html?_r=0

20 "Beatles Chicago Press Conference #1," August 11, 1966, The Ultimate Beatles Experience. Accessed October 6, 2017, at http://www.beatlesinterviews.org/db1966.0811.beatles.html

21 Jonathan Aitkin, *The Young Meteors* (London: Atheneum, 1967), p. 22.

22 *Rave* Magazine, Vol. 8, August 1966.

23 Paolo Hewitt, *Fab Gear* (London: Prestel, 2011), p. 116.

24 Tony Barrow, *John, Paul, George, Ringo & Me*, p. 182.

25 Interview with the author, November 9, 2017.

26 In "Granny Takes A Trip, a Boutique Everybody Wanted To Be Seen In . . .," A.G. Nauta Couture Blogspot, Accessed October 14, 2017, at https://agnautacouture.com/?s=granny+takes+a+trip&submit=Search

27 Interview with the author, February 2, 2016.

28 "Granny Takes A Trip," *Vintage Fashion Guild*, July 15, 2010. Accessed March 24, 2016, at http://vintagefashionguild.org/label-resource/granny-takes-a-trip/

29 Interview with the author, November 9, 2017.

30 Salmon Rushdie, "Heavy Threads," *The New Yorker*, November 7, 1994, p. 213.

31 Interview with the author, November 9, 2017.

32 "Men's Wear," *The Financial Post*, Toronto, February 26, 1966.

33 *Life Magazine*, July 26, 1968, p. 38.

34 *The Beatles Anthology*, 201.

35 Maureen Cleave, "Did I Break Up the Beatles?" *The Daily Mail*, December 18, 2009. Accessed October 3, 2017, at http://www.dailymail.co.uk/tvshowbiz/article-1237097/Maureen-Cleave-Did-I-break-The- Beatles.html#ixzz4uTCduHcg

36 "Beatles Chicago Press Conference #1, August 11, 1966," Ultimate Beatles Experience. Accessed October 6, 2017, at http://www.beatlesinterviews.org/db1966.0811.beatles.html

37 Turner, *Beatles '66, The Revolutionary Year*, p. 122.

38 *The Beatles Anthology*, pp. 204–5.

39 Capitol had printed 750,000 copies of the butcher cover, sending out advance copies to retailers and radio stations for promotional play, and then had to scramble to get them all returned.

40 Martin King, *Men, Masculinity and The Beatles* (London and New York: Routledge, 2016), p. 116.

41 "The Beatles Outside Abbey Road at Around Christmas 1966," *YouTube video*, September 7, 2013, https://www.youtube.com/watch?v=4_jP-tOKXXQ

1967: Raging Retro

1 "Sgt. Pepper's Turns 50: The Newsweek Review of The Beatles' Masterpiece, Newsweek, June 1, 2017. Accessed February 3, 2023, at https://www.newsweek.com/sgt-peppers-turns-50-newsweek-review-beatles-masterpiece-619008; Richard Poirier, "Learning from the Beatles," in *Shake it Up, Great American Writing on Rock and Pop from Elvis to Jay Z*, Jonathan Lethem and Kevin Dettmar, eds. (New York: Penguin Random House, 2017), pp. 19-20.

2 Ian Macdonald, *Revolution in the Head, 3rd Revised Edition* (London: Vintage Books, 2008), p. 231.

3 Steve Turner (1987), "The Beatles: *Sgt Pepper,* The Inside Story Part II". *Q. The Beatles*. Accessed March 5, 2020, at http://www.rocksbackpages.com/Library/Article/the-beatles-isgt-pepper-ithe-inside-story-part-ii

4 Costume designer Noel Howard, who worked for Berman's at the time, was part of the team that designed the Pepper suits. In 1999, at Yoko Ono's request, he made four exact copies of the Pepper suits for a museum in Japan, as he later confirmed in a letter: "In November of 1999, I was found and contacted by Yoko Ono's office to recreate an exact copy of the costumes, as I had done some 35 years earlier, for a museum in Japan. To ensure that I re-created perfect matching costumes, in color, fabrics, and sizes, I was flown out to New York to inspect the originals, three of which were made available to me at that time. This costume is the closest any private collector will come to owning an original." He also made a set for himself. One of the reproductions sold at auction in the United States in 2016 for over $25,000. In 2000, Howard made another duplicate set, again according to the original 1967 measurements, for Liverpool's The Beatles Story, according to a news report on his death in England in 2008. See: Chris Sadler, "Sgt Pepper costume man now in Stody churchyard," Network Norwich and Norfolk, October 21, 2019. Accessed May 1, 2022, at https://www.networknorwich.co.uk/Articles/557954/Network_Norwich_and_Norfolk/Regional_News/North_Norfolk/Sgt_Pepper_costume_man_now_in_Stody.aspx

5 Piet Scheuders et al., *The Beatles' London*, p. 136.

6 Interview with the author, November 10, 2017.

7 "Hendrix Hussar Jacket - Lord Kitchener's Valet 1967." YouTube Video, 2:11, https://www.youtube.com/watch?v=7mxDriwLyyU

8 "Uniforms for Non-Conformists," *Look,* Vol. 31, No. 26, December 26, 1967.

9 *The Beatles Anthology*, p. 248.

10 Costume analysis in "Sgt. Pepper – The Costumer's Guide to Movie Costumes." Accessed July 20, 2018, at http://www.costumersguide.com/cr_pepper.shtml.

11 Piers Hemmingsen email exchange with the author, July 24, 2018.

12 Kenny Everett, "Beatle Luv-In," *Teen Datebook,* November 1967, 16.

13 Interview with the author, February 21, 2019.

14 The songs, one by Paul and the other by John, were originally intended for *Sgt. Pepper*. But Epstein, aware that the Beatles hadn't released a single since August 1966—"Eleanor Rigby," a double-single paired with "Yellow Submarine"—told George Martin to release them in advance of the album, which he did, to his living regret.

15 Mark Lewisohn, *The Complete Beatles Recording Sessions* (New York: Harmony Books, 1988), p. 93.

16 The Beatles in Review: 'Strawberry Fields Forever/Penny Lane' (1967), Tea and A Butty, October 22, 2012. Accessed July 19, 2018, at http://www.thebeatlesthroughthe-years.com/2012/10/the-beatles-in-review- strawberry-fields.html

17 Thomas Thompson, "The New Far-Out Beatles," *Life*, June 16, 1967, p. 101.

18 *The Beatles Anthology*, p. 274.

19 Hanif Kureishi, "How the Beatles Changed Britain," Discovering Literature: 20th Century, The British Library. Accessed on December 19, 2021, at https://www.bl.uk/20th-century-literature/articles/how-the-beatles-changed-britain

20 Email exchange with Marijke Koger, September 18, 2018.

21 Norrie Drummond, "Dinner with the Beatles," *New Musical Express*, May 27, 1967. In Beatles Interviews Database. Accessed December 20, 2021, at http://www.beatlesin-terviews.org/db1967.0519.beatles.html

22 Email exchange with Marijke Koger, September 25, 2018.

23 *The Beatles Anthology*, p. 257.

24 Barry Miles, *London Calling, A Countercultural History of London since 1945* (London: Atlantic Books, 2010), pp. 243–6.

25 "Apple and the Beatles," *Rolling Stone*, November 9, 1967. Accessed on December 21, 2021, at https://truthaboutthebeatlesgirls.tumblr.com/post/97703702086/colorized-version-of-the-september-1967-ronald

26 Felicity Green, "Where Did Patti Get That Gear?" *Daily Mail*, August 8, 1967, p. 7.

27 Richie Unterberger, "George Harrison Visits Haight-Ashbury In Summer 1967". *MOJO,* Summer 2007. Accessed March 11, 2020, at http://www.rocksbackpages.com/Library/Article/george-harrison-visits-haight-ashbury-in- summer-1967.

28 *The Beatles Anthology*, p. 259.

29 The garment is now in the collection of Victoria & Albert Museum in London.

30 Now in the collection of the FDMI Museum in Los Angeles.

31 Email exchange with Marijke Koger, September 25, 2018.

32 *The Beatles Anthology*, p. 257.

33 *The Beatles Anthology*, p. 272.

34 Martin King, "Roll up for the Mystery Tour: Reading the Beatles' Magical Mystery Tour as a Countercultural Anti-Masculinist Text," *Global Journal of Interdisciplinary Social Sciences*, May–June 2015, pp. 102–110; p. 108.

35 Bob Neaverson, *The Beatles Movies*, p. 71.

36 Badman, *Beatles Off The Record*, p. 333.

37 *The Beatles Anthology*, pp. 273-4.

1968: Who's Minding the Shop?

1 Ann Ryan, "The Fool's Apple," Women's Wear Daily, Thursday, November 2, 1967.

2 *The Beatles Anthology*, p. 270.

3 *The Beatles Anthology*, p. 296.

4 The Beatles' Apple Boutique opens at Baker Street, London (1967), British Pathé, YouTube Video, 1:19, https://www.youtube.com/watch?v=i89qy9Dr81I =

5 Marit Allen, *Vogue UK*, January 1968.

6 Don Short, "With a Bite of the Apple for All their Old Mates," *Daily Mirror*, June 12, 1968.

7 See Heather Harris, *Interview with Marijke Koger-Dunham*, February 22, 2016. Accessed May 28, 2018, at http://fastfilm1.blogspot.com/2016/02/interview-with-marijke-koger-dunham.html

8 *The Beatles Anthology*, p. 270.

9 Inspiration for creating a store mural in the first place likely came from the London boutique Lord John, located on the corner of Carnaby and Ganton Streets, whose exterior had been painted over by Binder, Edwards & Vaughan (the same team had also painted Paul's Knight piano) with a psychedelic design earlier in 1967, easily making it the most-eye-catching building on the fashion block.

10 *The Beatles Anthology* p. 296.

11 *The Beatles Anthology*, p. 270.

12 Danae Brook, "Apple," *Eye Magazine*, April 1968, in The Fool and the Apple Boutique, 1968, *Sweet Jane Blog*, May 22, 2014. Accessed January 17, 2021, at https://sweetjane-spopboutique.blogspot.com/2014/05/apple-boutique-1968.html

13 Miles, *Many Years from Now*, p. 445.

14 Miles, *Many Years from Now*, p. 446.

15 Miles, *Many Years from Now*, p. 451 and Chet Flippo, *Yesterday: The Unauthorized Biography of Paul McCartney* (New York: Doubleday, 1988), p. 266.

16 Once in LA, the tambourine-shaking quartet signed on with Mercury Records to make an album, which their old friend Graham Nash, of the Hollies, produced. Released in 1969, *The Fool*, as it was entitled, flopped. "I vomited when the LP was released," said Mercury A&R director, Bob Reno. "It was dreadful and sold about three copies."

17 *The Beatles Anthology*, p. 270.

18 Email exchange with Alan Holston, July 20, 2018.

19 Interview with the author, March 4, 2020.

20 Interview with the author, March 4, 2020.

21 "Apple Tailoring opens in London, Thursday 23 May 1968," *The Beatles Bible*. Accessed September 24, 2018, at https://www.beatlesbible.com/1968/05/23/apple-tailoring-opens-in-london/

22 Betty Rollin, "Top Pop Merger: Lennon/Ono Inc.," *Look*, March 18, 1969, p. 37

23 Miles, *Many Years from Now*, p. 460.

24 June Skinner Sawyers, ed., *Read the Beatles* (New York: Penguin Books, 2006) p. 136.

25 Interview with the author, March 4, 2020.

26 Jonathan Cott, *Days That I'll Remember: Spending Time With John Lennon & Yoko Ono* (New York: Doubleday, 2013), p. 44.

27 "Long-hairs Ask. Do We Shave?" Barbara Lewis, *The Morning News*, November 29, 1969, p. 3.

28 *The Beatles Anthology*, p. 312.

29 *The Beatles Anthology*, p. 305.

30 "Critics Say Beatles Go From Riches to Rags," David Lancashire (AP), Pittsburgh Post-Gazette, January 10, 1969, p. 27.

31 Peter Brown, *The Love You Make: An Insider's Story of the Beatles (*New York: Berkley, 2002), p. 309.

32 Oldham, p. 349.

33 "Bonnie Fashion's New Darling," *Life*, January 12, 1968, pp.

34 Interview with the author, November 9, 2017.

35 Interview with the author, March 4, 2020.

36 Leslie Cavendish, *The Cutting Edge* (Surrey, UK, Alma Books, 2017), pp. 214–5.

37 Badman, *The Beatles Off the Record*, p. 376.

1969: Unravelling the Threads

1 Peter Jackson, The Beatles: Get Back, TV Docuseries, 2021, 7 hrs. 48 mins.

2 Greg Roberts, "3 Savile Row — Its Role in British History," Wicked William Regency blog, January 19, 2015. Accessed February 8, 2022, at http://www.wickedwilliam.com/3-savile-row-role-british-history/

3 American fashion brand Abercrombie & Fitch opened the first UK branch of "Abercrombie Kids" at 3 Savile Row in 2012; it shuttered the business in 2021.

4 Sara Schmidt, "Get Back Observations #4: John Lennon's fur coat," *Meet The Beatles For Real*, Blog Post, February 27, 2022. Accessed March 1, 2022, at http://www.meet-thebeatlesforreal.com/2022/02/get-back-observations-4- john-lennons.html

5 "Ultimate in luxury fur coats for men," Margaret Ness, *The Windsor Star*, November 11, 1969, p. 21.

6 Jimmy Kimmel Live! "Ringo Starr on Paul McCartney's Genius, Writing Octopus' Garden High & The Beatles Farting Habits," YouTube Video, February 18, 2022, 16:42. Accessed March 1, 2022, at https://www.youtube.com/watch?v=IFtOd7siwiI

7 Derek Taylor, *As Times Goes By* (London, Faber & Faber, 2018), chp. 11, Kindle.

8 Author interview, May 15, 2018.

9 Walter Logan, "Youthful British Tailor Nutter Is 'All The Talk' on Savile Row," *The Cumberland News*, August 5, 1971, p. 12.

10 Lance Richardson, *House of Nutter* (New York: Crown Archetype, 2018), pp. 103-4.

11 Interview with the author, May 15, 2018.

12 The name was a pseudonym, created by Mike (né McCartney), a musician in his own right, to distinguish him from his more famous brother.

13 *The Beatles Anthology*, p. 331.

14 Museum of Liverpool: Double Fantasy—John & Yoko, Exhibition, May 18, 2018, to March 11, 2019. Accessed on May 14, 2020, at https://www.artinliverpool.com/events/museum-of-liverpool-double-fantasy-john-yoko/

15 Jann S. Wenner, *Lennon Remembers,* New Edition (London: Verso, 2000), p. 40.

16 John Robinson, "High Concept," *The Guardian,* April 22, 2005. Accessed May 15, 2020, at https://www.google.ca/amp/s/amp.theguardian.com/artanddesign/2005/apr/23/art

17 *The Beatles Anthology*, p. 333.

18 Nick Logan, "Ringo: Beatles Today," *New Musical Express*, March 29, 1969.

19 "Ringo Starr Claims Beatles Are No Discarded Has-Beens," *Oshkosh Northwestern*, June 2, 1969, p. 24.

20 Kevin Howlett, *The Beatles: The BBC Archives 1962-70,* p. 267.

21 Barry Miles, *Many Years From Now*, p. 583.

22 *The Beatles Anthology*, p. 334.

23 Interview with the author, November 23, 2021.

24 *The Beatles Anthology*, p. 334.

25 Interview with the author, May 26, 2020.

26 Interview with the author, May 26, 2020.

27 Queen Elizabeth Hotel bellboy Tony Lashta, who was seventeen at the time, also picked up a new tight-fitting white suit that had been put on hold for John at Le Château. John would be photographed wearing it with a chocolate brown shirt and diagonal stripe tie when he departed Montréal to attend a University of Ottawa peace conference on June 3. See Joan Athey, *Give Peace a Chance: John and Yoko's bed-in for Peace* (Wiley: Mississauga, 2009), p. 107.

28 *The Beatles Anthology*, p. 345.

29 There would be other occasions for them all to socialize together. Just a week following the Tittenhurst shoot, three of the four Beatles travelled to the Isle of Wight music festival to watch their old friend Bob Dylan play to the masses. John, George, and Ringo, their faces similarly bearded and their hair past collar length, blended with the reefer-smoking crowd. Paul hadn't gone with them because his first child, Mary, was born just two days before the August 30 concert.

30 Interview with the author, September 4, 2019.

31 Interview with the author, May 15, 2018.

32 *The Beatles Anthology*, p. 342.

33 Interview with the author, May 15, 2018.

34 *The Beatles Anthology*, p. 342.

35 The Beatles were aware that everything about them was wildly interpretable—John's "Glass Onion" parodied the sign-seeking fan phenom—and so at first ignored the Paul is Dead rumor that had started to swell around them. Besides, there were other fires to put out. In early August, American actress Sharon Tate, then nearly nine months pregnant, was brutally murdered along with some of her friends at the Bel Air mansion she shared at the time with her director-husband, Roman Polanski. Cult leader Charles Manson had ordered the killings by members of his "Family," claiming to have been acting on subliminal messages which the Beatles had planted on the *White Album,* prophesizing the coming of an apocalyptic war. References to "Piggies" and "Helter Skelter," among other Beatles' songs, were found at the crime scene, written in the victims' blood.

36 *The Beatles Anthology*, p. 342.

37 *The Beatles Anthology*, p. 342.

38 *The Beatles Anthology*, p. 347.

39 *Life*, November 7, 1969, Vol. 67, No. 19, p. 105.

1970 and Beyond: Slouching Towards Immortality

1 Lloyd Shearer, "Overalls: Uniform of the Counterculture," *Parade*, January 2, 1972.

2 Francis Schoenberger, "He Said, She Said: An Interview With John Lennon, Spin, October 1988. Republished in digital form in 2019. Accessed May 3, 2022, at https://www.spin.com/2010/12/archive-1975-john-lennon- interview/

3 Keith Badman, *The Beatles: The Dream Is Over, Off the Record*, (London: Omnibus Press, 2009).

4 Alan Clayson, *Ringo* (London: Sanctuary, 2003), p. 200.

5 Editor Jay Spangler, "George Harrison Interview: Howard Smith, WABC-FM New York 5/1/1970," The Beatles Ultimate Experience, The Beatles Interviews Database. Accessed January 30, 2019, at http://www.beatlesinterviews.org/db1970.04gh.beatles.html

6 Kevin Howlett, The Beatles: The BBC Archives, p. 303.

7 Sara Schmidt, "The Long and Winding Road to the Anthology (part 2)," *Meet The Beatles For Real*, November 10, 2015, Accessed April 21, 2022, at http://www.meetthebeatlesforreal.com/2015/11/the-long-and-winding-road-to- anthology.html

8 May Pang and Henry Edwards, *Loving John* (New York, Warner Books, 1983), p. 33.

9 Vicki Sheff, "The Betrayal of John Lennon," Playboy, 1984. Reposted online at VickiScheff.com. Accessed May 11, 2022, at https://www.vickisheff.com/john-lennon-yoko-ono/

10 Interview with the author, May 30, 2019.

11 Mary Gottschalk, "The Groovy '60s: Men, It's Anything Goes and We Can Thank the Beatles," *Chicago Tribune*, May 30, 1984, p. S-B5.

12 Joe Bosso, "David Crosby on the impact of The Beatles: 'They changed my life,'" *Music Radar*, February 7, 2014. Accessed April 19, 2022, at https://www.musicradar.com/news/guitars/david-crosby-on-the-impact-of-the-beatles-they-changed-my-life-593827

13 Rolling Stone #181: Joe Walsh, in The Uncool: The Official Website for Everything Cameron Crowe. Accessed April 25, 2022, at https://www.theuncool.com/journalism/rs181-joe-walsh/

14 Gene Simmons of KISS talks Liverpool, The Beatles and why modern bands look like pizza delivery boys by Jade Wright, *The Liverpool Echo,* April 9, 2010, Accessed April 25, 2022, at https://www.liverpoolecho.co.uk/whats-on/music/gene-simmons-kiss-talks-liverpool-3425302

15 Maura Kelly, An Interview with Nancy Wilson, *Believer*, August 1st, 2007. Accessed April 28, 2022, at https://believermag.com/an-interview-with-nancy-wilson/

16 Mike Joyce, "Getting the Knack," *The Washington Post*, October 10, 1979. Accessed April 24, 2022, at https://www.washingtonpost.com/archive/lifestyle/1979/10/10/getting-the-knack/559d414f-2a12-4e76-b695-ce38502d4b52/

17 Marie Jackson and Kesewaa Browne, "BTS and K-pop: How to be the perfect fan," *BBC News*, October 9, 2018. Accessed April 25, 2022, at https://www.bbc.com/news/uk-45800924

18 Skylar Adams, "Paul McCartney Endlessly Praises BTS and Compares Them to His Legendary Band, The Beatles," *KoreaBoo News*, November 24, 2020. Accessed April 30, 2022, at https://www.koreaboo.com/news/paul-mccartney-praises-bts-compares-beatles/

19 "RM Q and A," *KpopHerald*, June 1, 2019.

20 Ryan Rolli, "The Beatles And BTS Are The Only Groups To Sell 1 Million Album Units In 2020," *Forbes*, July 14, 2020. Accessed on February 6, 2023, at https://www.forbes.com/sites/bryanrolli/2020/07/14/beatles-bts-1-million-albums-2020/?sh=6fe90c335ec4

21 Daniel Radosh, "While My Guitar Gently Beeps," *The New York Times Magazine*, August 16, 2009. Accessed June 25, 2022, at https://www.nytimes.com/2009/08/16/magazine/16beatles-t.html

22 The Beatles: Rock Band sold three million units worldwide within the first three months of its release, generating revenues of around $60 million and an estimated million new downloads of Beatles music by a new generation of fans.

23 "Austin Powers — 'George Harrison was a Big Influence for Me' Deena Appel," #117The Austin Powers Series, From Tailors With Love, April 21, 2021. Accessed April 30, 2022, at https://fromtailorswithlove.co.uk/austin-powers-george-harrison-was-a-big-influence-for-me-deena-appel-117

24 Booth Moore, Dressed to Regress, *The Los Angeles Times*, June 4, 1999. Accessed April 30, 2022, at https://www.latimes.com/archives/la-xpm-1999-jun-04-cl-43921-story.html

25 George Stark, "I've waited a long time to become a male model!" Ringo Starr fronts a new fashion campaign for John Varvatos, *Daily Mail.com*, July 8, 2014. Accessed May 1,

2022, at https://www.dailymail.co.uk/tvshowbiz/article-2685421/Ringo-Starr-celebrates-74th-birthday-fronting-new-fashion-campaign-John-Varvatos.html

26 Valentina Ottaviani, "Milano Moda Uomo. Peter Dundas debutta per Roberto Cavalli," *Moda* — 6 febbraio 2016. Accessed May 1, 2022 at http://www.trendstoday.it/trendstoday/milano-moda-uomo-peter-dundas-debutta-per-roberto-cavalli/

27 Miles Socha, "Comme des Garçons does the Beatles," *WWD*, November 6, 2009, p. 2.

28 Suzy Menkes, "Teaming up" the Beatles with Commes des Garçons, *International Herald Tribune,* November 10, 2009, p. 12.

29 Daniela Petroff, "Re-Vamped Beatles Sweeps Milan Runway," *The Associated Press*, October 7, 1992.

30 Tina Cassidy, "It's a Mod, Mod World At Fashion Week," *The Boston Globe*, February 15, 2003, F1.

31 Derrick Chetty, Blazing Blazers; We Salute the Sgt. Pepper-style jacket as it marches back into style on the Paris runways and sells out in stores here," *Toronto Star*, May 28, 2009, L02.

32 Clare Press, "50 Years After Sgt. Pepper, the Beatles' Retro Military Jackets Continue to Inspire," *Fashionista.com*, June 14, 2017. Accessed July 1, 2022, at https://fashionista.com/2017/06/sgt-pepper-beatles-suits-uniform-fashion

33 Dylan Jones, "Hey Dude," *The Sunday Times*, March 20, 2022, pp. 26, 27, 29.

34 Emily Zemler, "Stella McCartney Unveils New Beatles-Inspired Collection," Rolling Stone, July 9, 2019. Accessed May 1, 2022, at https://www.rollingstone.com/music/music-news/stella-mccartney-beatles-inspired-collection- 856767/

35 Stella McCartney, @stellamccartney, July 8, 2019.

36 Interview with the author, February 22, 2023.

37 Lisa Armstrong, "This year's biggest style icons? The Beatles," *The Telegraph*, January 5, 2022, Accessed May 1, 2022, at https://www.telegraph.co.uk/fashion/people/years-biggest-style-icons-beatles/

38 Luke Leitch, "Takahiromiyashita The Soloist Collections," *Vogue,* March 8, 2022. Accessed February 5, 2023, at https://www.vogue.com/fashion-shows/designer/takahiromiyashita-the-soloist

39 Layla Ilchi, "Market Debuts the Beatles Capsule Collection," *WWD,* November 4, 2022. Accessed January 30, 2023, at https://wwd.com/fashion-news/fashion-scoops/market-the-beatles-fashion-collection-1235408554/

40 Samantha Tse, "Paris Fashion Week; Top moments from the menswear shows," *CNN,* January 24, 2023. Accessed January 30, 2023. https://www.cnn.com/style/article/paris-fashion-week-mens-fw-2023/index.html

Index

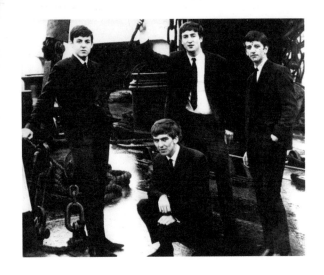
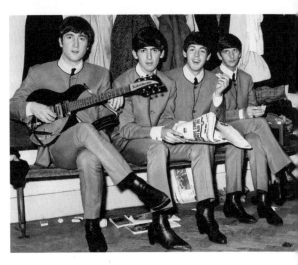
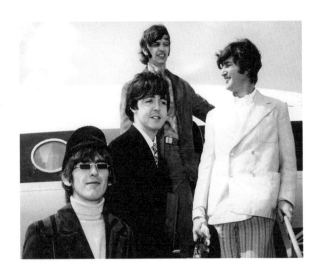
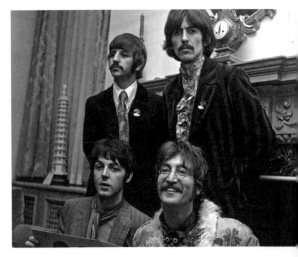